The Impressionists

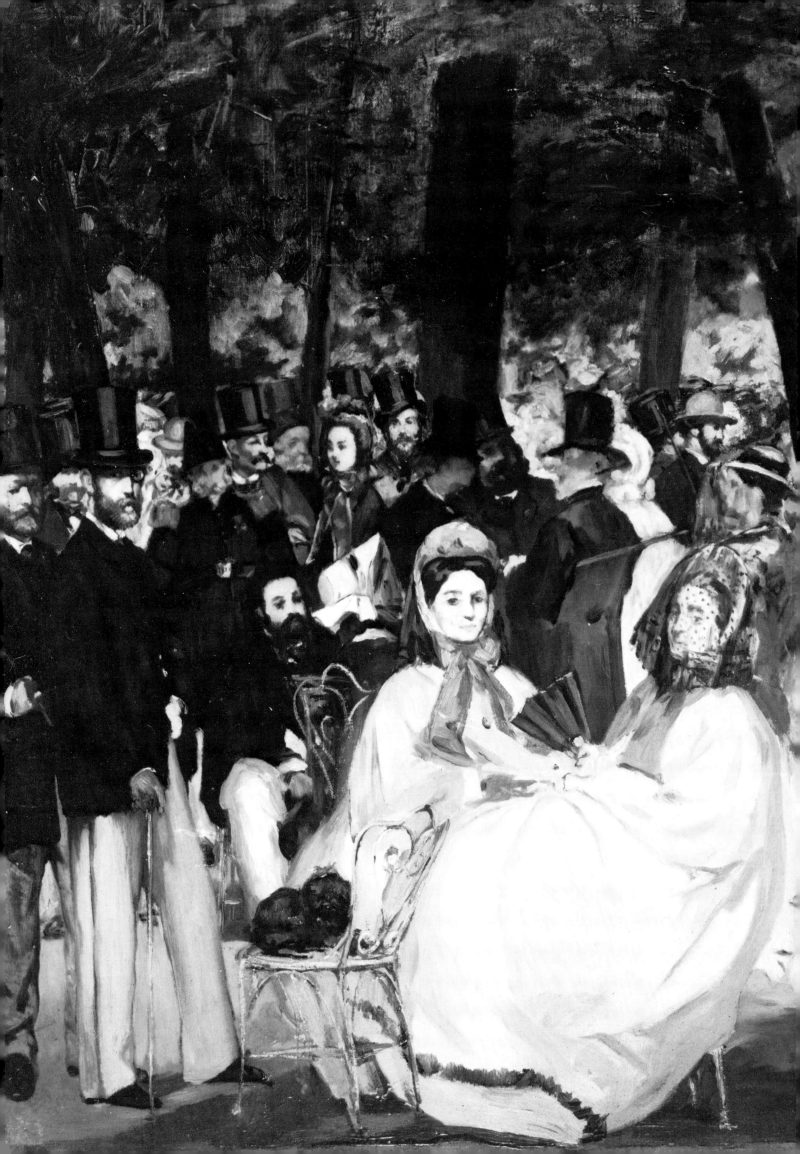

The Impressionists

Michael Wilson

Phaidon · Oxford
Phaidon Universe · New York

Published in Great Britain by Phaidon Press Limited,
Musterlin House, Jordan Hill Road, Oxford OX2 8DP

ISBN 0 7148 2661 8

A CIP catalogue record for this book is available from the
British Library

Published in the United States of America by Phaidon Universe,
381 Park Avenue South, New York, N.Y. 10016

Library of Congress Cataloging-in Publication Data

Wilson, Michael. 1951–
 The impressionists / Michael Wilson.
 p. cm.
 Originally published: Oxford : Phaidon. 1983.
 Includes bibliographical references.
 ISBN 0-87663-771-3
 1. Impressionism (Art)—France. 2. Painting, French.
3. Painting, Modern—19th century—France. 4. Impressionist
artists—France—Biography. I. Title.
ND547.5.I4W54 1990
759.4'09'034—dc20 90-30256
 CIP

First published 1983
Second edition (paperback) 1990

© 1983 by Phaidon Press Limited
Text © 1983 by Michael Wilson

Printed in Singapore under co-ordination of C S Graphics Pte Ltd

Contents

ENGLISH CHANNEL

○ DIEPPE

• Fécamp

• Étretat

• Sainte-Adresse

LE HAVRE

• Honfleur

• Trouville
Deauville

N O R M A N D Y

Paris and the Seine Valley
showing the main centres of
Impressionist activity

BEAUVAIS
◇

⬦ ROUEN

The Seine

• Eragny

The Oise

La Roche
Guyon

Osny

• Auvers

Giverny

• Vétheuil

• Pontoise

Chatou Argenteuil

Gennevilliers

St Denis

Évreux

Mantes •

Poissy

Asnières

The Batignolles

Bougival Marly
Louveciennes

PARIS

VERSAILLES Bellevue

Rueil

• Montgeron

Ville d'Avray

N

W ─┼─ E

S

MELUN

CHARTRES
◇

ETAMPES
•

Chailly
Barbizon

FONTAINEBLEAU

• Moret

Marlotte

The Forest of Fontainebleau

SCALE

Miles 10 20 30 40 50

10 20 30 40 50 60 70 80
Kilometres

For my sister Carol

Preface

Few painters have achieved the popularity of the French Impressionists. Their devotion to the beauties of the everyday scene has given their pictures a lasting attraction; so appealing is the freshness of colour, the liveliness of technique, that it is easy to forget how long ago they were painted. The sepia photographs of the last century are like relics of a lost age — an age that did not know radio, jazz, the talking picture or the combustion engine — but the paintings of the Impressionists are invariably as immediate in their appeal as our own visual sensations. Yet Manet, Degas and Pissarro were born before the accession of Queen Victoria. They were young men at the time of the American Civil War.

There is no shortage of books devoted to the Impressionists. Few of them, however, have tried to place the men and women who created the marvels of painting we still enjoy in the context of their age, or have concentrated on their intimate and intricate relationships. When we do so, their achievements come to appear more remarkable still.

Although a great deal has been written — and published — on the subject, much vagueness surrounds the term Impressionism. Some definitions concern themselves with technique and colour theory, others with subject matter, and others still with the history of the movement. Inevitably out of this jumble of definitions emerge some surprising contradictions. Degas, for instance, participated in more of the group exhibitions than Monet and Renoir, as indeed did his friend Rouart. But is his work — chiefly figure compositions produced in the studio — more representative of Impressionism than Monet's? Manet, the painter of portraits, religious subjects, still-lifes, and modern history pictures like *The Execution of the Emperor Maximilian*, refused to participate in the group exhibitions, but in 1874 painted at Argenteuil alongside Monet and Renoir — is he to be admitted to the Impressionist circle? Monet's *Impression, Sunrise* (Plate 1), the very painting that gave the movement its name when it was exhibited in 1874, is itself untypical of the artist's work. It probably owes its character less to his immediate visual experience of the harbour of Le Havre on a foggy morning than to his memory of Whistler's contemporary views of the Thames — the *Nocturnes*, works which in their subordination of appearances to a semi-abstract, decorative mode represent a trend diametrically opposed to Impressionism.

In case it should appear that the word Impressionism has no meaning, it is worth returning to the artists themselves, who in the eyes of the public of their time constituted so formidable a force. If definitions seem to divide them, the scorn and insults poured upon them in their lifetime serve to bind them together. In 1894, when the painter Caillebotte died, bequeathing his collection of Impressionist pictures to the Louvre, prominent critics, artists and men of letter united in protest. Their spokesman, the academic painter Gérôme, gave voice to the general mood of righteous indignation when he said, 'I do not know these gentlemen, and of this bequest I know only the title ... Does it not contain paintings by M. Monet, by M. Pissarro and others? For the Government to accept such

1
CLAUDE MONET:
Impression, Sunrise.
1873. Oil on canvas.
Paris, Musée Marmottan

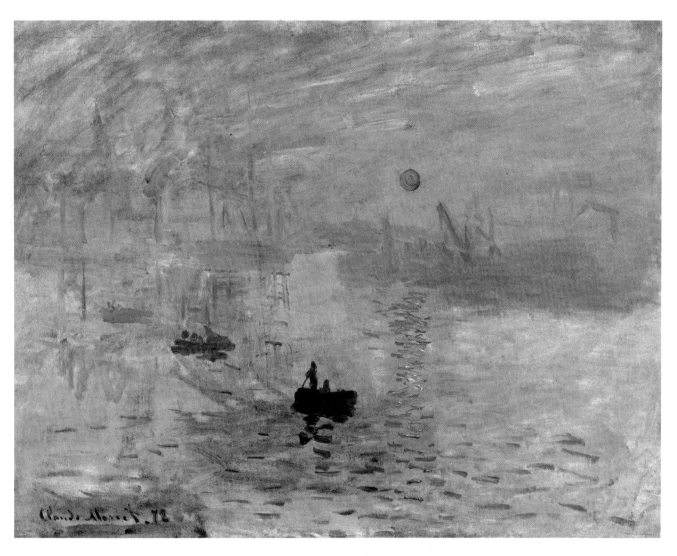

filth, there would have to be a great moral slackening ...'

It is astonishing that twenty years after their first public appearance together, when the youngest of them was no less than fifty, they should still have been considered dangerous. The suppressed hysteria of Gérôme's remarks, however, serves to remind us of the chief force behind the formation of the Impressionist group: opposition to and exclusion by the backbone of the French art establishment. Artists at all times have joined together for mutual support, both material and artistic, and out of the studios of great painters — Raphael, Rubens, David — have come schools of artists with aims and techniques in common. Few schools, however, have ever operated in so hostile an atmosphere as the Impressionists. Thus it was in spite of variations of technique and subject matter that they came together in close fellowship under the banner of liberty to pursue their studies and experiments without restriction. This book tells the fascinating and moving story of this fellowship, from their first encounters in 1861 and 1862 up to their last group exhibition in 1886, when conflicting aims, new influences and changed circumstances led to the break-up of the circle.

1 Origins

The year 1862 was an auspicious one for the history of painting, a year of new friendships and new beginnings which were to lead to one of the most fruitful associations of artists in modern times. It was in this year that Monet, Renoir, Sisley and Bazille met as fellow pupils in the Paris studio of the Swiss painter Gleyre, that Edouard Manet became friends with Edgar Degas, and that Manet painted *Music in the Tuileries Gardens*, a picture of modern society which was to inaugurate a new era of painting. Add to this the meeting of Monet and Pissarro at the Académie Suisse in 1859, and Pissarro's encounter with both Cézanne and Guillaumin at the same studio in 1861, and the chief links that make up the Impresssionist circle are forged.

It was not until twelve years later, however, that the group appeared before the public in their first independent exhibition. Thirty artists participated, among them realists of the older generation such as Cals, and fashionable artists of a conventional stamp such as de Nittis, but there was never any doubt as to who were the guiding spirits of the enterprise. Those whom the critics selected for their most passionate invective are those whom we today remember and revere as the Impressionists.

Gustave Caillebotte (Plate 2), a friend and collaborator as well as a collector of Impressionist works, neatly identified the group when, in 1876, he wrote a will making provision for an exhibition after his death 'of the painters who are called *Les Intransigeants* or *Les Impressionnistes*'. 'The painters to take part in this exhibition,' he wrote, 'are Degas, Monet, Pissarro, Renoir,

Cézanne, Sisley, Berthe Morisot. I name these, not to the exclusion of others.' In retrospect we need add no one else to this front line of Impressionist painters, except Manet, who of his own volition remained apart, and Frédéric Bazille, who had died in 1870.

No one could have foreseen that these eight or nine painters were to combine forces so effectively. Their origins differed markedly, and while some of them had the benefit of an expensive education and a handsome allowance, others had neither. No less varied were their characters, although each in his way contributed something to their joint enterprise. Their union was built on both strong affection and common artistic aims.

The eldest of them was Camille Pissarro, who was born on the island of St Thomas, a Danish protectorate in the West Indies, on 10 July 1830. Cézanne described him as 'something like *le bon dieu*', and to all who knew him he seemed to have something of the sage about him. Thadée Natanson remembered him in old age, with 'his prominent beaky nose and long white beard', as 'infallible, kind and just ... like God the Father'. Already in his self-portrait of 1873 (Plate 3) he looks far older than his forty-four years. But while his kindly wisdom won the affection of all his colleagues and made him the father-figure of the group, he was also the most radical in his political convictions. An atheist, and a follower of the ideas of Prince Kropotkin, Pissarro was a passionate believer in socialism. As well as being a prime mover behind the group exhibitions, he was, in effect, the evangelist of Impressionism. He alone exhibited at all

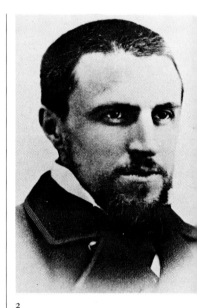

2
Gustave Caillebotte in 1878. Photograph from the Caillebotte Family Archives

3
CAMILLE PISSARRO: *Self-Portrait*. 1873. Oil on canvas. Paris, Musée d'Orsay

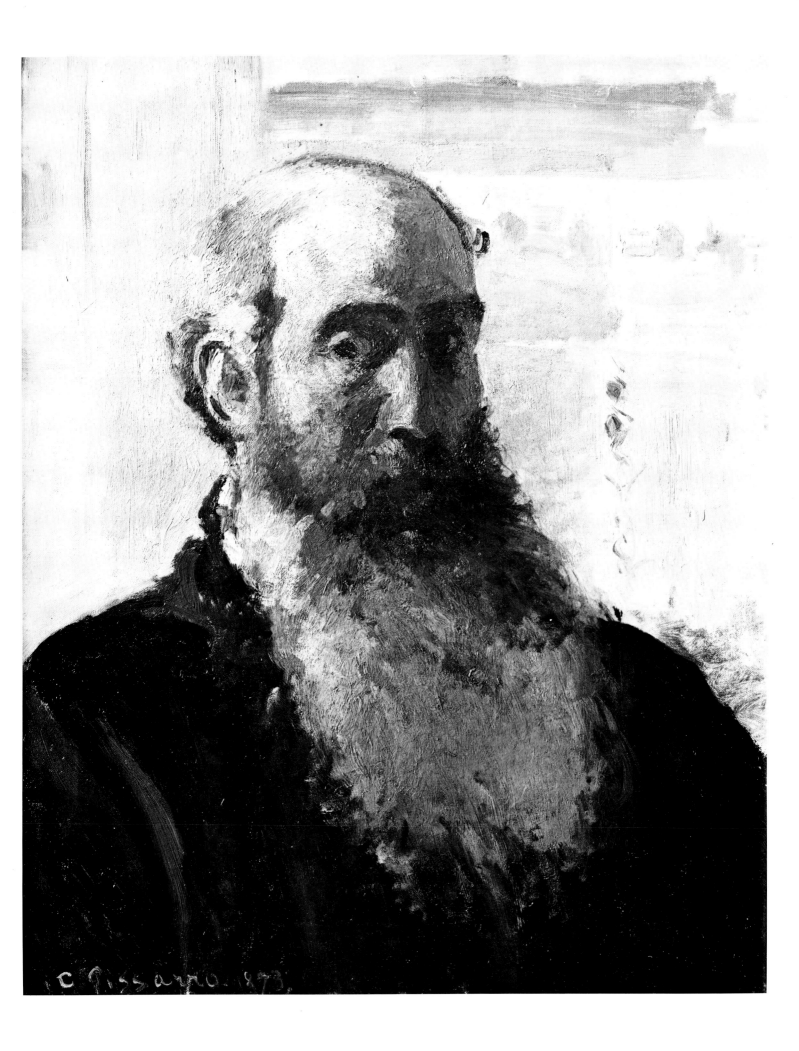

eight Impressionist exhibitions, and he befriended and encouraged younger painters, especially Gauguin and Seurat, inviting them to exhibit with him.

The son of Jewish parents of ample means, Pissarro was sent as a boy to school near Paris. He there showed an early talent for drawing, but in 1847 he was back in St Thomas, working in his father's shop. He ran away with a Danish artist, Fritz Melbye, to Venezuela, and when at last his father consented to his becoming an artist, it was on condition that he train in Paris under a reputable master.

Pissarro returned to France in 1855 and worked under Anton Melbye, the brother of Fritz and a painter of marines, as well as under such academic masters as Lehmann, Picot and Dagnin. In 1857 Melbye introduced him to Corot (Plate 4), whose example led Pissarro to concentrate on landscape painting and determined the course of his career. Among the pictures he painted soon after his arrival in Paris are views of the West Indies in a somewhat romantic vein (Plate 6). Corot urged him to paint direct from nature, and Pissarro henceforth abandoned his formal training in favour of painting in the open in the company of other disciples of Corot, such as Chintreuil and Jean Desbrosses, and at the Académie Suisse, an open studio where for a small fee artists worked from the model without tuition. It was a haunt of landscapists, and there in 1859 Pissarro met Monet, ten years his junior, who shared his independent spirit.

As a young painter Pissarro was not unsuccessful. Some of his works were accepted at the Salon, but they received scant attention and he found few buyers. In 1860 began his liaison with Julie Vellay, his mother's maid (they were married in London in 1870), and in 1863 the first of their many children were born. Two years later Pissarro's father died, and his struggle against poverty began. But Pissarro was indomitable. He never veered from his chosen course. 'I have the temperament of a peasant,' he remarked, 'I am melancholy,

coarse and savage in my work.' And work itself, for a man of his convictions, had a beneficial and assuaging effect: 'Work is a wonderful regulator of mind and body. I forget all sorrow, grief, bitterness, and I even ignore them altogether in the joy of working.'

Quite different in character and inclinations was Edouard Manet (Plate 5), who was born in Paris on 25 January 1832, the son of a high official in the ministry of Justice. His father intended him for a naval career, but Manet very soon abandoned his training in favour of painting, entering the studio of Thomas Couture in 1849. Manet's ambition, which never substantially altered, was to achieve wealth, renown and public honours as a painter. He was fundamentally a traditionalist. He studied the old masters in the Louvre, particularly the Venetians and the Spanish school, and travelled in Italy, Germany and Holland visiting the museums, fully intending to play his part in the perpetuation of the tradition of European painting. He never expected his efforts to provoke ridicule and abuse, first from his own teacher, Couture, and subsequently from the press and the public. As his friend, the critic Astruc explained: 'M. Manet has never desired to protest. On the contrary, it is against him, who did not expect it, that there has been protest, because', he goes on, those brought up on 'traditional' principles 'do not accept any others'. But while he was a reluctant revolutionary he was incapable of compromise. He despised the anaemic slickness of the popular Salon artists, and his technique, with its unfinished appearance and broad areas of flat colour, pointed the way for the whole generation of artists in the 1860s. Consequently, although he continued in the next decade to submit pictures to the Salon, refusing to join the independent exhibitions of the Impressionists, Manet became their friend, collaborator and, in the eyes of the public certainly, their figure-head.

His style was largely modelled on the work of Velázquez and Goya, and many of

4
Camille Corot in 1873, at work on the property of Monsieur Bellon. Photograph by Desavary. Paris, Bibliothèque Nationale

5
Edouard Manet. Photograph by Nadar. Paris, Bibliothèque Nationale

6
CAMILLE PISSARRO: *Coconut palms by the sea, St Thomas (Antilles).* 1856. Oil on canvas. Upperville, Va. Collection of Mr and Mrs Paul Mellon

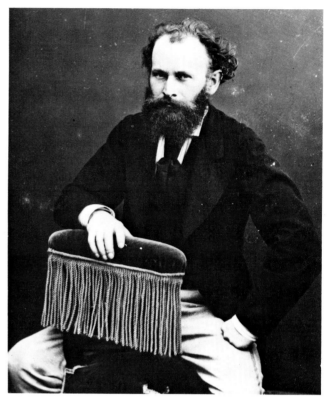

his early subjects were Spanish in inspiration. He painted genre groups, bull-fights and in 1862 a series of pictures of a Spanish dance troupe visiting Paris. His first Salon submission in 1859 was rejected, but in 1861 he had a notable success with *The Spanish Guitar Player* (Plate 7), a work which pleased the public with its engaging subject, and won Manet the admiration of the whole rank of avant-garde critics and painters for its forthright realism and vigorous handling. He was launched, but over the succeeding years his work was to become the subject of the most heated controversy.

It was not only by virtue of his painting that Manet was a leader. His was a magnetic personality. His lively intelligence, enthusiasm and wit, and not least his scathing criticism of academic painting, attracted like-minded artists to him. Emile Zola described him as

> of medium size, small rather than large, with light hair, a somewhat pinkish complexion, a quick and intelligent eye, a mobile mouth, at moments a little mocking: the whole face irregular and expressive, with an indescribable expression of sensitivity and energy. For the rest, in his gestures and tone of voice, a man of the greatest modesty and kindness.

In 1863, while in Holland, Manet married Suzanne Leenhoff, a Dutch woman two years his senior. She had come to Paris thirteen years previously, at the age of twenty, to study the piano and teach the three Manet brothers music. She had become Edouard's mistress, but their liaison was kept a close secret until the death of Manet's father in 1862. In 1852 she had given birth to a son, to whom Edouard became godfather and who was afterwards referred to as Suzanne's younger brother. The boy, Léon, who was eleven when they married, was long rumoured to be Manet's son, but it seems that his true father may have been Manet *père*, who introduced the young and pretty piano student into the household, and that Léon was therefore half-brother to Edouard.

Close to Manet and deeply influenced by his work was Berthe Morisot (Plate 9), the principal woman painter of the Impressionist group. She was introduced to him in about 1868 by Fantin-Latour, and subsequently sat for her portrait. Yet although Manet's influence was decisive in the development of her art, Berthe Morisot had exhibited at the Salon since 1863. She was born in Bourges on 14 January 1841 into a rich family of good standing. Her father was a magistrate, and as a girl in Paris she was early acquainted with painting and music. Together with her sister Edma, she decided in 1857 to study painting seriously, firstly with a pupil of Ingres, Guichard, who encouraged them to copy in the Louvre, where they met Fantin-Latour and the etcher Bracquemond, and after 1861 with Corot. Corot rarely took pupils, but the Morisot sisters worked with him at Ville d'Avray, his home near Paris, and he became a regular guest at their parents' home.

They worked as far as possible in the open, in the Pyrenees, and on the Oise with Oudinot, a pupil of Corot, faithfully observing the master's advice to study nature closely. Berthe Morisot became increasingly committed to the modern movement in art through new friendships with Manet, Degas and Puvis de Chavannes, but her sister married in 1869, and gave up painting. Subsequently Berthe's participation in the group exhibitions, and her marriage in 1874 to Manet's brother Eugène, placed her among the leaders of Impressionism.

Of all the members of the Impressionist group the artist who most resembled Manet in background, education and tastes was Edgar Degas (Plate 8), who became his close friend in 1862. The son of a distinguished banker, he was born Hilaire-Germain-Edgar de Gas in Paris on 19 July 1834. He displayed remarkable ability as a draughtsman at an early age and was copying at the Louvre before he was twenty. His chosen mentor was the classical painter, Ingres, whose intolerance of innovation in painting had earned him the enmity first of

7
EDOUARD MANET: *The Spanish Guitar Player*. 1860. Oil on canvas. New York, The Metropolitan Museum of Art

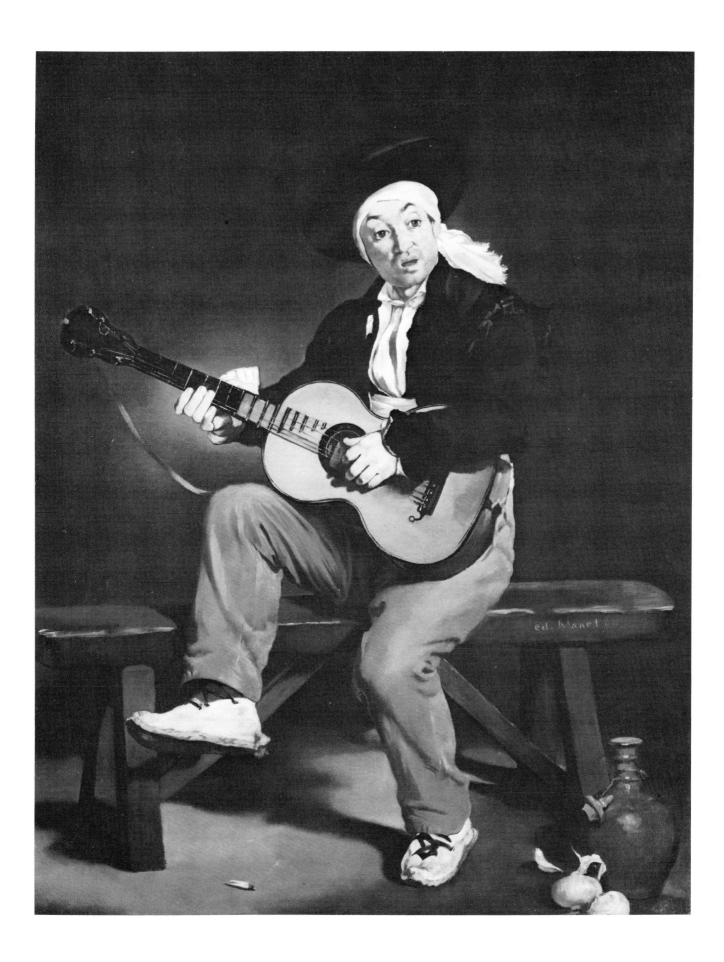

Delacroix and, later, of Courbet and the whole Realist school. It was on Degas's insistence that his father's friend, the collector Edouard Valpinçon, had been persuaded to lend his *Bather* by Ingres to the Exposition Universelle of 1855. Valpinçon, impressed by the young man's fervent admiration of Ingres, introduced him to the elderly master, who is said to have exhorted him to 'draw lines, young man, many lines, from memory or from nature, it is in this way you will become a good artist.'

In 1855 Degas abandoned his law studies, enrolled at the Ecole des Beaux-Arts and entered the studio of Ingres's pupil, Louis Lamothe. Had he been satisfied to follow obediently the precepts of academic painting, he would have soon reached the heights of his profession. He had remarkable facility — his earliest works include such compositions as *The Daughter of Jephtha* and *Semiramis founding Babylon* — and he was also an adept portraitist, depicting his family in striking poses that echo Ingres and the masters of the High Renaissance. He was exceptionally knowledgeable about art and travelled widely in England, Belgium, Holland, Italy and Spain during his student years. But he was also independent. While he had little interest in landscape painting, he combined his fervour for Ingres with a strong appreciation of the merits of Delacroix and Courbet that alarmed his father. And like Manet he was not prepared to paint the costumes and manners of a bygone age. As the early portrait group of his relations, the Bellelli family (Plate 11), shows, he was captivated by what he observed of his own time. From these confident beginnings he was to go on to depict the life of the race-course and the theatres and cafés of Paris.

Erudite, aristocratic and refined, Degas was also acutely sensitive. He made friends with difficulty and frequently caused offence with his caustic tongue. His introverted and suspicious nature was reflected in his slight person, his 'quick, shrewd, questioning eyes deep set under high-arched eyebrows shaped like a circumflex, a

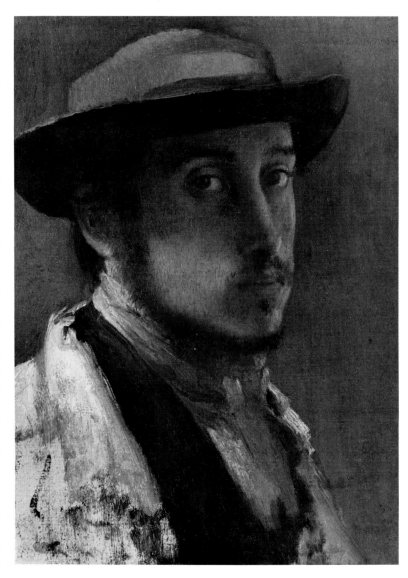

slightly turned-up nose with wide nostrils, a delicate mouth...' Although he was respected by his friends, he remained isolated, a solitary observer barred from intimate relationships. His chauvinistic remarks on women concealed a fear of the sex. He never married and the loneliness of his last years makes a poignant contrast with the happy family life of Renoir, Monet and Pissarro.

After Degas and Manet, the most socially elevated of the group was Jean-Frédéric Bazille, whose career was cut short in 1870 when he was killed in the Franco-Prussian

8
EDGAR DEGAS:
Self-Portrait. 1857.
Oil on canvas.
Williamstown, Mass.,
Sterling and Francine
Clark Art Institute

9
EDOUARD MANET:
Portrait of Berthe Morisot. 1872. Oil on canvas. Private Collection

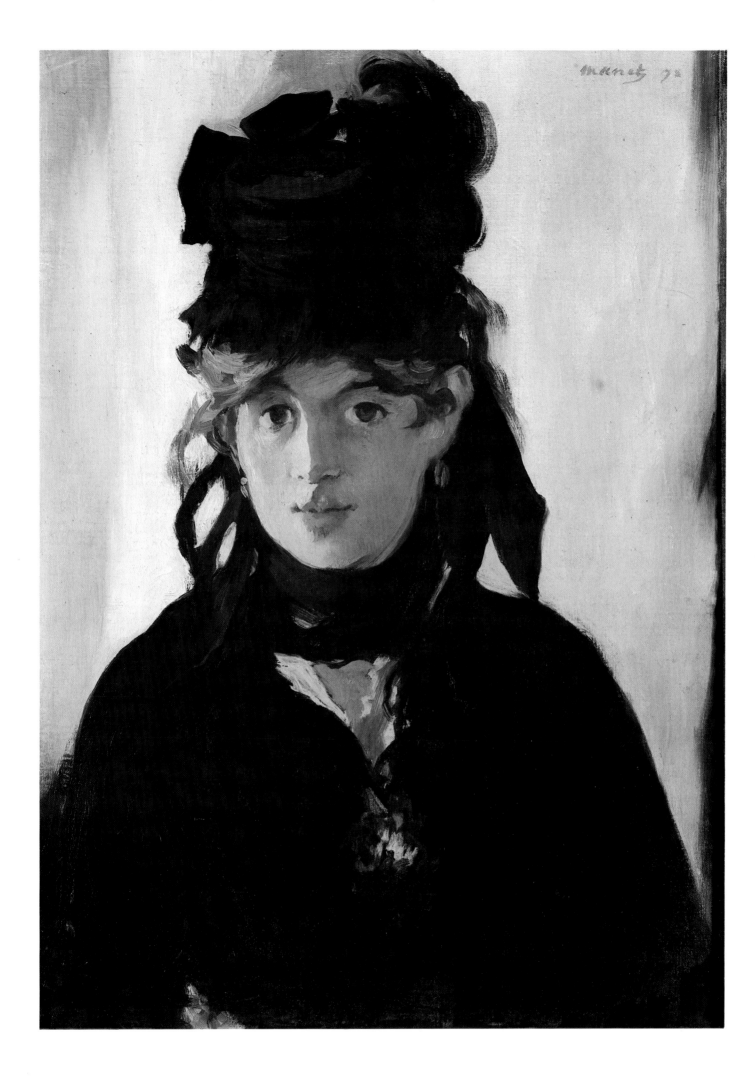

War. In a large canvas entitled *The Family Reunion* (Plate 14) Bazille depicted his family assembled on the terrace of their country estate at Méric, near Montpellier. His parents, both immaculately dressed, are seated on the bench. Frédéric himself, easily recognized by his exceptional height, stands at the extreme left next to his cousin, whose wife and daughter Thérèse are seated centre. At the right stands Frédéric's brother Marc with his wife Suzanne, and Thérèse's sister, Camille. Standing arm in arm are two more cousins, M. and Mme Teulon.

Frédéric was born in the family house on the Grand' Rue of Montpellier on 6 December 1841, and brought up in the town, where his parents occupied a high place among the wealthy bourgeoisie. At their insistence he studied at the famous medical school of Montpellier, and in 1862 moved to Paris to divide his time between further medical studies and his true passion, painting, which he studied at the studio of Charles Gleyre. Not surprisingly he failed his medical examinations and finally won his parents' consent to devote all his time to painting.

In a letter to his parents of 1865 he speaks of gaining practice with a lifesize self-portrait. No doubt it is the picture reproduced here (Plate 10) showing the handsome artist at twenty-three years. His bearing is erect and aristocratic, his clothing elegant, and his expression sensitive as he scrutinizes himself in the mirror. (He has faithfully copied his reflection, so that he appears to hold his brush in his left hand.)

In April 1863 Bazille had reported to his parents that he had just spent a week painting at Chailly, near the Forest of Fontainebleau, 'I was there with my friend, Monet, from Le Havre, who is quite good at landscapes. He gives me very helpful advice.' Although he was only one year older than Bazille (he was born in Paris on 14 November 1840) Claude Oscar Monet (Plate 12) was far more experienced as a painter. There was never any doubt that he would become an artist. At Le Havre,

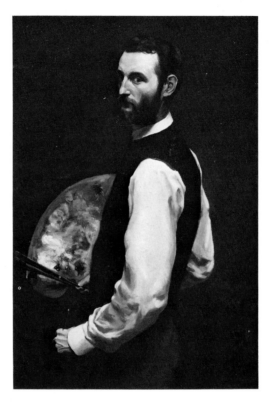

10
FRÉDÉRIC BAZILLE:
Self-Portrait. 1865.
Oil on canvas. The Art
Institute of Chicago

where his father and uncle owned a grocery store, he established a reputation at the age of fifteen with his irreverent caricatures of local figures, which he was soon selling at twenty francs apiece (Plate 13). Not only was Claude Monet a precocious artist, he was also the most determined and business-like of the whole Impressionist group. A born leader, he was the first — apart from Manet — to gain recognition at the Salon, and after years of struggle and poverty, the first to command high prices.

His caricatures were displayed at Le Havre in the window of a framemaker's shop where, when Monet was seventeen, he was introduced to a local artist who wished to compliment him. 'You are gifted,' Monet was told, 'yet soon you will have had enough of caricaturing. Study, learn to see and to paint, draw, make landscapes. The sea and the sky, the animals, the people, and the trees are so beautiful, just as nature has made them, with their character, their genuineness, in the light, in the air, just as they are.' The painter who thus laid down

11
EDGAR DEGAS:
The Bellelli Family.
1858-60. Oil on canvas.
Paris, Musée d'Orsay

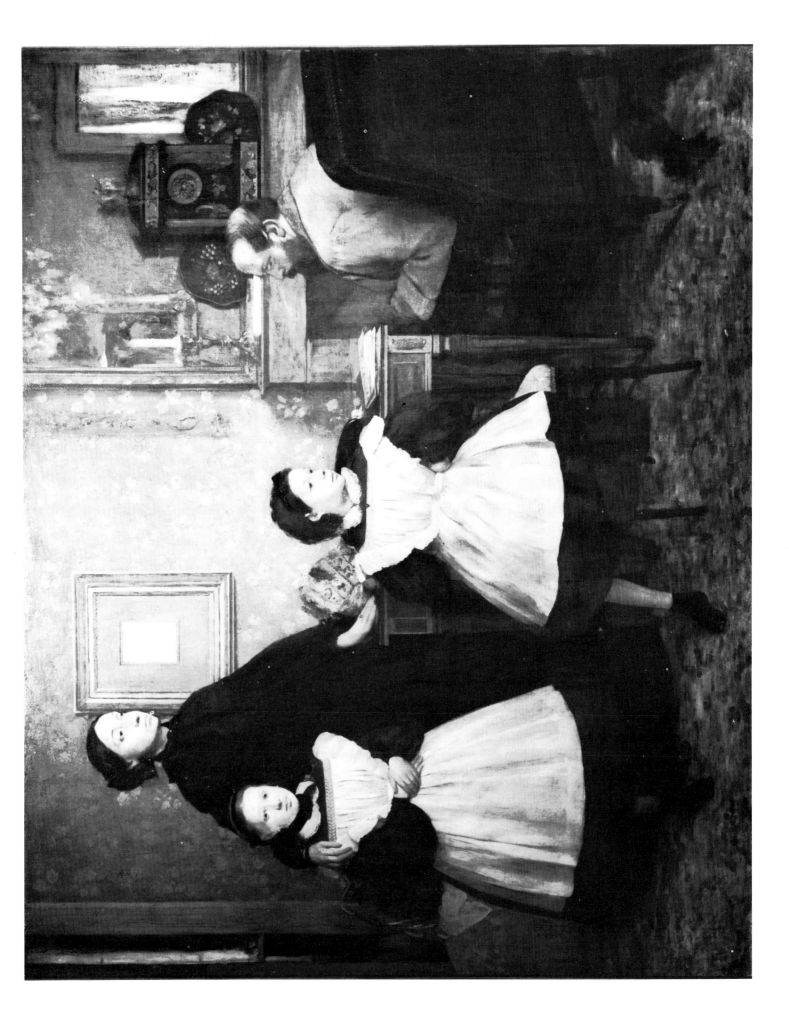

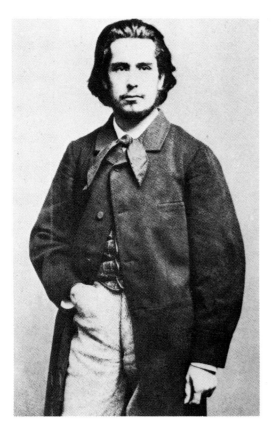

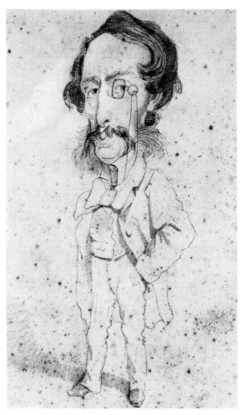

12
Claude Monet.
c. 1860. Photograph by
Carjat

13
CLAUDE MONET:
*Caricature of his teacher,
M. Ochard.* 1856–8.
Drawing. The Art
Institute of Chicago

the programme for Impressionist art — the art *par excellence* of the open air and natural atmosphere — was Eugène Boudin (Plate 15), a framemaker-turned-artist from near-by Honfleur, then almost twice Monet's age, who had taken it into his head to paint in the open — not just sketch, like the Barbizon painters, but to produce complete works out of doors.

Boudin's subject was invariably the Channel coast, particularly the fashionable visitors on the beaches of Trouville. But he also did pastels and watercolours of waves and clouds (Plate 16), 'sketches of things that are almost imperceptible', as Baudelaire described them, 'of what is most fleeting and changeable in shape and colour'. At first Monet had no liking for Boudin's work, and no interest in working out of doors — *plein air*. Finally he agreed to join Boudin: 'I gave in at last, and Boudin, with untiring kindness, undertook my education. My eyes were finally opened

and I really understood nature; I learned at the same time to love it.' In the years of his youth Monet was frequently to work with Boudin, as well as with the Dutch painter Jongkind, so that when he met Bazille in Gleyre's studio, he was already adept at *plein-air* painting.

In 1859 Monet came to Paris with introductions to various artists, including the successful animal painter and friend of Boudin, Constant Troyon, and, at the Salon, he admired the work of Daubigny and Corot. He also owned a small painting by Daubigny, a present from his Aunt Lecadre, a friend of painters and an amateur painter herself. He frequented the Brasserie des Martyrs, a favourite meeting-place for bohemian artists and a haunt of Courbet, and he attended the Académie Suisse where he befriended Pissarro. In 1860 he was conscripted into military service. His father offered to buy him out on the condition that he renounce his painting.

14
FREDERIC BAZILLE:
The Family Reunion.
1867. Oil on canvas.
Paris, Musée d'Orsay

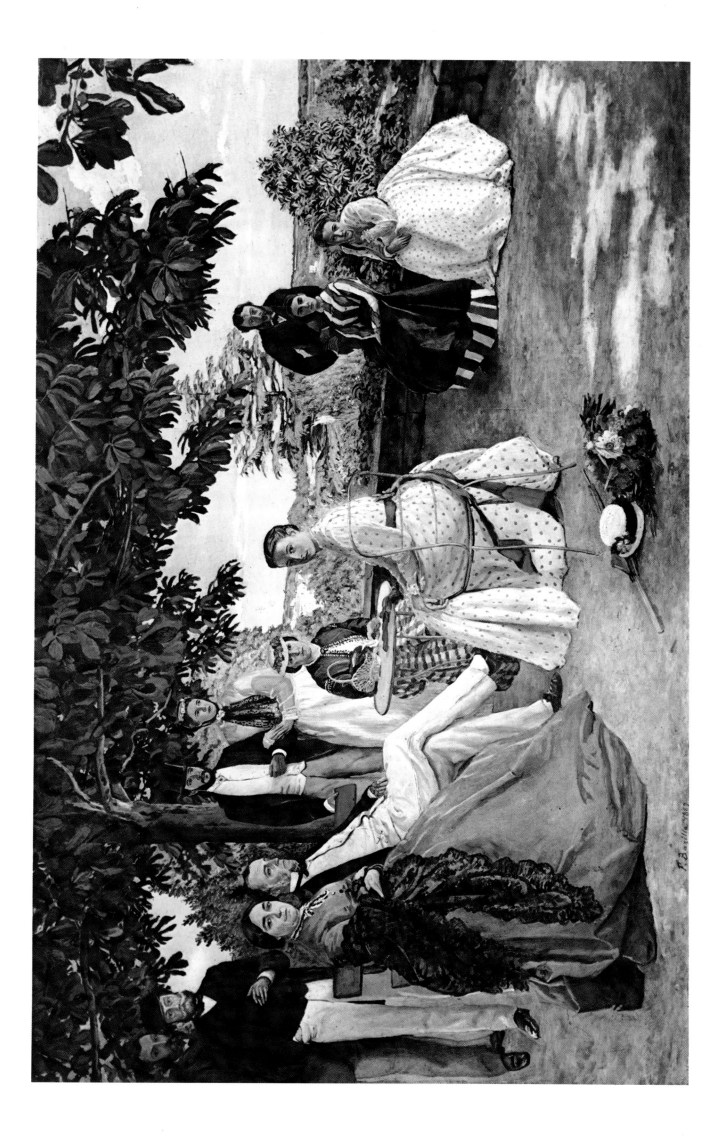

Monet refused and served in Algiers for two years before falling seriously ill. On the doctor's advice, Monet's father relented and secured his son's release. Having recovered, Monet returned to Paris to enter the studio of Gleyre late in 1862.

Monet was a natural revolutionary. Undisciplined by nature, he had a cavalier disregard for authority. His friend Renoir (Plate 17), the third of the little group who became acquainted in Gleyre's studio, was, in sharp contrast, conservative in his views and a traditionalist by inclination. He denied that he was an artistic rebel and claimed to continue in the path of the great masters of the past. Like Manet he drew inspiration from their work, and spent much of his apprentice years copying in the Louvre, where he was frequently accompanied by Fantin-Latour, the friend of Manet, and the American painter Whistler. But unlike Manet, Fantin and Whistler, Renoir regarded himself less as an artist than as an artisan-painter, like the medieval craftsman who submerged his personality in working for the Church. In

15
Eugène Boudin.
Photograph by Pierre
Petit. Paris,
Bibliothèque Nationale,
Cabinet des Estampes

discussing his art, Renoir modestly dismissed high-flown notions of inspiration, and preferred to speak of it as a craft requiring skill, experience and, above all, humility.

Such views were in keeping with Renoir's origins and upbringing. He came from the lower bourgeoisie. His father was a tailor

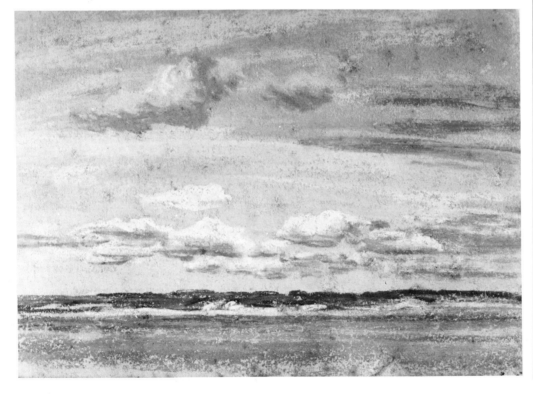

16
EUGÈNE BOUDIN:
*White Clouds over the
Estuary. c.* 1859. Pastel.
Honfleur, Musée Eugène
Boudin

17
FRÉDÉRIC BAZILLE:
*Portrait of Auguste
Renoir.* 1867. Oil on
canvas. Algiers, Musée
des Beaux-Arts

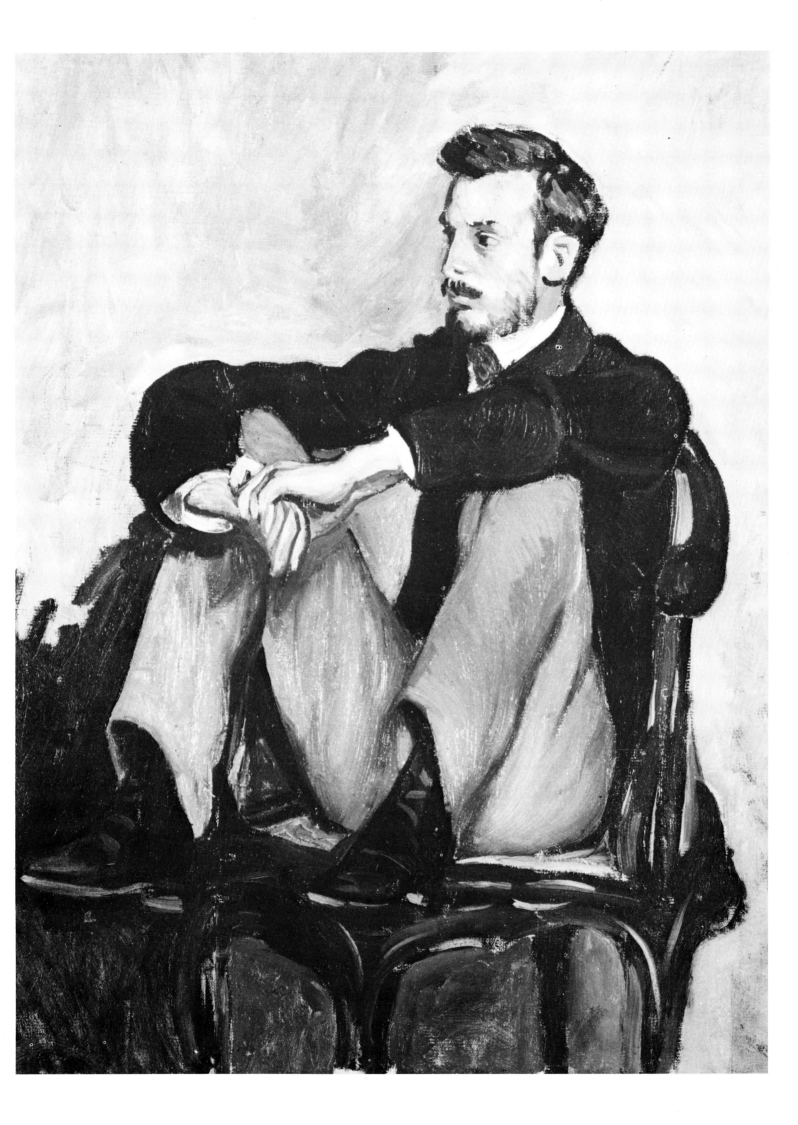

from Limoges, and it was there that Pierre-Auguste Renoir was born on 25 February 1841. When he was four the family moved to Paris and settled in one of the old houses that stood in the shadow of the Tuileries palace in the heart of the city, and were later swept away in Baron Haussmann's improvements. His artistic inclinations did not go unnoticed, but it was naturally into a trade that he was channelled. His brother Henri became a silversmith; Renoir was apprenticed as a painter of porcelain, decorating plates with heads of Marie Antoinette and copies of the Bouchers in the Louvre. When, in 1858, competition from mass-produced wares forced the little firm of Lévy Brothers to close, Renoir devised a co-operative scheme with his fellow workmen to continue hand-painting, but the public preferred the cheap products of the factories. Without work, he turned his hand to the painting of blinds, fans and decorative murals for cafés, and it was through such odd-jobbing that he raised the money to enroll in 1861 or 1862 at the Ecole des Beaux-Arts and the studio of Gleyre.

Renoir never lost the feeling for well-made things that his family background had instilled in him. His spiritual home was the eighteenth century, the age of great furniture and porcelain, and of his best-loved artists, Boucher and Fragonard. He deplored the decline of aesthetic standards that nineteenth-century mass-production had brought about. He thought the fashion for corsets and high heels ugly, and he hated Garnier's bombastic new Opera House and the gothicizing architecture of Viollet-le-Duc. The latter, he asserted, had destroyed more French monuments through his restorations than all wars and revolutions put together.

Nevertheless Renoir, more than any of the Impressionists, found beauty and charm in the sights of Paris, and especially in the working girls and children of Montmartre, the area that he made his own. He instilled the subjects he painted with his own carefree, gentle and affectionate nature. An often repeated anecdote tells

18
Alfred Sisley.
Photograph.
Paris, Durand-Ruel

19
CAMILLE PISSARRO:
Portrait of Paul Cèzanne. 1874. Etching.
Private Collection

that when his teacher, Gleyre, remarked, 'No doubt it's to amuse yourself that you are dabbling in paint,' the young Renoir replied, 'Why, of course, and if it didn't amuse me, I beg you to believe I wouldn't do it.' He refused to adopt a firm artistic programme, preferring to be led by his inclinations. 'One is merely a "cork",' he used to say, 'You must let yourself go along in life like a cork in the current of a stream.... Those who want to go against it are either lunatics or conceited, or what is worse, destroyers.' Renoir was certainly none of these. Modest and benevolent, he was well loved throughout his long life.

His first close friend among the students at Gleyre's studio was Alfred Sisley (Plate 18), who like Renoir had also enrolled at the Ecole des Beaux-Arts. In his early years Sisley was comfortably off and approached his art in a somewhat dilettante spirit, more akin to Bazille than to Monet or Renoir. He was supported by his father, a successful businessman who exported silks and artificial flowers to South America, a business

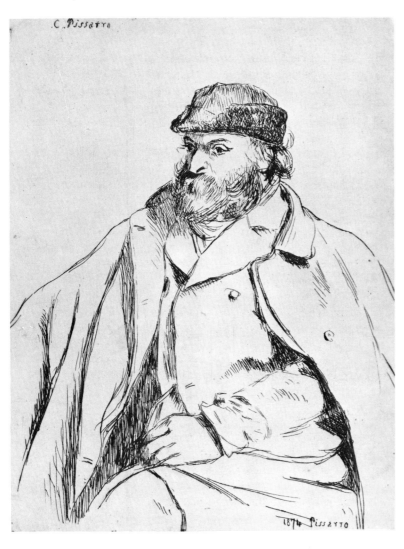

Sisley was the most retiring of the Impressionists and preferred to remain at a distance from the Paris world of artists, critics and dealers, with its noisy intrigues and disputes. He was a genial, good-natured man, 'a delightful human being' according to Renoir, with a strong penchant for women, who were charmed by his gentleness. The romantic turn to his character, apparent in his gallantry towards women, appears too in his contemplative immersion in nature. Throughout his career Sisley painted virtually nothing but landscapes. Nature offered a release, an emotional outlet for one whom life treated roughly. 'Although the landscape painter must always be master of his brush and his subject,' he wrote, 'the manner of painting must be capable of expressing the emotions of the artist.' Like his earliest masters, Turner and Constable, Sisley conceived of painting as a combination of representation and expression.

Paul Cézanne (Plate 19), whom Pissarro met at the Académie Suisse in 1861, also preferred the country to the city and avoided the social gatherings of his fellow artists. Yet in other respects he and Sisley were quite dissimilar: Sisley, with his English parentage, was quiet, mild and inclined to dream; Cézanne, a native of Aix, was passionately emotional and given to wild outbursts. Renoir said he was 'like a porcupine'. With his black hair, swarthy complexion, piercing eyes and rough provincial accent, be must have seemed like a savage in Paris. Just as the polished *haut-monde* found him uncouth, so he found Paris society shallow, effete and hypocritical. It is not surprising that his relations with Degas and Manet were troubled, and that the closest bonds he formed were with Pissarro and Renoir, the most ingenuous of the group. His morbid sensitivity and abrasiveness were exacerbated by the frustration he experienced as an artist. Lacking the manual dexterity of Monet, Renoir and Degas, Cézanne had to struggle to give form to his strong sensations. His earliest pictures are chiefly coarsely worked paint-

which apparently owed its origins to the smuggling activities of Sisley's great-grandfather. Alfred Sisley was born in Paris on 30 October 1839, but like both his parents he was of British nationality. At the age of eighteen he was sent to London to study commerce in preparation for entering his father's business, but there he found his true vocation. At the National Gallery he admired the works of Constable, Turner, Bonington and the Dutch landscapists, and he decided to devote himself to painting. His parents, highly cultivated people both, seem not to have opposed his decision, for on his return to Paris in 1862, Alfred immediately entered Gleyre's studio.

ings in which the sombre colouring is matched by a darkness of theme — scenes of violence, eroticism and suffering, such as *The Rape* (Plate 20).

Cézanne was born in Aix-en-Provence on 19 January 1839. His father, a wealthy banker, was a self-made man who, with ruthlessness and determination, had made his fortune as a hat manufacturer. At first he frustrated his son's ambition to become a painter by forcing him to study law. In his spare time Paul copied in the Aix Museum, or attended classes at the art school, until in 1861 his father permitted him to go to Paris, where he met his school-friend Emile Zola, who was pursuing a career as a journalist. For less than a year he stayed in Paris working at the Académie Suisse, until disillusioned with the city and the art he discovered there, he returned to Aix to work in his father's bank. However, after a few months he was back in Paris, having finally decided to devote all his energies to painting. Zola sketched this portrait of him:

'Bearded, with knotty joints and a strong head. A very delicate nose hidden in the bristly moustache, eyes narrow and clear ... Deep in his eyes great tenderness. His voice was loud ... He was a little stoop-shouldered and had a nervous shudder, which was to become habitual.' This formidable character was to pursue a dedicated and solitary course, dividing his time between Paris and his father's house, the Jas de Bouffan, near Aix. Although he worked alongside Pissarro and Renoir, the 1860s and 70s were apprentice years for him. He had to wait until later before he achieved mastery and recognition.

The individuality that is so marked in Cézanne is to be found in each member of the Impressionist group and can be seen in their work. Their predilection for certain subjects can to some extent, however, be taken as a reflection of their position in society and their wealth. Degas and Manet had little time for landscape painting and did not share Monet's passion for working

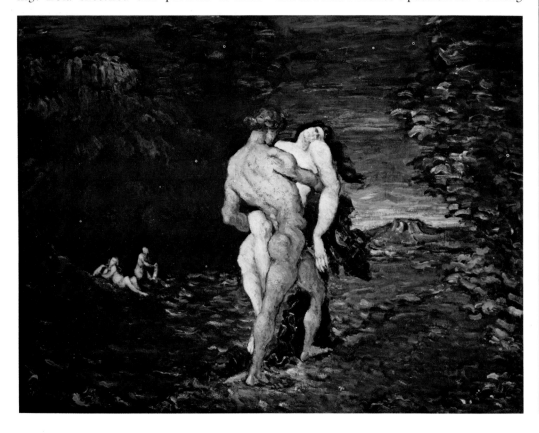

20
PAUL CÉZANNE:
The Rape. 1867. Oil on canvas. Private Collection

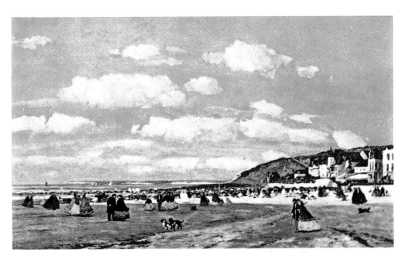

21
EUGENE BOUDIN:
The Beach at Trouville.
1863. Oil on canvas.
Private Collection

in the open. They were principally figure painters and, as such, saw themselves as followers of Titian, Rubens and Velázquez, who had achieved wealth and honours with portraits and compositions — figure paintings with themes taken from the Bible, history or mythology.

The cultivated circle in which Degas and Manet moved expected of modern art equivalent epic themes. Ingres and Delacroix had achieved this in the previous generation; so — it was held — ought their successors. To paint epic themes a painter required a studio, models and the means to pay for them. These Manet and Degas possessed. Monet, Renoir and Pissarro, however, when they wished to paint figures, had to prevail upon their friends to pose. On the other hand, it was relatively easy and cheap to set up a canvas and easel in some chosen semi-rural haunt on the outskirts of Paris and paint landscapes. For this reason landscape painting had found its chief recruits from among the lower bourgeoisie. In selecting this path, Monet and his friends were following the precedent of Corot and the Barbizon school — Rousseau, Diaz and Millet — whom they so admired.

Retreating to the Forest of Fontainebleau in the 1830s and 40s, the Barbizon painters had renounced material gain to pursue an ideal of moral regeneration through communion with nature, an ideal

which found expression in their paintings. They represent the opposite of the cultivated, city-dwelling artist whose time was shared between the studio, the café and social gatherings. Because of its creed of individualism, the work of the Barbizon school was associated with radical politics and regarded as a threat to society as well as to art. It was only to be expected that those young painters of the 1860s who lacked position and wealth should want to emulate the artists of this school, pursuing the course which had become identified with egalitarianism.

While, however, the artists of the Realist generation, of the 1848 revolution, and particularly Courbet and Millet, celebrated the life of the peasant, the milieu proper to the Impressionists was the bourgeoisie. Although Manet and Degas began with figure subjects of a traditional stamp, and Monet, Pissarro and their friends with landscapes, they all ended up painting the multifaceted society of the enormous middle class that prospered in France during the Second Empire and the Third Republic.

Monet's mentor, Boudin, in his pictures of holiday-makers on the Normandy beaches (Plate 21) was among the first to argue the case of the bourgeoisie in art. 'The peasants have their painters of predilection,' he wrote, 'but between ourselves, have not these middle-class people strolling on the pier at the hour of sunset, a right to be fixed on canvas?' And as Renoir pointed out much later in conversation with the politician Clemenceau and the critic Geoffroy, the society they depicted was their own. 'We are not aristocrats,' he argued, 'because we have no hereditary titles. We don't belong to the working class, because we don't labour with our hands. If we're not of the middle class, what are we then?' More than any other artist of the group, Renoir, in his pictures of riverside parties, of bustling city streets, and in countless pictures of his own family, celebrated the life and pleasures of the French middle class in the last third of the nineteenth century.

It was in effect a devotion to the here and now that united the Impressionist painters, in spite of differences of background and character. The bond forged by this absorption with the sights of the modern world, and by the desire to represent them in paint, was only made stronger by the hostility they encountered from the art establishment.

By the middle of the nineteenth century Paris had become the undisputed centre of the art world. Thousands of artists, native and foreign, worked there, vying with each other for recognition and sales. The young Impressionists were at first no different from many a more conventional painter. They trained in the studios of acknowledged masters and at the State-run Ecole des Beaux-Arts, and they submitted works for exhibition at the Salon (Plate 22). The Salon exhibitions, held for most of the century on a yearly or biennial basis, were of vital importance to artists hoping to attract the attention of the public and the press. While one jury selected pictures for exhibition from the thousands submitted, another awarded medals and honours. Successful painters could well expect not only purchases, but also important State commissions.

The Salon exhibitions of the Second Empire were enormous affairs. Held first in the Louvre and later in the Palais de l'Industrie on the Champs-Elysées, they were designed to reflect glory on France and on the régime of Napoleon III, who had seized power in 1851 and proclaimed himself Emperor in 1852. Louis-Napoléon (Plate 23), nephew of Napoleon Bonaparte, had taken advantage of his name and the political disorder following the Revolution of 1848 to gain widespread support in France. As Emperor he consolidated his position by sending thousands of Republicans into exile and restricting the liberty of the press. However, the authoritarian government he set up was welcomed by businessmen as conducive to industrial growth, and during the Second Empire France enjoyed unprecedented economic

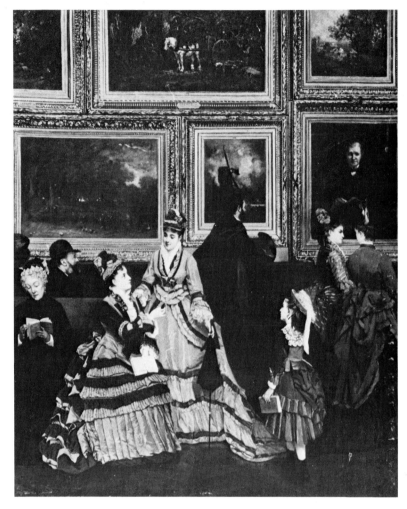

prosperity. It was stimulated by a massive programme of public works. Under the direction of Baron Haussmann, Prefect of the Seine, Paris was transformed into a modern metropolis. A network of broad new boulevards was constructed to open up the old cramped city (Plate 24), some twenty thousand houses were pulled down and over forty thousand new ones built. New squares and churches were constructed, parks laid out, and the Opéra and the new Louvre begun. The population of the city almost doubled in twenty years, numbering 1.8 million by 1870, and almost ten thousand miles of rail track were laid, linking Paris to the most distant parts of the country.

Louis-Napoléon saw to it that his new city would be the showplace of Europe. His

22
JEAN BÉRAUD:
The Salon of 1874.
Oil on canvas.
Private Collection

23
The Emperor Napoleon III. Engraving after a portrait by Hippolyte Flandrin, of 1863

24
Paris Improvements: Transformation of the Montagne Sainte-Geneviève. 1866. From a contemporary engraving

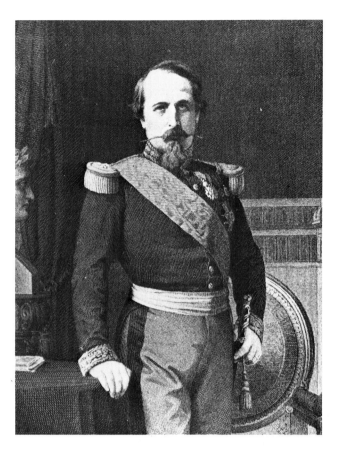

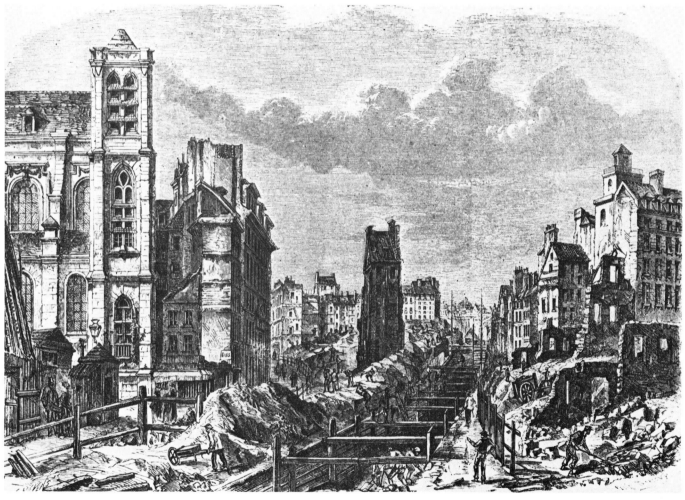

marriage to a beautiful Spanish Countess, Eugénie de Montijo, led to the creation of a brilliant and extravagant court. Foreign Heads of State, including in 1855 Queen Victoria and Prince Albert, were entertained at spectacular receptions, and enormous exhibitions were mounted in Paris to display the country's achievements in the arts and industry. But in spite of the great programme of State patronage, and the prizes, distinctions and speeches that marked the country's pride in her artists, painting by 1855 had fallen into a decline. While thousands flocked to see the machines and new inventions at the Exposition Universelle of that year, the halls of the Palais des Beaux-Arts were almost deserted. The shopkeepers and industrialists of nineteenth-century France cared little for art. They meekly accepted the judgements of the pedagogues of the French Academy, those elderly and honoured masters who dominated the Salon juries and controlled the teaching at the Ecole des Beaux-Arts. These institutions had the power to make or break an artist, and they exercised that power with arrogance and bigotry, ruthlessly excluding all new tendencies from the Salon. Through the century, Géricault, Delacroix, Rousseau, Millet and Courbet, not to mention Manet and the Impressionists, were among those who suffered disapproval and rejection. The juries favoured those artists who meekly accepted the conservative doctrines of the Academy, doctrines derived from the teaching of Jacques-Louis David.

David's neo-classicism, with its purity of line and subjects drawn from ancient history, had been well fitted to the austere expression of martial ideals at the end of the eighteenth century, but it had long since degenerated in the hands of imitators into sterile and sententious mannerism. By the middle of the nineteenth century it lingered on in trivial costume pieces without a trace of virility or heroism. Nevertheless, it was such pieces that won the eulogies and awards of the juries and made the repu-

tation of Cabanel, Bouguereau and Gérôme. The Imperial family, for their part, preferred lighter genre pieces in a decorative vein borrowed from the eighteenth century. Napoleon III was a keen patron of Ernest Meissonier, creator of meticulously painted cavalier scenes, and of Franz-Xaver Winterhalter, portraitist to the French and English courts, whose glamorous pictures reflect the self-esteem of the rulers of the period (Plate 26).

While the official products of French art were proudly vaunted at the Salon, the cafés and brasseries of Paris became meeting-places for those independent artists whose attempts to forge new forms of art to reflect the contemporary world had led to their ostracism by the art establishment. The Café Taranne, the Café Fleurus, the Café Tortoni and the Brasserie des Martyrs were all popular haunts for artists during the Second Empire. Gustave Courbet, the leading opponent of the Academy and bohemian champion of Realism, was a regular customer at the Andler Keller on the Left Bank (Plate 25), where painters, writers, poets and journalists of Republican sympathies gathered in the smoke-filled rooms to drink beer and argue over the artistic questions of the day. Courbet's two great works, *The Studio* and *The Burial at Ornans*, had been excluded from the 1855 Exposition Universelle, and in response he had organized his own one-man show in a specially constructed Pavilion of Realism.

The expense of such an undertaking, however, not to mention the lack of interest on the part of public and critics in art unsanctioned by official patronage, obliged most artists, in the absence of an alternative showplace, to submit to the whim of the Salon jury. In 1863 a staggering total of three thousand canvases, out of the five thousand submitted, were rejected by the jury, and so great was the outcry that the Emperor authorized an exhibition of rejected works, a *Salon des Refusés*. On the face of it, it seemed that the opponents of the Salon system had won a notable victory,

25
GUSTAVE COURBET: *The Andler Keller.* 1862. Etching. Illustration from Delvau's *Histoire Anecdotique des Cafés et Cabarets de Paris*

26
FRANZ-XAVER WINTERHALTER: *The Empress Eugénie and the Ladies of her Court.* 1855. Oil on canvas. Compiègne, Musée National de Palais de Compiègne

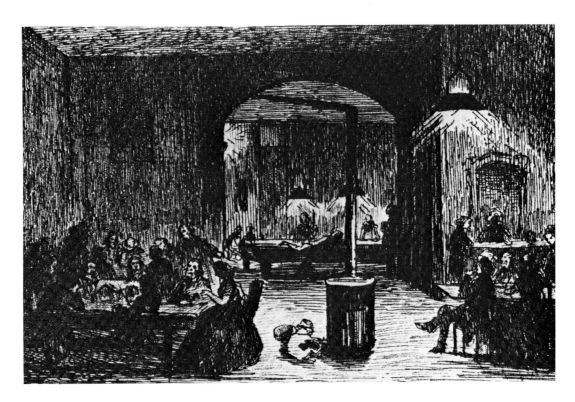

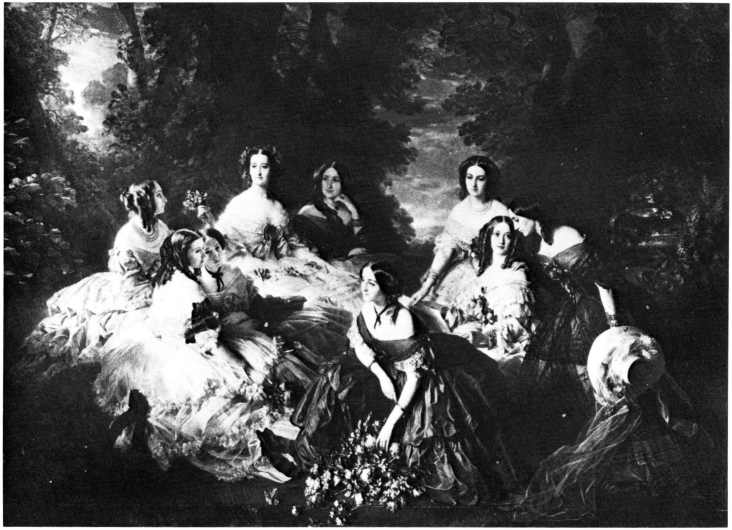

but many of those rejected, especially the more talented, refused to participate for fear of compromising themselves. The public treated the whole affair as a joke, and merely came to poke fun at good and bad pictures alike, much to the satisfaction of the members of the jury.

Among the pictures which achieved notoriety was *The White Girl* (Plate 27) by James McNeill Whistler, an American friend of Courbet and Manet. Intended as a study of colour harmonies and contrasts, it was attacked for its broad brushwork and thick impasto. Other participants were Pissarro, Cézanne and Manet, whose *Déjeuner sur l'Herbe* (Plate 28) (or *Le Bain*, as it was originally called) had a *succès de scandale*. Although Manet — like Winterhalter in his picture of the Empress Eugénie and her ladies — had been inspired by a model from the past (the Giorgionesque *Fête Champêtre* in the Louvre) and had actually borrowed poses from the old masters, his painting was criticized for its vigorous handling, and pronounced 'immodest' because it showed men in modern dress beside a naked woman. 'There they are, under the trees,' wrote one critic, 'the principal lady entirely undressed ... another female in a chemise, coming out of a little stream that was hard by, and two Frenchmen in wide-awakes sitting on the very green grass with a stupid look of bliss. There are other pictures of the same class which lead to the inference that the nude, when painted by vulgar men, is inevitably indecent.' Manet's model was Victorine Meurend, who posed again for *Olympia* — another 'scandalous' nude. The men are Ferdinand Leenhoff, Manet's brother-in-law, on the left, and Gustave, the youngest of the Manet brothers.

Distressing though it was for Manet to

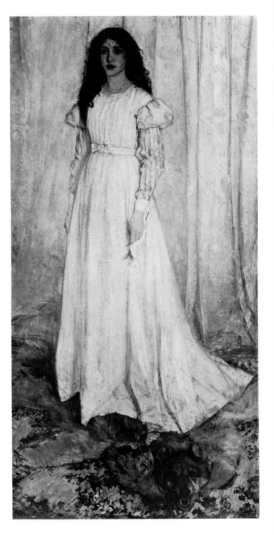

27
JAMES MCNEILL WHISTLER:
The White Girl. 1862.
Oil on canvas.
Washington, National
Gallery of Art

see his intentions misunderstood, the scandal of the Salon des Refusés confirmed his position as head of the modern school — a position usurped from Courbet, whose work was seen by most critics as in decline, debased by recent popular successes. For Manet there was to be no turning back. It was to him that young painters now looked for leadership in the fight against the Academy and the Salon jury.

28
EDOUARD MANET:
Le Déjeuner sur l'Herbe.
1863. Oil on canvas.
Paris, Musée d'Orsay

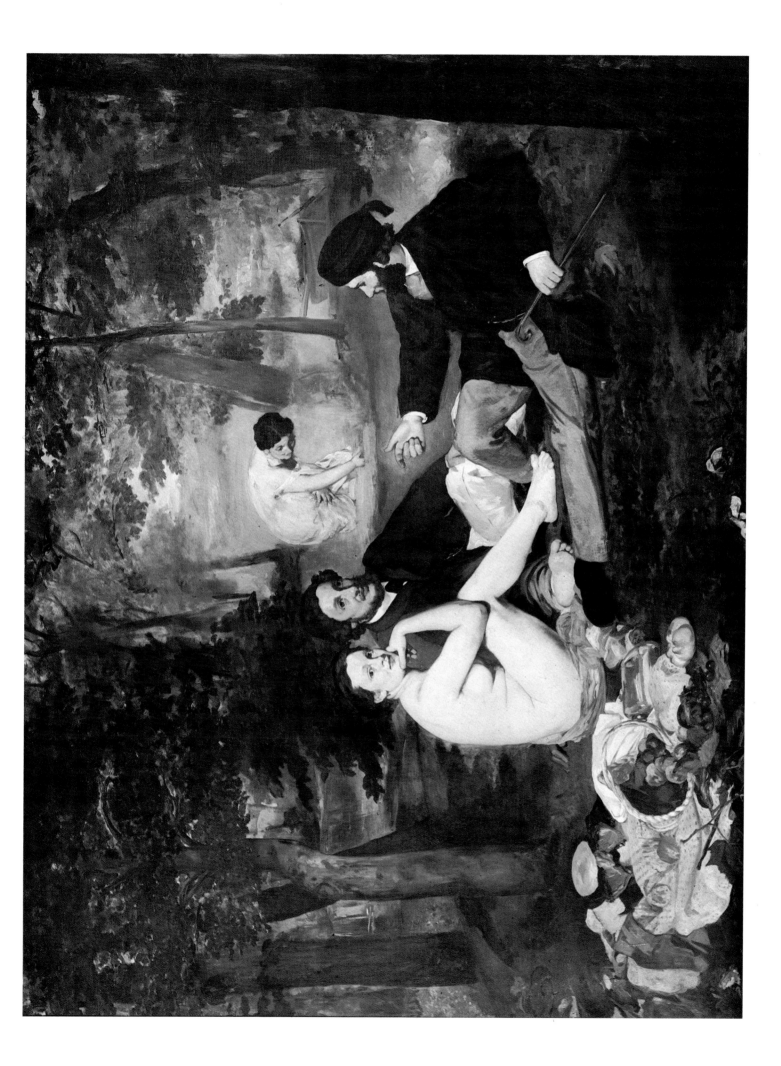

2 The Batignolles Group

The sculptor and critic Zacharie Astruc voiced the views of all advanced opinion when he wrote these lines on Manet in his paper *Le Salon de 1863*:

> Manet! One of the greatest artistic characters of the time. Manet's talent has a decisive nature that startles; something trenchant, sober and energetic, that reflects his nature, which is both reserved and exalted, and above all sensitive to intense impressions.

Manet had first attracted attention two years earlier at the Salon of 1861 when he had shown with great success *The Spanish Guitar Player*. Several painters, among them Fantin-Latour, had subsequently called on him to express their admiration and they apparently brought with them the poet Charles Baudelaire (Plate 29), and the critics Duranty, Astruc, Castagnary and Champfleury, who became Manet's support and defence. In his article of 1862, *Painters and Etchers*, Baudelaire spoke of the lively stir created by *The Guitar Player* and it is certain that by this date painter and poet had become intimate friends.

In March 1863 a show of Manet's work opened at the gallery of the dealer Martinet. It included several paintings of Spanish dancers — who had visited Paris the previous year — among them the portrait of *Lola de Valence* (Plate 30), which prompted these lines of Baudelaire:

> Surrounded by so many things of beauty,
> I well understand, my friends, that
> desire hesitates to choose.
> But in Lola de Valence scintillates and
> shines
> The unexpected charm of a pink and
> black jewel.

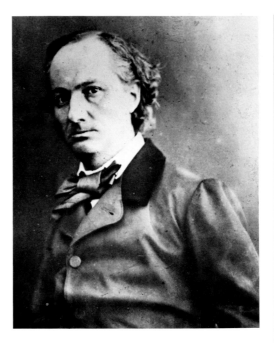

29
Charles Baudelaire.
Photograph by Nadar.
Paris, Archives
Photographiques

Manet's tribute to the poet was another painting in the same exhibition, entitled *Music in the Tuileries Gardens* (Plate 31), showing Baudelaire among the assembled crowd. It owes its existence to the poet's programme for modern painting, as expressed in his Salon reviews and in the essay he wrote in 1860 on the draughtsman Constantin Guys, *The Painter of Modern Life*. Manet's painting is his response to his poet-friend's exhortation to 'make us see and understand, with brush or with pencil, how great and poetic we are in our cravats and our patent-leather boots'. As Baudelaire's frequent companion, Manet would have been familiar with the ideas expressed in *The Painter of Modern Life* even before it was published — the view of the artist as a man of the world, or '*dandy*', the concept of

30
EDOUARD MANET:
Lola de Valenca. 1862.
Oil on canvas. Paris,
Musée d'Orsay

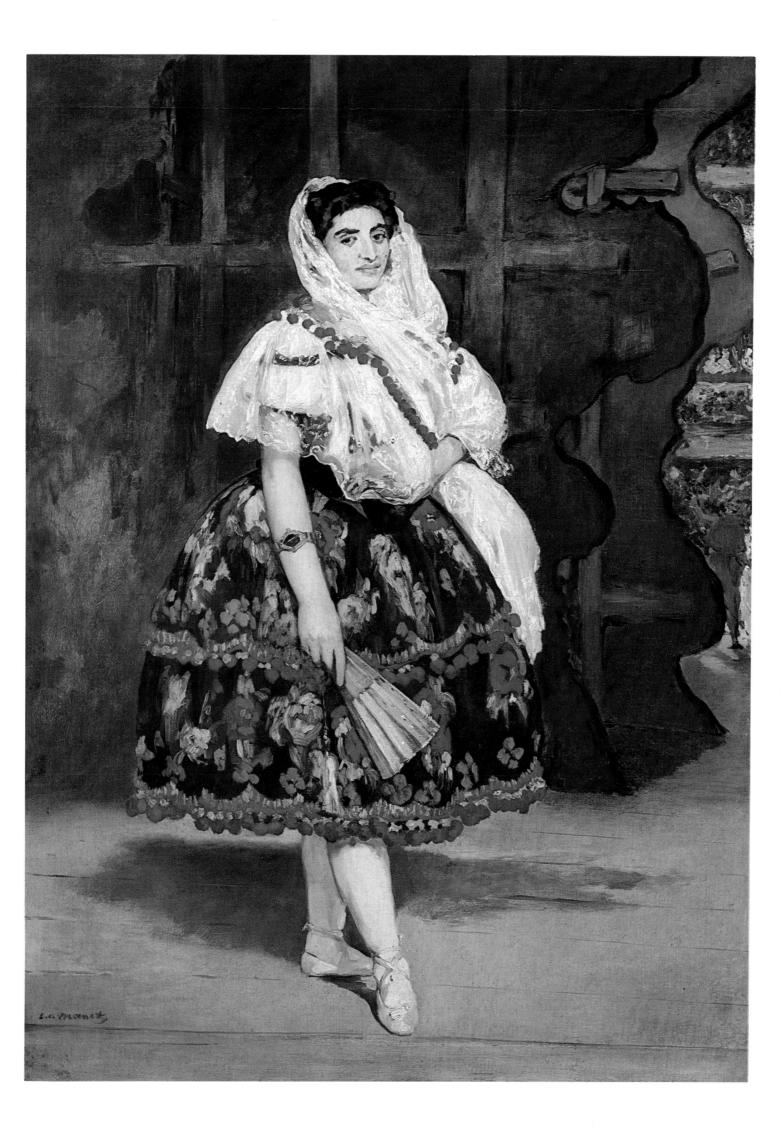

beauty as something partaking of the fashionable ideals of a given period, and such suggested subjects for pictures as society taking the air beneath the trees of Paris gardens, and children playing with their nannies. Poet and painter shared the same social milieu, the cultivated intelligentsia of the upper bourgeoisie, and it is no surprise to see Manet responding with such alacrity and such success to the challenge of portraying his own world.

Like Baudelaire, Manet admired the lively sketches of Constantin Guys, the chronicler of the Crimean War for the *Illustrated London News*, and the hero of Baudelaire's essay, and he shared with Baudelaire a strong interest in etching and printing as forms of art which were less constricted by academic dogma, and more readily responsive to the spirit of the time. From the same period as *Music in the Tuileries Gardens* date an etched profile portrait by Manet of his new friend Baudelaire as well as numerous etchings after his Spanish paintings.

Music in the Tuileries Gardens is Manet's first painting of modern life, and it is executed in a style which is as novel as it is disconcerting. Parts remain unfinished, scarcely brushed in, faces and dresses are set down in flat unmodulated colour, and the figures sprawl across the surface in apparent confusion. But Manet planned the picture with great care, and the casual arrangement and broad handling, far from being accidental, show him consciously striving towards a more penetrating depiction of the contemporary scene. As an artist, sketching in the Tuileries, passing round his drawings among his friends at the Café Tortoni, he is Baudelaire's *'flâneur'*, the idle·stroller who absorbs impressions and captures the tone and atmosphere of the moment.

A passionate interest in modern expression and contemporary subjects must have been among the factors which drew Manet to Degas when they met in 1862, although at that date Degas was still producing historical compositions in the

pattern of his teacher Lamothe, and his mentor Ingres. Nevertheless, Manet was struck by Degas's confidence as a copyist when he found him working in the Louvre. Thus began a friendship which, while not without its storms, lasted until Manet's death.

In spite of their subject matter, Degas's early pictures already betray the characteristic note of originality of, for example, *The Café-Concert at 'Les Ambassadeurs'*, painted in 1876/7. In *Young Spartans exercising* (Plate 32), a picture purporting to illustrate Plutarch's account of the martial exercises of Spartan girls and boys, which Degas painted in 1860 at the age of twenty-six, he has strayed far from the rhetorical and stylized norm of classical painters. Although naked, the children are clearly recognizable as adolescents of the streets of Paris, casually grouped in commonplace attitudes. Far from emulating the enamel-like smoothness of academic paintings, Degas has left his picture unfinished, mapped out in coarsely worked paint with changes of poses still showing.

It was chiefly through portraiture that Degas had developed a keen sense of the contemporary, in pictures of his brothers and his Italian relations, such as the Bellelli family and the Duke and Duchess of Morbilli (Plate 33). Elegantly and formally posed, the Duke and Duchess recall the aristocratic sitters in the portraits of Bronzino that Degas had copied in the Uffizi. Rather like Ingres in his late portraits, Degas shows a keen visual response to the fashions of the day, the slim black figure of the Duke offset by the Duchess in her full crinoline and scarlet shawl. Like the *Young Spartans*, the portrait is unfinished — carried to the point where life is captured and not killed. There is in the two sitters an alertness of expression and a spring in bearing which already proclaim Degas as the master of the living being in movement — the race-horse, the ballet-dancer, the laundress and the bather.

In their novel *Manette Salomon*, published in 1866, Jules and Edmond de

31
EDOUARD MANET:
Music in the Tuileries Gardens. 1862. Oil on canvas. London, National Gallery

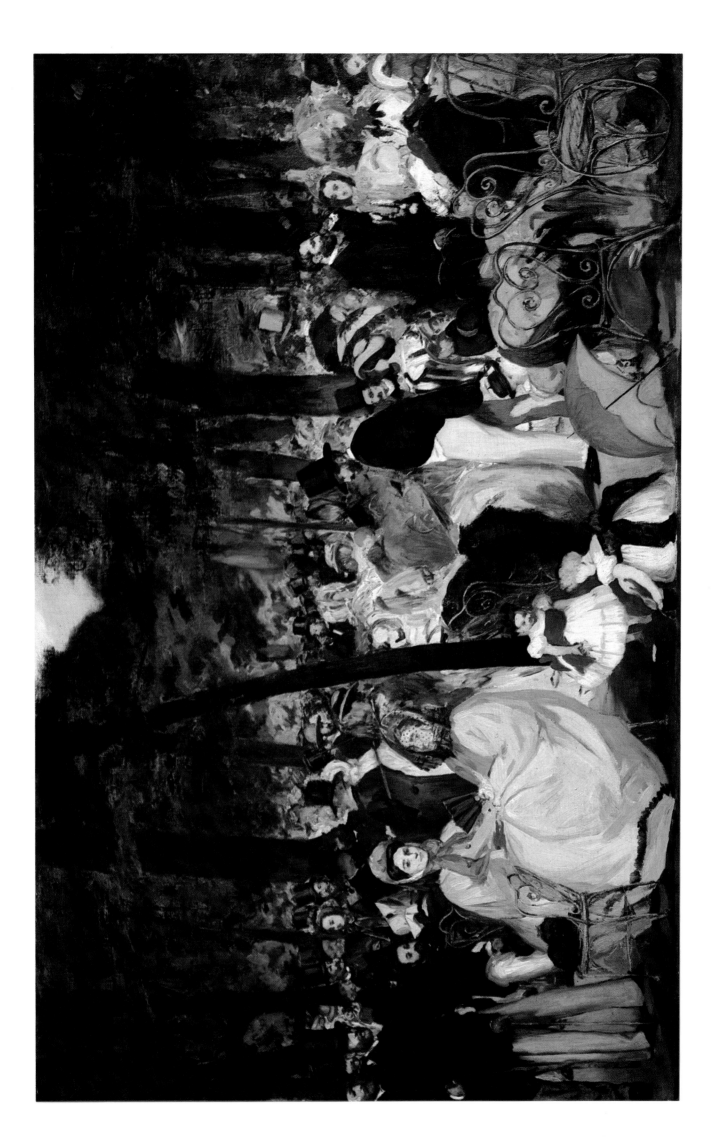

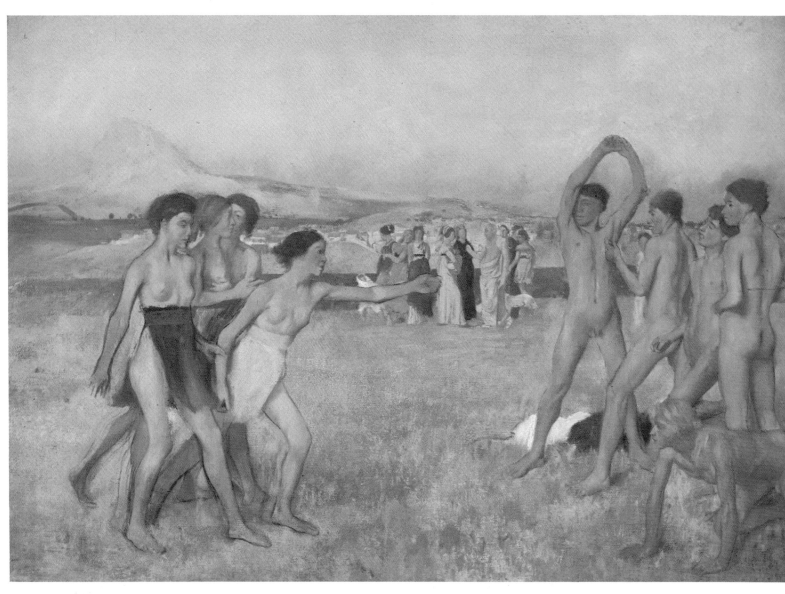

Goncourt, the rediscoverers of eighteenth-century art and members of the same avant-garde artistic circle as Baudelaire, took up the latter's plea for a modern art expressive of contemporary beauty:

It is possible that the Beauty of today may be covered, buried, concentrated. To find it, there is perhaps need of analysis, a magnifying glass, near-sighted vision, new psychological processes... There must be found a line which would precisely render life, embrace from close at hand the individual, the particular, a living, human, inward line...a drawing truer than all drawing — a drawing more human.

Degas was fired by the Goncourts' analysis, and no artist of the century responded more to their challenge. In his note-books he listed subjects that might be treated in the way they suggested: musicians with their instruments, mourners and undertakers, dancers, cafés, locomotives, steamboats — a broad range of studies of movement and atmosphere. The work of the 1870s and 80s shows him embarking on these and many

32
EDGAR DEGAS:
Young Spartans exercising. c. 1860.
Oil on canvas. London, National Gallery

33
EDGAR DEGAS:
Edmondo and Thérèse Morbilli. c. 1865. Oil on canvas. Washington, National Gallery of Art

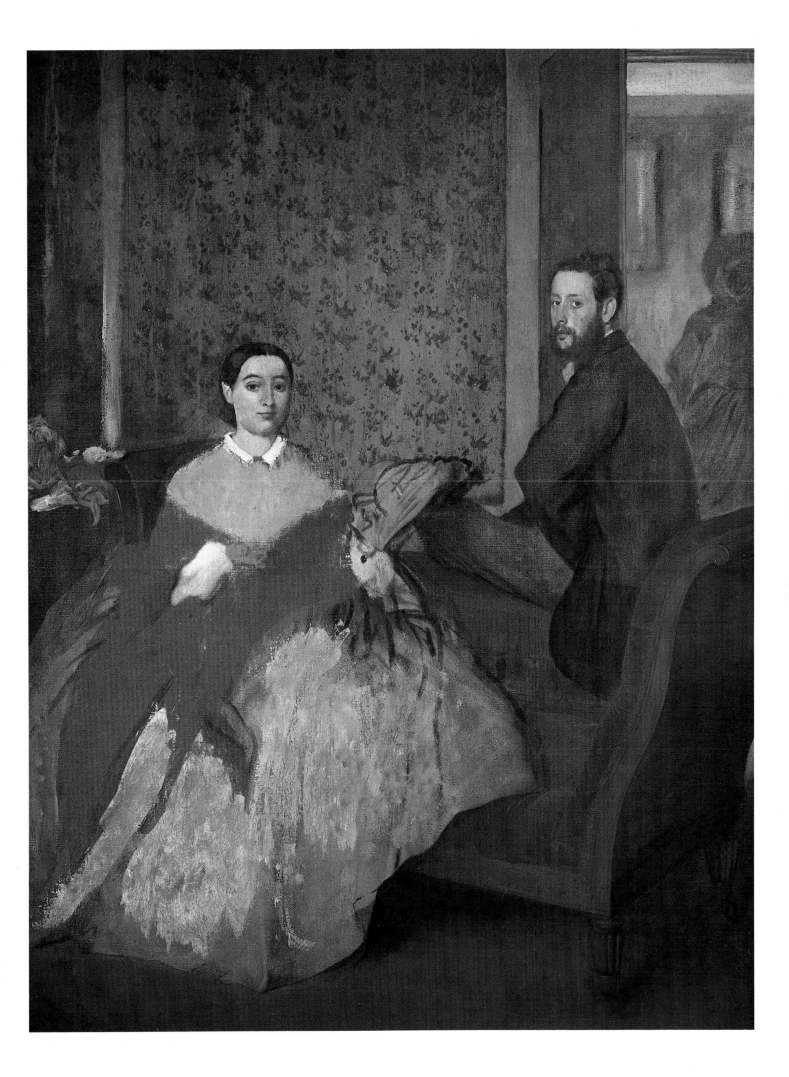

other areas of the contemporary scene previously uncharted by the painter. He shows jockeys and race-horses biding time before a race (Plate 36), and dancers exercising or at rehearsal. His medium is predominantly the 'living, human, inward line' vaunted by the writer brothers — and nowhere better exemplified than in the etching he produced of his friend Manet at an early stage of their acquaintance (Plate 34).

No less than Manet, Degas fulfilled Baudelaire's requirements for a painter of modern life, but while he was undoubtedly acquainted with the poet, there is no evidence of intimacy. Quite possibly Degas's sensitive nature could not stand dissection by Baudelaire's penetrating intelligence, and he may have resisted any overtures of friendship. Even with the ingenuous Manet, Degas found occasion to take offence. Manet deeply offended Degas when he cut in two the latter's portrait of him listening to his wife, Suzanne, playing the piano (Plate 35). Degas took back the portrait and returned a still-life of plums, a gift from Manet. To the fragment of his portrait showing Manet he attached a piece of canvas with the intention of repainting Madame Manet, but never did so.

As the writings of Baudelaire and the Goncourts show, the ideas expressed in the early work of Manet and Degas were current among a whole section of Paris society. It is this society of avant-garde artists, writers and composers that *Music in the Tuileries Gardens* actually depicts. Manet's picture in fact embodies the ideas that the people he portrays stand for. At the extreme left is Manet himself; beside him, cane in hand, is Albert de Balleroy, a painter and Manet's studio-companion. Further to the right, seated, are two women: Madame Loubens, whose portrait was later painted by Degas and Manet and, wearing a veil, Madame Le Josne. Seated between them and de Balleroy is the critic Zacharie Astruc. Immediately above Madame Loubens is a group of three men in conversation: Baudelaire himself, sil-

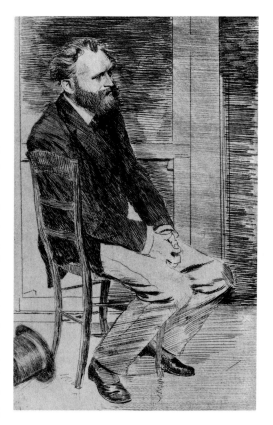

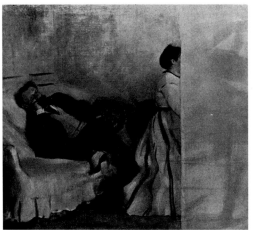

houetted in profile against a tree, the bearded Théophile Gautier, poet, novelist and most respected art critic of the day, and Baron Taylor, *Inspecteur des Musées*, draughtsman and connoisseur of Spanish art. Other identifiable faces include those of the painter Fantin-Latour (immediately to the left of Baudelaire), the composer

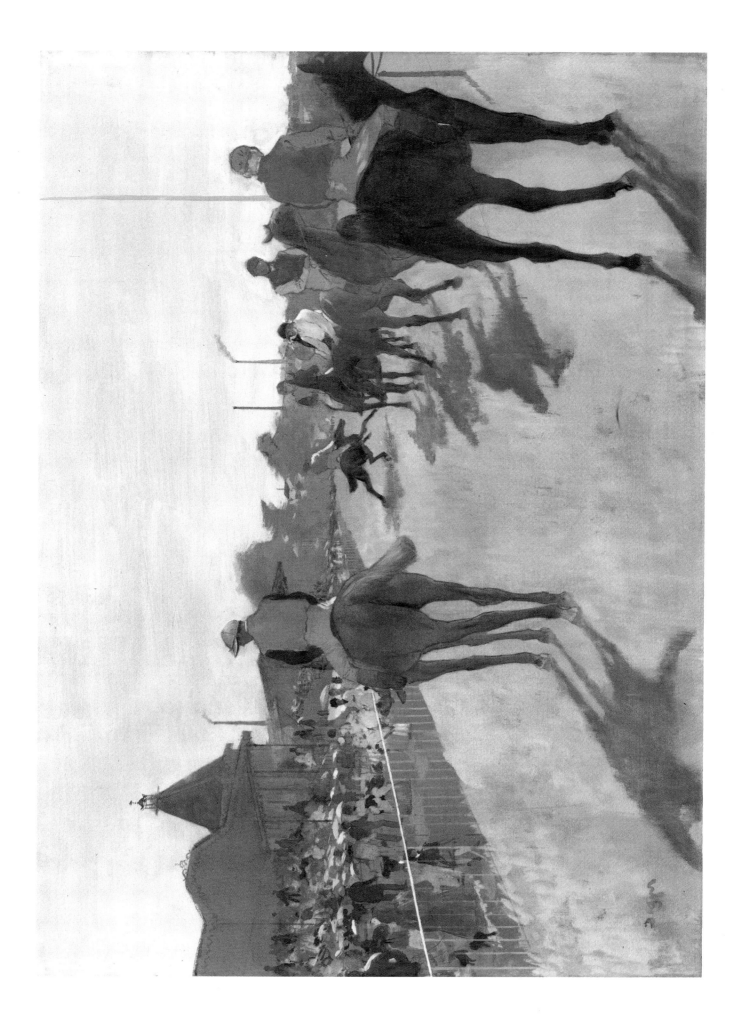

Offenbach (the mustachioed figure in front of a tree, centre right), and beside him, standing in profile, the artist's brother Eugène Manet, who frequently posed for him and in 1874 married Berthe Morisot. Others too are surely intended as portraits but their identity is lost. Nevertheless, these alone are sufficient to give the flavour of Manet's sophisticated circle.

It is hardly surprising to find such society assembled in the fashionable quarter of Paris, attending an open-air concert. Offenbach, whose most popular operetta, *Orpheus in the Underworld*, was first produced in 1858, and whom Renoir later visited in his house in the Rue La Rochefoucauld and accompanied to the Variétés, must have been a common sight in the Tuileries. The husband of Madame Le Josne, Commandant Hippolyte Le Josne, was a great lover of art and a particular friend of Manet. After the Salon des Refusés in 1863, he organized a reception for the painter of *Le Déjeuner sur l'Herbe*, and in gratitude Manet presented him with the study for the picture. It was Le Josne who found the model for Manet's painting *The Fifer*, and his home was a constant meeting-place of artists and often the scene of amateur theatrical and musical performances.

During the late 1860s Manet and his artist and critic friends met most often at the Café Guerbois on the Grande Rue des Batignolles. The cafés of Paris had long been favourite meeting-places for artists. Courbet and his Realist supporters had met at the Andler Keller and at the Brasserie des Martyrs. Manet, at the time of *Music in the Tuileries Gardens*, frequented the Café Tortoni and the Café de Bade in the centre of the fashionable Right Bank district. But since 1860 he had occupied a studio in the Batignolles, and from 1866 the Café Guerbois in the quieter northern quarter, near the Place Clichy, became his favourite resort. In the late afternoons, he would quit his studio to join his friends and discuss the topical artistic issues that so preoccupied them all (Plate 37).

The core of the group consisted of all those that had rallied around him at the time of the scandal of the Salon des Refusés — Astruc, Duranty, Silvestre, Fantin-Latour and Degas. Astruc had defended him in his paper on the 1863 Salon and in 1864 Manet painted his portrait (Plate 38). The critic is shown beside a table piled high with books, among them a green volume of Japanese woodcuts bearing the inscription, 'au poète Z. Astruc, son ami, Manet'.

Closer to Degas than to Manet was the novelist and critic Edmond Duranty, whose portrait Degas painted in 1879 (Plate 39). A writer of several Realist novels and founder of the review *Réalisme*, Duranty was chiefly concerned with subject matter in painting, and preferred Degas's explicitly modern themes to Manet's often traditionally inspired works and the landscapes of Monet and his friends. 'He is an artist of unusual intelligence,' he wrote of Degas, 'and unlike most of his colleagues is really interested in ideas.' Duranty himself was described by his friend, the critic Armand Silvestre, as gentle, sad, resigned, 'a man of incredible delicacy'. The failure of his own literary efforts had left him slightly embittered, but he devoted himself wholeheartedly to the defence of his painter friends. He held his convictions with passion and was a match for the strong-willed Manet, who hated to be contradicted. On one occasion in 1870 Manet took offence and challenged Duranty to a duel. The two adversaries met in the Forest of St-Germain, and the fight concluded with Duranty wounded and their swords twisted like 'a pair of corkscrews'. By evening, though, they were amicably reconciled.

Notwithstanding occasional eruptions, the Batignolles group was strongly united, and successive attacks from the body of conservative critics bound them still more firmly together. Manet's work was the focus of heated criticism at the exhibition at Martinet's in 1863, again at the Salon des Refusés of that year, and once more in 1865 when *Olympia* (Plate 40) was shown at the Salon. This large picture, which Manet

37
EDOUARD MANET:
Paris Café. 1869. Pen and ink. Cambridge, Mass., Fogg Art Museum

38
EDOUARD MANET:
Portrait of Zacharie Astruc. 1864. Oil on canvas. Bremen, Kunsthalle

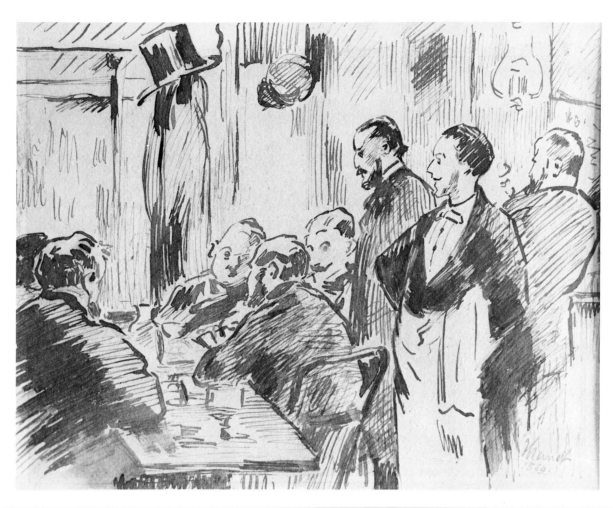

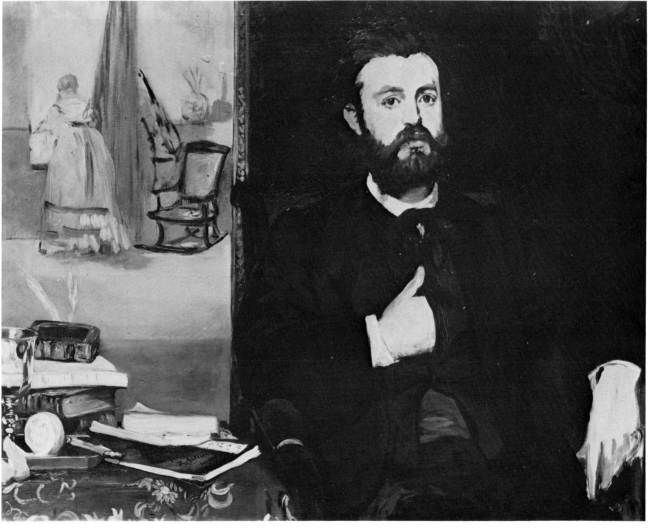

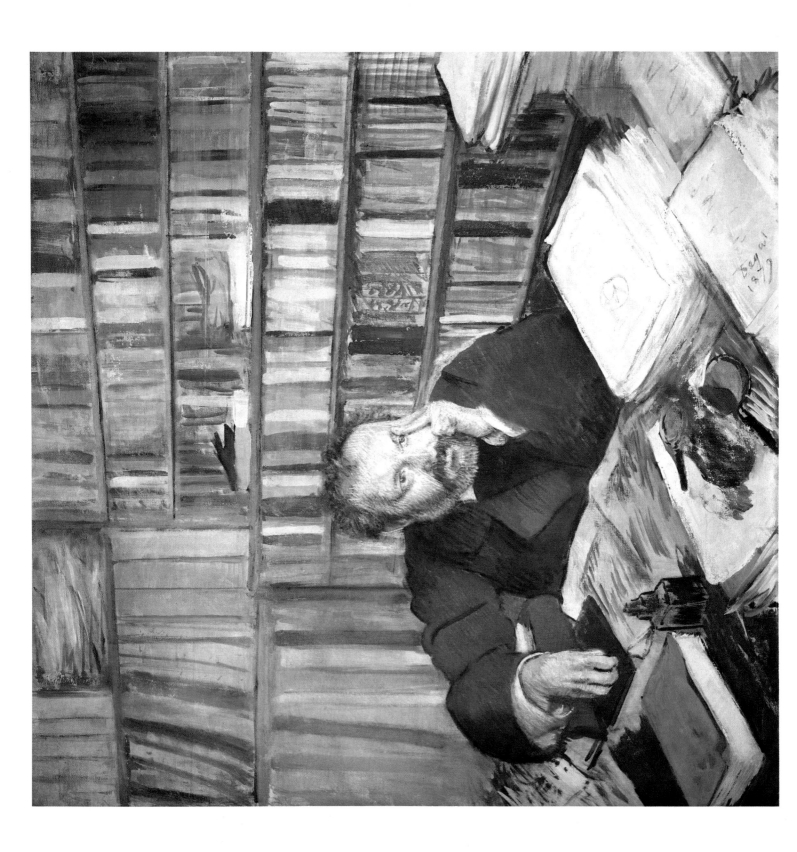

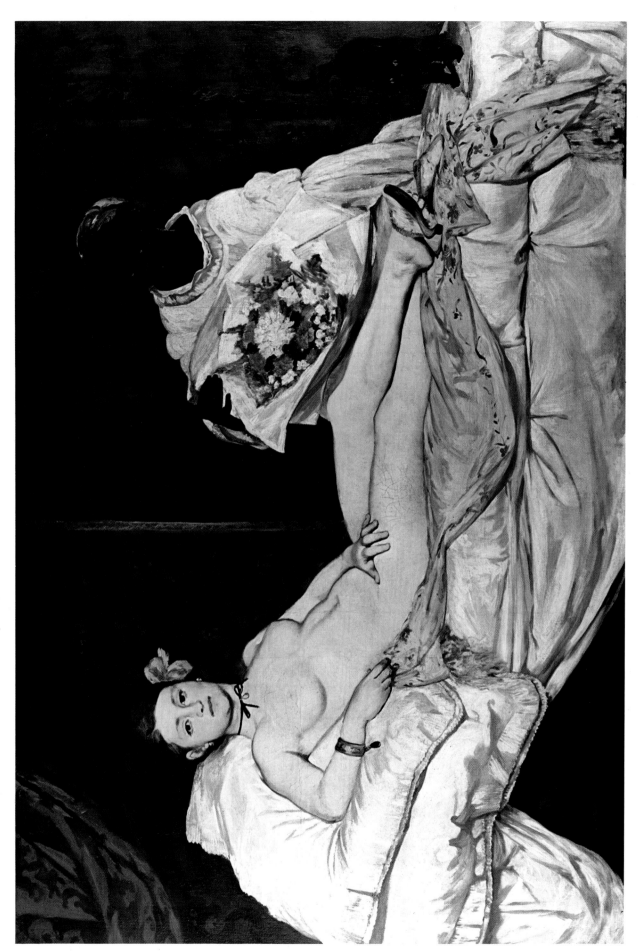

39 EDGAR DEGAS: *Portrait of Edmond Duranty*. 1879. Distemper, watercolour and pastel on linen. The Burrell Collection – Glasgow Museums and Art Galleries

40 EDOUARD MANET: *Olympia*. 1863. Oil on canvas. Paris, Musée d'Orsay

painted in 1863, took its title from a character in a play by Dumas fils, *La Dame aux Camélias*, and inspired some verses by Zacharie Astruc. The brazenness of the portrayal of a modern girl of the streets — young, audacious and unreflecting — shocked the public. 'What is this odalisque with yellow belly,' one critic asked, 'a degraded model picked up I don't know where, and representing Olympia?' She was, in fact, Victorine Meurend, who appears in *Le Déjeuner sur l'Herbe*, and was Manet's favourite model during these years. But perhaps more shocking than the subject, which painted in the manner of Cabanel or Bouguereau would have earned lavish praise and rewards, was the execution, the lack of modelling in the figure, the absence of pictorial depth and the use of line to define contours. Courbet thought she looked like a figure on a playing-card, and Gautier, who had previously supported Manet, considered the picture coarsely executed, ugly and lacking in truth. Few were prepared to recognize qualities of design, colour, harmony and handling united by a new, decorative concept of the canvas. Overwhelmed by the insults, Manet lost control and gave in to despair. Depressed and disheartened, he wrote to Baudelaire, who had encouraged him to send the picture to the Salon and was absent in Brussels, 'I would have liked to have had your verdict on my pictures, because all these attacks grate on me, and evidently someone is mistaken.' Although Baudelaire wrote encouragement, he was past helping Manet. In Brussels he suffered a stroke, and he returned to Paris in 1866 with less than a year to live.

The flat pictorial qualities of *Olympia*, which went uncomprehended in 1865, while representing Manet's conscious choice of direction, owe their character to the influence of the Japanese print. The enthusiasm for Japanese art and artefacts was widespread in the 1860s and was shared by such artists as Tissot, Whistler and Fantin-Latour. The etcher Bracquemond and the Goncourt brothers were among the first in France to discover Japanese prints, and in 1862 a shop specializing in *japonaiseries* opened on the Rue de Rivoli. Run by a Monsieur de Soye and his wife, it became the haunt of artists and aesthetes. The presence of the volumes of Japanese prints in Manet's portrait of Astruc is evidence of a shared enthusiasm, as also are the Japanese screen and the Utamaro print in Manet's portrait of Emile Zola of 1868 (Plate 41). Zola was the first to point out the connection between Manet's style and Japanese woodcuts. In his study of the artist, published in 1867, he spoke of the similarity of certain works to the popular Epinal prints, and then continued, 'it would be far more interesting to compare this simplified painting with those Japanese prints, which resemble it in their strange elegance and magnificent strokes.'

Baudelaire's place as intimate friend and supporter of Manet was taken by two newcomers to the Batignolles group — Théodore Duret and Emile Zola. Manet had met Duret in 1865 in Spain, where he went after the *Olympia* fiasco. In 1868 he painted his portrait (Plate 42), and apparently at Duret's suggestion signed it upside down, so that his acquaintances might first admire it without identifying the artist, and subsequently be obliged to acknowledge his talent. A journalist and politician, and founder of the anti-Imperialist paper *La Tribune*, Duret became a major collector and defender of Impressionist painting.

Manet's main supporter in the press during the 1860s, however, was Zola. During these years he worked for Hachette, the publishing-house, as a journalist for *L'Evénement*, and began his career as a novelist. An advocate of Realism in literature, Zola, like his friend Duranty, believed that Manet and the artists around him stood for an equivalent kind of realism in painting, dedicated to the representation of contemporary social issues. However, he subsequently grew disenchanted with Impressionism.

It was through Paul Cézanne that Zola was introduced into the circle of artists and

41
EDOUARD MANET:
Portrait of Emile Zola.
1867–8. Oil on canvas.
Paris, Musée d'Orsay

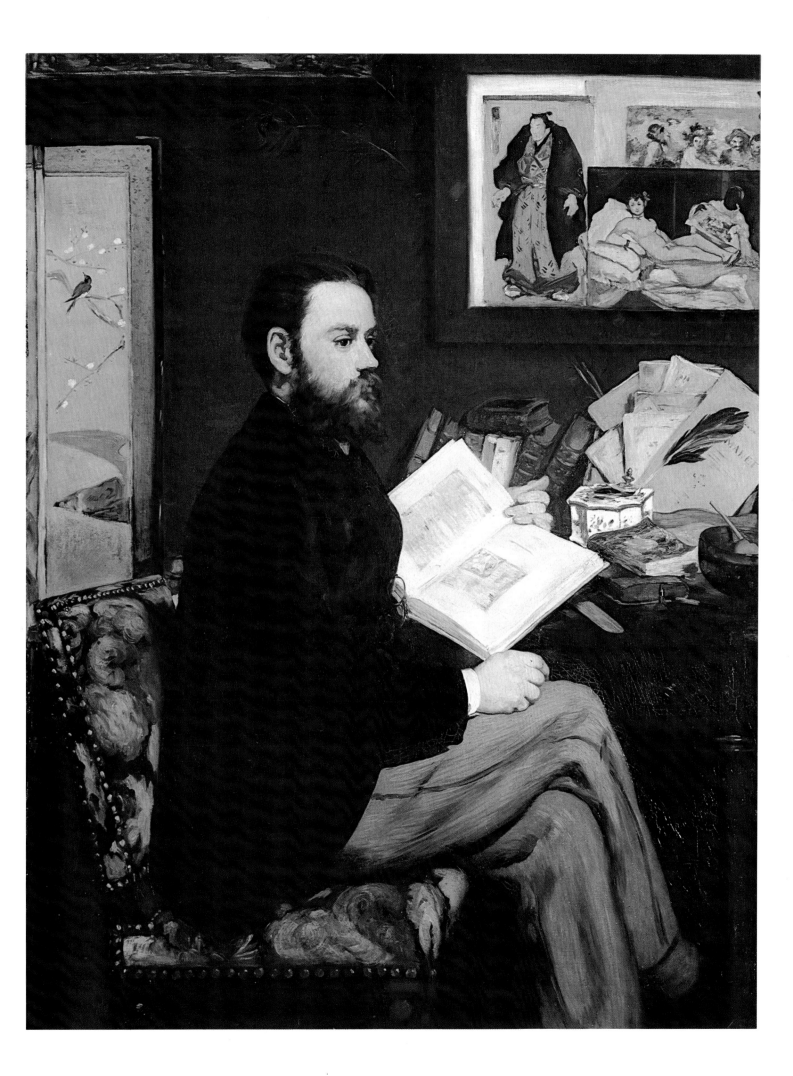

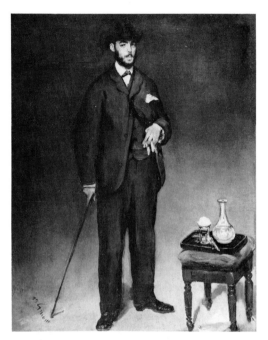

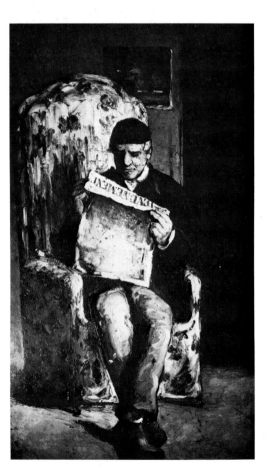

became so deeply involved in the latest developments in art. The two had been at school together in Aix, where Zola's father was an engineer, and when Zola moved to Paris in 1861, Cézanne took him to the exhibitions and introduced him to Pissarro and Guillaumin, his friends from the Académie Suisse. In his first Salon reviews of 1866, Zola singled out a landscape by Pissarro for particular praise, commending his 'extreme concern for truth and accuracy'. His early ideas on painting must have owed much to Cézanne. His concept of a work of art as 'a bit of creation seen through the medium of a powerful temperament' seemed especially to suit the paintings of his friend, which were repeatedly rejected by the Salon.

Cézanne's early works are dark and clumsy in handling, yet they convey the strong emotions of a powerful temperament. Alongside imaginary pieces conveying passionate sensual feeling are still-lifes — like the one he gave to Zola which features a black marble clock (Plate 46) — in which he tries to control his emotions and his means of expression through careful study of the object. 'Cézanne', wrote one of his friends, 'keeps on working violently and with all his might to regulate his temperament and to impose upon it the control of cold science.' Zola's Salon reviews of the 1860s do not comment on Cézanne's pictures because they were always rejected. He no doubt helped his friend write the petition for another Salon des Refusés in 1866, which however went unheeded, and he prefaced his volume of articles on the 1866 Salon, *Mon Salon*, with a letter 'To my friend Paul Cézanne'. In gratitude, Cézanne responded with a large portrait of his father reading Zola's paper *L'Evénement* (Plate 43).

Zola, however, failed to comprehend the formal preoccupations of Cézanne's painting, and ultimately abandoned hope in his friend. Renoir related that when Zola once complained that Cézanne's characters expressed nothing, the painter retorted in fury, 'And what about my backside? Does

42
EDOUARD MANET:
Portrait of Théodore Duret. 1868. Oil on canvas. Paris, Musée du Petit Palais

43
PAUL CÉZANNE:
Louis-Auguste Cézanne, the Artist's Father.
c. 1868–70. Oil on canvas. Washington, National Gallery of Art

44
PAUL CÉZANNE:
Portrait of Achille Emperaire. c. 1868. Oil on canvas. Paris, Musée d'Orsay

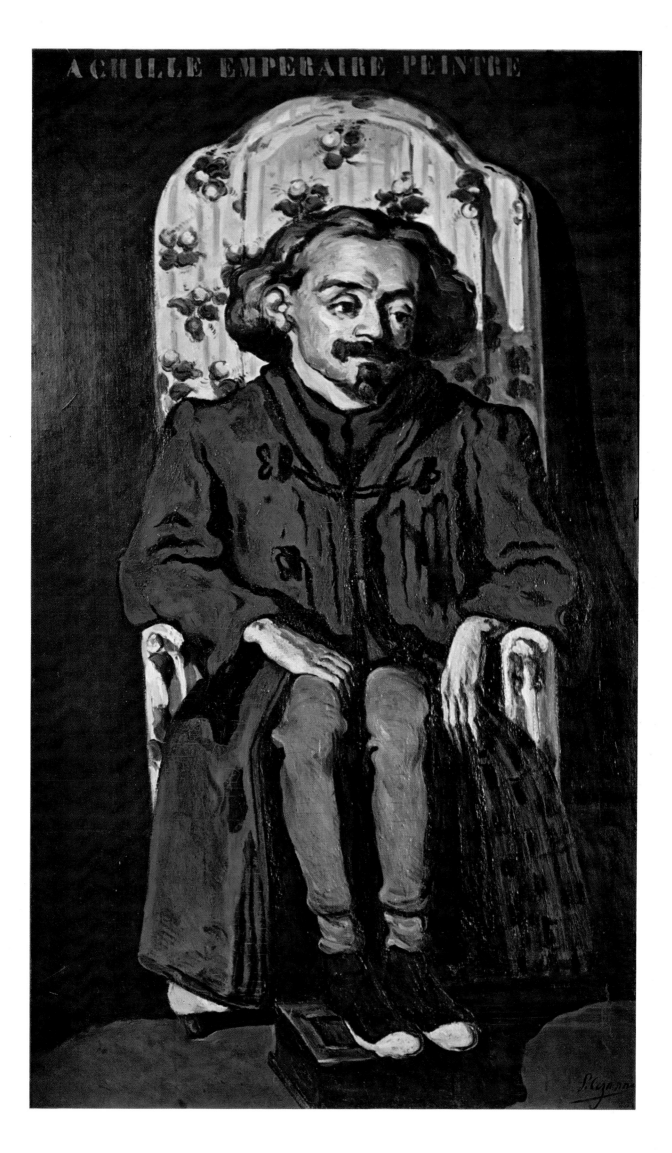

that express anything?' Outrageous defiance of a similar kind characterized Cézanne's dealings with the Salon. He refused to compromise and sent his boldest and most eccentric works for exhibition, such as the portrait of his friend Achille Emperaire (Plate 44), although they were always rejected. He achieved fame in the press as the most intransigent of the *refusés*.

Zola repeatedly defended Manet and his friends in spite of certain reservations. 'M. Manet's place in the Louvre is marked out,' he asserted in 1866, 'like that of Courbet, like that of any artist of original and strong temperament,' and in front of the work of Monet he exclaimed, 'Here is temperament, here is a man in the midst of that crowd of eunuchs.' Complaints from the incensed readership of *L'Evénement* at Zola's support of such radical artists, and at his attacks on the Salon favourites, led to his series of articles in 1866 being cut short. But he wrote again on the Salons of 1867 and 1868, by which time he could speak of the 'group' of naturalists. 'They form a group which grows every day. They are at the head of the [modern] movement in art, and tomorrow they will have to be reckoned with.'

By 1866 a new body of recruits had joined Manet at the Café Guerbois and the Salon: the four friends from Gleyre's studio, Monet, Bazille, Renoir and Sisley. Renoir was connected with the Batignolles group through his early acquaintance with Fantin-Latour, while Monet — whom many critics confused with Manet when he first exhibited in 1865 — was introduced to Manet by Astruc in 1866. Bazille was almost certainly already acquainted with Manet through the Commandant and Madame Le Josne who were cousins of Bazille's mother. From the time of his arrival in Paris, he saw them regularly, sharing their box at the theatre and visiting their home, where he joined in their artistic circle. In 1868 Bazille was persuaded to participate in one of Madame Le Josne's theatrical evenings, a performance of *Ruy Blas*. 'The Commandant is playing Don Salluste,' he wrote to

his mother. 'Ruy Blas will be played by the young poet Coppée. I will bring Blau along to work the lights. Maître refuses to get involved. The painter Stevens also has a role.' Alfred Stevens was a highly successful Belgian painter; Blau was a writer friend, and Edmond Maître a musician, composer and intimate of Bazille.

Monet and Bazille had long been familiar with Manet's art — on seeing the exhibition at Martinet's in 1863, Bazille wrote to his parents, 'You would not believe how much I learned in looking at these pictures. A single visit is worth a month of work' — and they continued to admire his paintings at the Salon. By the end of the decade they had become part of Manet's close circle. For Bazille this was easy and natural since they were connected socially; for Monet it was above all an artistic liaison, the coming together of perhaps the two most powerful talents of the period. Renoir also had become friendly with Manet, who had expressed great admiration for his portrait of Bazille (Plate 45) and either bought it or was given it by the artist. The three of them, together occasionally with Sisley, Pissarro and Cézanne, attended the gatherings at the Café Guerbois, Bazille talking with ease, an equal amid the educated group of critics and painters, the others contributing less, mostly listening.

In 1870 Fantin-Latour's large group portrait, *A Studio in the Batignolles* (Plate 47), was exhibited at the Salon. It shows Manet, seated, at work, painting a portrait of Astruc, also seated; standing from left to right are Otto Scholderer (a German Realist painter), Renoir, Zola, Maître, Bazille and Monet. Like his earlier picture, *Hommage à Delacroix*, Fantin's painting is a pictorial tribute to a master — this time a living one. The assembled group represents Manet's closest followers and his chief supporters among the critics. On a table beside the easel are assembled various objects, including a classical statue of Minerva and a Japanese lacquered tray, to show the range of the artist's inspiration. The picture itself is a stolid piece of documentary realism,

45
AUGUSTE RENOIR:
Portrait of Frédéric Bazille. 1867. Oil on canvas. Paris Musée d'Orsay

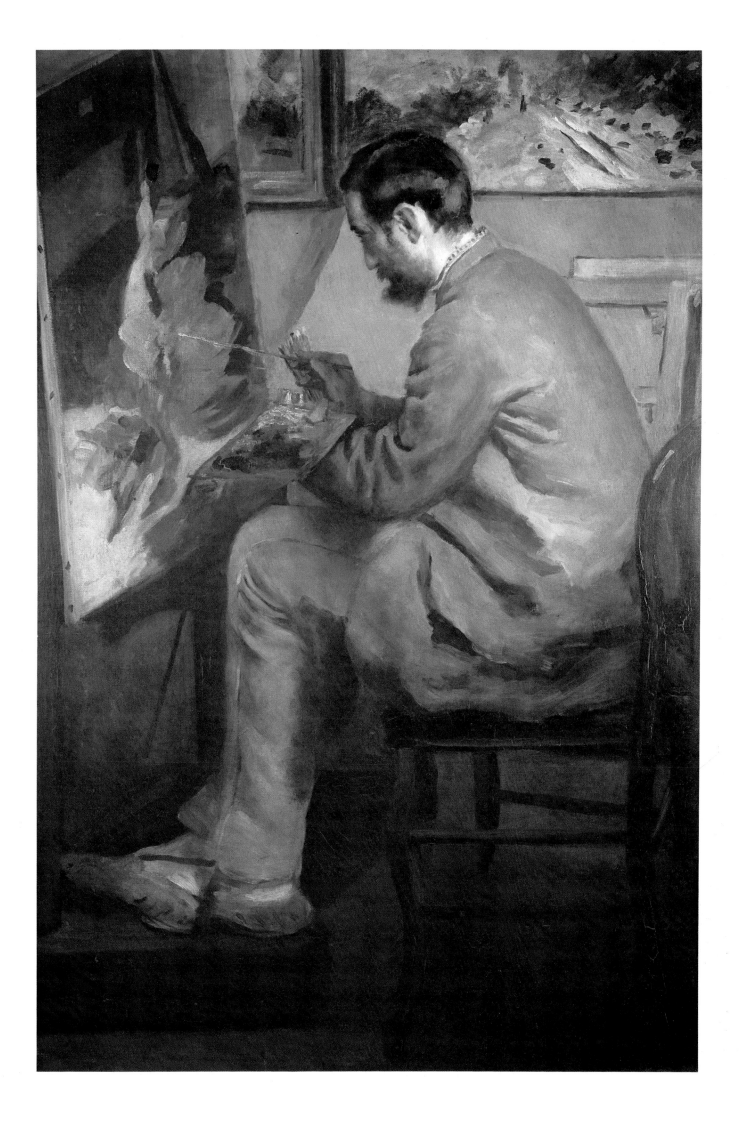

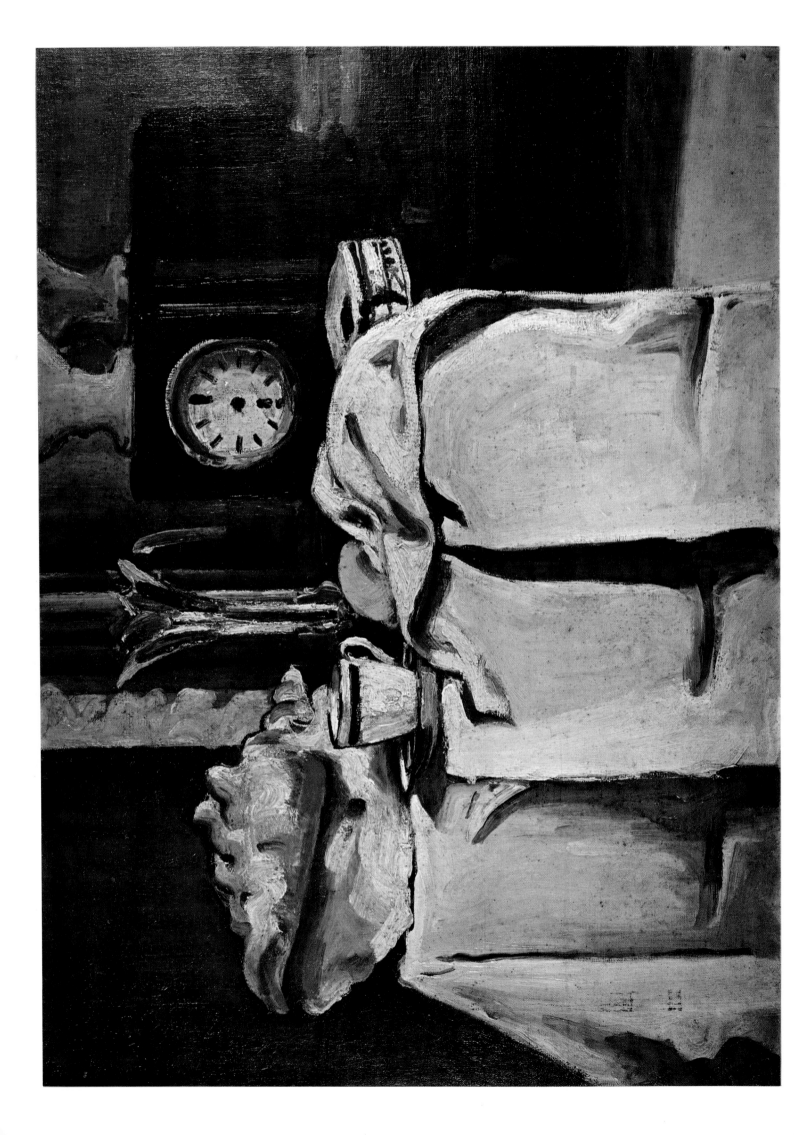

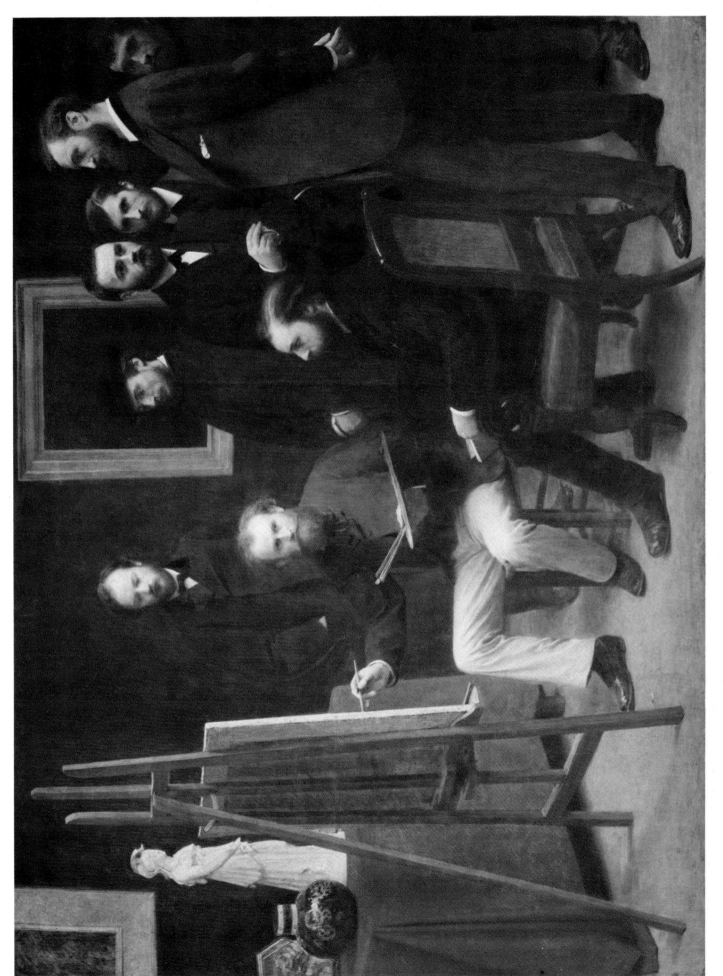

47 HENRI FANTIN-LATOUR: *A Studio in the Batignolles.* 1870. Oil on canvas. Paris, Musée d'Orsay

sombre in colour and painted in a rather
laborious, academic style. But it unites the
three major Impressionist painters: Monet,
Renoir and Manet himself. Significantly,
Bazille, whom Zola described as 'of fine
stock with a haughty forbidding air when
angry, and very good and kind usually', is
placed more prominently than his friends.
He was by this date intimate with Manet
and, no doubt in view of his connections,
well liked by Fantin (Plate 48). Fantin dis-
approved, on the other hand, of Monet, the
most radical of the young painters, whom
he considered a bad influence on his friend.
Strangely — and this may again be a re-
flection on Fantin rather than Manet —
Degas is not present; and Fantin, perhaps
in recognition of the fact that he was being
left behind by the rapidly developing pain-
ters, has neglected to include himself.

The group at the Café Guerbois inevit-
ably consisted only of men. Yet by 1870 two
women painters had joined Manet's circle:
Berthe Morisot and Eva Gonzalès. It was
under the influence of Manet, to whom
Fantin introduced her in 1868, that Berthe
Morisot began to paint figure subjects in a
broad style. Until then her contacts had
been with more conservative painters —
Corot, Oudinot and Puvis de Chavannes.

48
HENRI FANTIN-LATOUR:
Self-Portrait. 1867. Oil
on canvas. City of
Manchester Art
Galleries

Quite suddenly her work became bolder in
conception and handling. Manet so ad-
mired a picture of hers showing Edma
Morisot by the harbour of Lorient (Plate
49) that she gave it to him. At Manet's re-
quest, she had also posed with the painter
Guillemet and a woman violinist, Jenny
Claus, for his principal exhibit at the 1869
Salon, *The Balcony* (Plate 50). It is no
wonder that Edma felt envious. 'Your life,

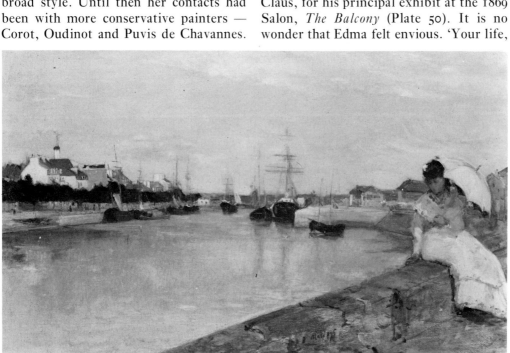

49
BERTHE MORISOT:
The Harbour of Lorient.
1869. Oil on canvas.
Washington, National
Gallery of Art

50
EDOUARD MANET:
The Balcony. 1868-9.
Oil on canvas. Paris,
Musée d'Orsay

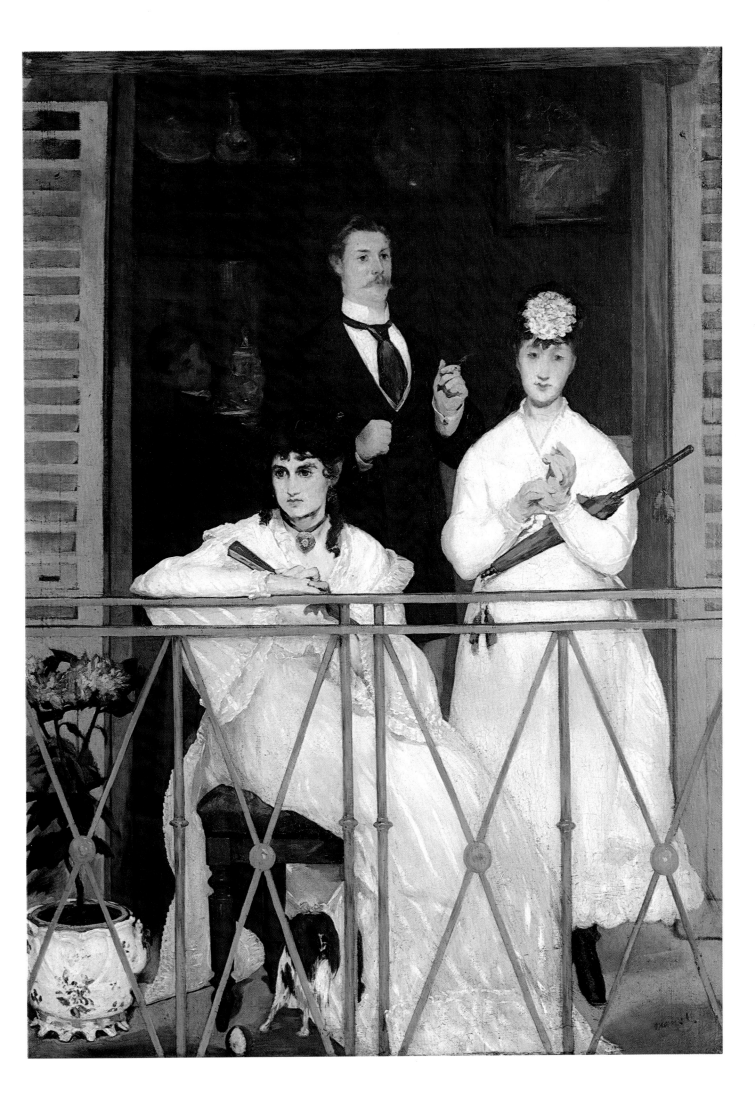

it seems to me, must be very charming at the moment,' she wrote to her sister. 'To chat with Degas, while watching him draw, to laugh with Manet, to philosophize with Puvis, these are things which deserve my envy...' According to Berthe Morisot, Manet was very anxious about the reception of his picture. Nevertheless he claimed she brought him luck and she confessed to finding him 'a charming person who pleases me infinitely'. Manet, for his part, was fascinated by Berthe's looks, and painted her portrait several times. *The Balcony* is the first of his major paintings in which the psychological interest, arising from a silent and engimatic interplay between the protagonists, matches in importance the formal and painterly interest. This may be largely thanks to the contribution of Berthe Morisot's dark beauty. As she confessed to her sister, 'it seems that the epithet *femme fatale* has circulated among the curious'.

Her jealousy was roused when Manet became captivated by another dark and beautiful woman painter, Eva Gonzalès, the daughter of the novelist Emmanuel Gonzalès and a former pupil of the fashionable genre painter, Charles Chaplin. She was twenty (and Berthe Morisot twenty-eight) when she was introduced to Manet by Alfred Stevens and became his pupil. Her work never achieved the strength or independence of Berthe Morisot's and remained closely imitative of Manet's, for the most part consisting of figure subjects painted in a rather sombre palette. Soon after they met, Manet painted a full-length portrait of her (Plate 51), which was shown at the Salon of 1870. While he is said to have encouraged a rapid and spontaneous execution in his pupil, she is shown in the portrait, mahlstick in hand,

putting the finishing touches to an already framed flower-piece. The picture in fact cost him great pains, as is evident in the conventional pose, the contrived if beautifully painted peony on the floor, and the expressionless face, which he repeatedly had to repaint. The failure of the portrait must have given Berthe Morisot some satisfaction, and when Manet and his brother Eugène visited her studio a little later she was delighted to report, 'it seems that what I do is decidedly better than Eva Gonzalès. Manet is too frank for one to be mistaken about it.' Eva Gonzalès, however, never ceased to admire her master and his work. In 1879, the year that her picture *The Box at the Théâtre des Italiens* (Plate 53) was accepted at the Salon, she married another painter Henri Guérard. In 1883 she gave birth to a son, but never afterwards recovered her health. The news of Manet's death in April gravely affected her and days later she died too, of an embolism, at the age of thirty-four.

At the same Salon that Manet showed the *Portrait of Eva Gonzalès*, Berthe Morisot exhibited a picture of her mother and sister Edma (Plate 52), which, although relatively well received, caused the artist great embarrassment. Shortly before the exhibition, Manet, who came to give his opinion, proceeded to retouch the whole picture until it became, in her words, 'the prettiest little caricature'. 'Mother finds the whole adventure funny,' she wrote to Edma, 'though I find it distressing.' She was relieved when the picture attracted from the critics no accusations of plagiarism. 'People are sufficiently kind not to leave me with any regrets,' she confided. 'I except, of course, M. Degas, who has a supreme contempt for anything I may do.'

51
EDOUARD MANET:
Portrait of Eva Gonzalès. 1870. Oil on canvas. London, National Gallery

52
BERTHE MORISOT:
The Artist's Sister, Edma, and their Mother. 1870. Oil on canvas, Washington, National Gallery of Art

53
EVA GONZALES:
The Box at the Théâtre des Italiens. 1874. Oil on canvas. Paris Musée d'Orsay

3 The Plein-Air Painters

It is tempting to think that Monet, Bazille, Renoir and Sisley straight away formed a close bond when they met in Gleyre's studio in 1862, but it does not seem to have happened like that. In his letters home, Bazille speaks in general of his companions, mentioning none by name, until early in 1863 he announces that a Vicomte Lepic (who later became a friend of Degas and exhibited with the Impressionists) 'and another young man, from Le Havre, by the name of Monet ... are my best friends among these *rapins*'. His first studio mate was not one of the future Impressionists, but another pupil at Gleyre's called Villa. Bazille's letters also demonstrate that his earliest friends in Paris were not necessarily artists but acquaintances of his family and other young men from Montpellier. Indeed, during his period at Gleyre's studio he was still keeping up the pretence of studying medicine, attending the life classes at Gleyre's in the mornings and rushing off to the Faculté de Médecine in the afternoons for lectures.

Renoir could not fail to notice Bazille's tall figure among the students at Gleyre's, 'a handsome, well-groomed young man — the sort who gives the impression of having his valet break in his new shoes for him!' During walks in the Luxembourg Gardens and at the nearby café, the Closerie des Lilas, Renoir and Bazille eagerly discussed the issues of modern art and the work of Edouard Manet. Later Sisley began to join their sessions and finally Monet too, who by virtue of his self-assurance and experience became their leader.

Charles Gleyre, the teacher of the four young painters, has over the years been cast

54
CHARLES GLEYRE: *Lost Illusions* or *Evening*. 1843. Oil on canvas. Paris, Musée d'Orsay

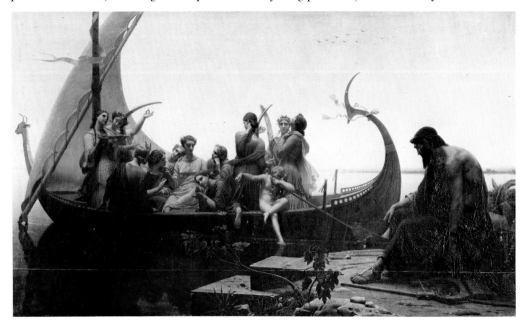

as the villain in the Impressionist story — the doctrinaire and intolerant pedagogue who blindly asserted the principles of Classicism and railed against the Impressionists' independent methods. He is said to have criticized the realism of their life studies and to have told them not to copy what they saw but to 'remember the Antique'. But Gleyre was not a member of the Academy like Gérôme and Cabanel. He did not teach at the Ecole des Beaux-Arts, and his success was limited. In fact, his reputation was based on one painting, *Lost Illusions* (Plate 54), which won him a medal at the 1843 Salon and was bought by the State.

Reliable accounts show that as a painter Gleyre was far from doctrinaire. Duranty, in an obituary article on 'the man of poetic reveries' in 1875, the year after his death, said he had 'beautiful and vigorous faculties and a rich comprehension of colour'. He was a timid and kind man who never lectured his classes, but spoke quietly to each pupil in turn about his work. Unlike other teachers, he did not charge for tuition, but merely took contributions towards the cost of the model and the studio. This must have recommended him to Monet and Renoir, but they also expressed affection for him, and while his own work, a blend of romantic themes, eccentric sentiment and a classical, enamel-like execution, was of little direct value to the young painters, he was not entirely intolerant of originality in his pupils.

The studio where he taught was probably situated in an old building in the Rue Notre-Dame-des-Champs in the Latin Quarter, not far from the Ecole des Beaux-Arts, where several other painters, including Gérôme, and a cousin of Monet, Toulmouche, also had studios. Some thirty or forty students worked at Gleyre's, drawing and painting from the model. The furnishings consisted of stools, easels, low chairs, a platform for the model and a stove, and the walls were covered with scrapings of palettes, caricatures and graffiti. The painting studios of Paris had time-hallowed traditions which students continued to follow in the 1860s. Each novice or *rapin* underwent the humiliation of initiation rites, students rivalled each other in the invention of practical jokes and obscene rhymes, and wild behaviour was the norm. Amateur theatricals were not uncommon; Bazille acted in a performance of *Macbeth* at Gleyre's which was watched by Whistler, Fantin, Manet, Duranty and Baudelaire.

For two years, or perhaps more in Renoir's case, the new friends trained with Gleyre, until, in the summer of 1864, the studio was forced to close through lack of funds. For Monet at least, the work in the studio was less valuable than the experience gained through painting in the open. The railway made it possible to escape to the semi-rural outskirts of Paris at weekends, and further afield during holiday periods. For a week at Easter in 1863, Monet and Bazille worked together at Chailly, a village near the Forest of Fontainebleau, not far from the more frequented village of Barbizon. Monet stayed on after Bazille left, much to the displeasure of his aunt Lecadre, who felt that he needed the discipline of studio training. A year later Monet and Bazille returned to Chailly, this time with Renoir and Sisley, for whom working in the open direct from nature was a new experience, one which converted them to the gospel of *plein air*.

For a young painter in 1846, it would have been hard to resist the spell of the Forest of Fontainebleau, not only because of its ancient trees, its rocky outcrops and wide avenues (features which appear in the studies the Impressionists did there), but also because of its intimate association with those artists of the previous generation who had opened the eyes of painters and public to the undiscovered beauties of the countryside around Paris.

Monet and his friends knew they were following in the footsteps of the Barbizon painters, and at one time or another they met the venerable figures of Diaz, Millet and Corot in the Forest. Renoir told how the one-legged Diaz came to his rescue

when he was being bullied by a gang of ruffians while painting in the woods. The old man emerged through the trees wielding his cane and drove Renoir's assailants away. At last he turned his attention to the young man's painting and carefully examined it. 'You've got talent, a great deal of talent,' he said, 'but why do you paint in such dark tones?', and he indicated how much colour might be perceived in shadows. On another occasion it was Renoir's turn to offer help. A Republican journalist called Raoul Rigaud, who was fleeing from the Imperial authorities, came up to him in the Forest in search of food and shelter. Renoir fed him and, supplying him with smock and painting-kit, disguised him as a painter. With the help of friends in Paris, the fugitive made his way to England, where he remained until the War of 1870.

While Diaz and Millet sought to convey in their work the ideas of purity, innocence and grandeur that the Forest and its peasant communities inspired in them, Monet looked with fewer preconceptions, and with an eye directed on purely visual phenomena. In this he was guided more by Charles-François Daubigny, a landscape painter who had made a practice of painting as far as possible in the open, choosing everyday subjects without obvious romantic associations. He had even constructed a studio boat, the Botin (Plate 55), so that he could paint the banks of the River Oise and the reflections on the water from a close vantage-point. Monet imparted his more objective approach to his friends. They painted restrained and vigorously truthful views of the wild terrain, not yet with the scintillating colour of the 1870s, but with a careful regard to light and tonal variations. Their pictures show a greater debt to Corot than to Rousseau, the most dramatic of the Barbizon landscapists, and sometimes recall Courbet's solidly painted woodland scenes. Sisley's large view of the Forest at La Celle St-Cloud of 1865 (Plate 56) demonstrates the conviction, shared by them all, that plain nature, unadorned with classical or picturesque incident, deserves to be treated for its own sake and on a grand scale.

During the early years Monet's most constant painting companion was Frédéric Bazille. In 1864 they travelled to Honfleur, stopping off at Rouen, and admiring Delacroix's *The Justice of Trajan* in the Museum. At Honfleur they rented rooms with a baker, and took their meals at the Saint-Siméon farm on the cliffs, a favourite haunt of Boudin, Jongkind, Courbet and other painters. 'The country is heaven,' Bazille enthusiastically reported to his parents. 'Nowhere could one find richer meadows or more beautiful trees. Cows and horses roam freely everywhere.' They rose at five in the morning and worked all day, and when Bazille returned to Paris, Monet stayed on, avidly painting the beaches and cliffs. 'My studies are far from what I should wish,' he wrote to his friend, 'It is indeed frighteningly difficult to do something that is complete in every respect... I want to struggle, scrape off, start again, because one can do what one sees and understands... All of which proves that we must think of nothing else. It is through observation and reflection that one makes discoveries.' So enraptured was Monet that he could not bring himself to leave. Jongkind and Boudin joined him and left again. In the autumn he wrote, 'I am quite alone at present and frankly I work better for it.' He was never so in need of support as his fellows, and pursued his aims with fierce independence.

It was on the basis of the studies he had painted around Honfleur that Monet composed, in the winter of 1864/5, the pictures that marked his debut at the Salon. *The Seine Estuary at Honfleur* and *La Pointe de la Hève* (Plate 58) were acclaimed by critics at the 1865 Salon, who acknowledged his characteristic mixture of sensitivity and boldness. But as yet he had not strayed far from his models. His pictures were rather sombre in tone and clearly not difficult to accept. They won him a reputation as a talented new marine painter.

For the next Salon, in an attempt to shake

55
CHARLES-FRANÇOIS DAUBIGNY: *The Artist in his Floating Studio.* 1861. Etching. The Baltimore Museum of Art (on indefinite loan)

56
ALFRED SISLEY: *Alley of Chestnut Trees at La Celle St-Cloud.* 1865. Oil on canvas. Paris, Musée du Petit Palais

off this label and achieve higher status, Monet undertook a much more daring project — a huge canvas of life-size figures at a picnic in the Forest of Fontainebleau. The idea was inspired by Manet's notorious *Déjeuner sur l'Herbe*, but while that picture with its allusions to Giorgione and Raphael stood on the cusp of past and present, Monet wished to create a thoroughly modern picture, to represent a scene of contemporary life in full scale with all the truth to atmosphere that he as a *plein-air* painter could muster. He established himself at the Inn of the Cheval-Blanc at Chailly in the early summer of 1865 and began to make studies for the setting of his picnic, meanwhile writing to Bazille, urging him to join him, to give his opinion on the landscapes and pose for the male figures.

Bazille, however, delayed in Paris, occupied with some decorative panels for his uncle's house. Monet was nearly driven to distraction and reproached his friend for neglecting him. Finally, on 19 August,

Bazille arrived and Monet painted him in various poses for eventual transposition on to the full-scale canvas. He persuaded several women to model, including one called Gabrielle, whom Bazille had apparently taken a fancy to, and perhaps 'la petite Eugénie', a friend of Monet's since the previous year. Progress was interrupted by bad weather and an accident which put Monet in bed. Bazille, doctor manqué, rigged up an apparatus to drip water onto Monet's injured leg to ease the pain. To restrain the impatient artist from quitting his bed, he painted an affectionate picture of him in which he showed the curious rig-up of buckets and basins (Plate 57).

Eventually, the preparatory studies completed, Monet painted a half-size composition sketch of the whole work, not in the open, but attempting to reproduce the shimmer of sunlight through leaves, and the range of colour and reflected tints that he had experienced in the Forest (Plate 59). In Paris in the autumn, in the studio which

57
FRÉDÉRIC BAZILLE: *Monet after his Accident at the Inn in Chailly.* 1865. Oil on canvas. Paris, Musée d'Orsay

58
CLAUDE MONET: *La Pointe de la Hève.* 1865. Oil on canvas. Fort Worth, Texas, The Kimbell Art Museum

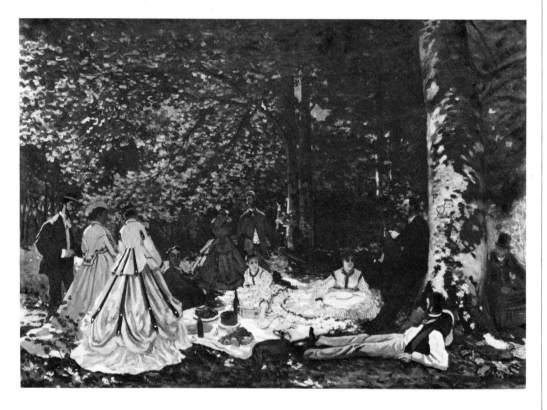

59
CLAUDE MONET:
Le Déjeuner sur l'Herbe.
1866. Oil on canvas.
Moscow, Pushkin
Museum

he shared with Bazille in the Rue de Furstenberg, Monet worked on the full-size canvas, which measured an astounding fifteen by twenty feet. It was never completed. In 1878 he was obliged to leave it with his landlord at Argenteuil in lieu of rent and when, eight years later, he finally retrieved the canvas, it was ruined by damp. He salvaged parts, one of which shows Bazille with two ladies against a background of trees (Plate 60). It reveals that in the final studio work, Monet adopted a means of working in broad areas of flat colour, without all the delicate nuances of his *plein-air* sketches, that comes much closer to Manet. It is as though when faced with the huge canvas he was obliged to conceive of it primarily as a decorative arrangement, and not, as he had wished, a faithfully observed moment in time. Shortly before the Salon, he is said to have reworked the picture on the advice of Courbet, and then became dissatisfied with it. True or not, it does not alter the fact that Monet was frustrated in his venture by the

sheer impossibility of preserving the spirit of *plein-air* painting in a huge studio composition, a figure subject which, notwithstanding its contemporary theme, was conceived in the traditional terms of a history picture.

In his next major venture, another large-scale picture, Monet hoped to overcome some of these difficulties by working as far as possible in the open. *Ladies in a Garden* (Plate 62), which was refused by the Salon of 1867, was painted in the garden of a house at Ville d'Avray, south-west of Paris, in the summer of 1866. He dug a trench into which the canvas could be lowered, to enable him to reach the upper parts without changing his vantage-point. His model for the female figures posing in their full skirts among the roses was Camille-Léonie Doncieux, his new mistress, a young woman of twenty who was to bear his children and, in 1870, become his wife. In the meantime the irregularity of their liaison led to ruptures with both his family and hers, and the termination of the financial support from

60
CLAUDE MONET:
Fragment of *Le Déjeuner
sur l'Herbe,* 1866. Oil on
canvas. Paris,
Musée d'Orsay

Monet's aunt and parents upon which he depended.

The first picture for which Camille modelled is probably the *Woman in a Green Dress* (Plate 61), which Monet painted in great haste early in 1866 to send to the Salon in place of his aborted *Déjeuner sur l'Herbe*. Composed in the studio, it shows him coming closest to the academic figure painting of the day. The colouring is again sombre, with the figure placed against a sonorous dark ground. Not surprisingly it achieved a great success, and he was commissioned by a dealer to paint a smaller version. But with the failure of *Ladies in a Garden* the following year, Monet's problems began. He had already been forced to leave Ville d'Avray for Le Havre to escape his creditors, and in 1867 Camille was expecting a child. Without money, he was obliged to bow to the will of his family, and for a time he separated from her and stayed with his aunt at Sainte-Adresse. In July, in his absence, his son Jean was born in Paris, and Bazille and

Madame Sisley were named as godparents.

Although the emotional and financial pressures on Monet continued, he succeeded that summer in producing views of the beaches at Sainte-Adresse (Plate 64) which rank amongst his finest creations. But working in brilliant sunshine resulted in strain on his eyes, and in the autumn he had to stop painting. In 1868, having rejoined Camille and the baby, he could not even afford to buy coal. He managed to sell the *Woman in a Green Dress* to Arsène Houssaye, an official in the Ministry of Culture and editor of the magazine *L'Artiste*, and won a commission to paint the daughter-in-law of a Monsieur Gaudibert, who lived in a château near Le Havre. However, following an exhibition at Le Havre in the spring in which Monet had participated, his works were seized by creditors, and he was left with nothing but a silver medal worth fifteen francs. By the summer he had reached the depths of despair. Thrown out of the inn at Fécamp where he was staying, abandoned by his family, he attempted to take his life. 'I was so upset yesterday,' he confessed to Bazille, 'that I had the stupidity to throw myself into the water. Fortunately no harm came of it.'

At such moments the friendship that linked the young Impressionists was all they could depend upon. Bazille, being better off than Monet and Renoir, was the object of countless appeals and repeatedly came to the rescue. He bought *Ladies in a Garden* for 2,500 francs, to be paid in monthly instalments of 50 francs. His payments, though, were not always on time, and Monet was often obliged to remind his friend of the extremity of his situation, writing to him in Paris with reproaches and recriminations.

Bazille did not intentionally neglect Monet. But the social distractions of his life must have dimmed his awareness of his friend's hardships. While Bazille participated fully in the pastimes of high society, Monet's life was dominated by his art on the one hand and material exigencies on the

61
CLAUDE MONET:
*Woman in a Green Dress
(Camille)*. 1866. Oil on
canvas. Bremen,
Kunsthalle

62
CLAUDE MONET: *Ladies in
a Garden*. 1866. Oil on
canvas. Paris
Musée d'Orsay

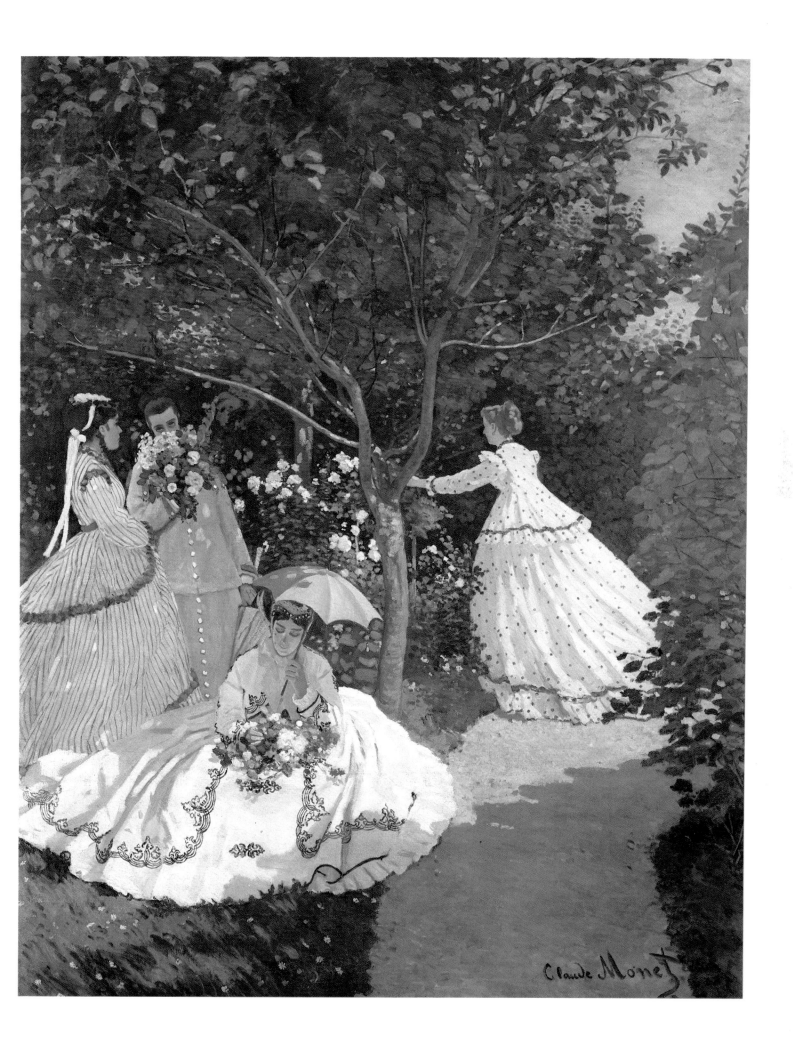

other. 'I assure you,' he wrote to Bazille
from Fécamp,

> I don't envy your being in Paris. Frankly I
> believe that one can't do anything in such
> surroundings. Don't you think that dir-
> ectly in nature and alone one does better?
> ... One is too much taken up with what one
> sees and hears in Paris, however firm one
> may be; what I am painting here will have
> the merit of not resembling anyone, at
> least I think so, because it will be simply
> the expression of what I have felt. I my-
> self, personally.

Nevertheless, even Monet returned peri-
odically to Paris, to see the exhibitions, to
discuss what he saw there with his friends
at the Café Guerbois, to try to sell his paint-
ings and to reconsider his work in the
studio in the winter months, when the
weather prevented him continuing his re-
searches outside. At such times it was with
Bazille he lodged, at first in the studio in the
Rue de Furstenberg (Plate 63), later in the
Rue Visconti, the Rue de la Paix in the
Batignolles, and the Rue des Beaux-Arts.
Often Renoir shared with them too.

Once a studio was found, they joined
forces on fitting it out. 'I found a very dirty
studio,' Frédéric reported home in 1869.
'Now everything is in order. I bought a
large bureau for 75 francs. I had my room
covered with cheap paper, Renoir and I
painted the doors ourselves, and I am now
very well installed.' If they were lucky, a
studio would have living-accommodation
attached. Furnishings were basic. 'I have
bought an iron bed with a boxspring and
mattress, a bedside table, an iron wash-
stand, some curtains, four chairs, a table
and an armchair which is my only luxury; I
did not get a rug,' wrote Bazille. For the
studio little was required: easels, stools, a
stove and good light. In 1867, Bazille wrote
with delight to his parents, 'Monet has
fallen upon me from the skies with a collec-
tion of magnificent canvases ... Counting
Renoir, that makes two hardworking pain-
ters I'm housing.' Shortly afterwards he
announced to his father his move with
Renoir to the Rue de la Paix, where he had

rented a huge studio in the same building
that Sisley and his wife occupied. 'Tell
Mama not to worry. The Batignolles is a
quiet neighbourhood, where living ex-
penses are less than in Paris.' Thus early in
1868 the painter friends became neighbours
of Manet, with whom they regularly joined
forces at the Café Guerbois.

The studio in the Rue de la Paix, later
renamed Rue de la Condamine, is the sub-
ject of a painting by Bazille showing him-
self and his friends casually gathered there
(Plate 65). The pictures on the wall give an
idea of the kind of painting with which he
was preoccupied: large canvases of figures
in the open, influenced by Courbet and

63
FRÉDÉRIC BAZILLE:
*The Artist's Studio in
the Rue de Furstenberg.*
1866. Oil on canvas.
Private Collection

64
CLAUDE MONET:
*The Beach at Sainte-
Adresse.* 1867. Oil on
canvas. The Art
Institute of Chicago

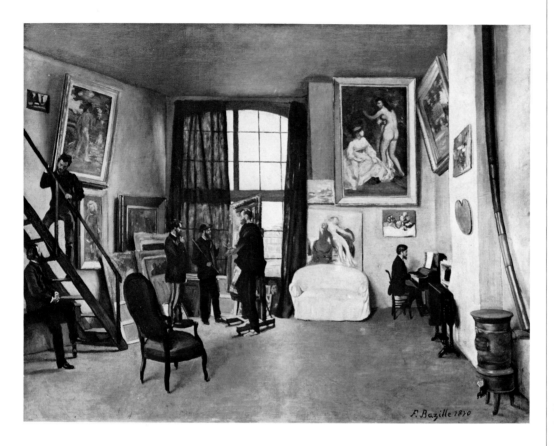

65
FRÉDÉRIC BAZILLE
*The Artist's Studio in
the Rue de la Condamine.*
1870. Oil on canvas.
Paris, Musée d'Orsay

Manet, and related to Monet's and Renoir's figure paintings of the 1860s. A huge picture of his family was accepted at the Salon of 1868, and another, of a girl seated with a view of the village of Castelnau behind her, at the Salon of 1869 (Plate 66). Berthe Morisot remarked on the latter, 'Our good Bazille has done something which I admire very much... He is seeking what we have all so often sought: how to place a figure in outdoor surroundings. This time, I think he has really succeeded.'

In the picture of his studio, Bazille himself is standing in front of the easel, palette in hand, talking to Manet and, behind him, Monet. The two on the left have been variously identified, but are probably Zola, on the steps, and Renoir or Sisley seated below. On the right, playing the piano, is Bazille's musician friend, Edmond Maître. The figure of Bazille may have been sketched in by Manet, with whom by this date he was very close. A drawing of similar

date by Bazille shows Manet drawing at his easel, elegantly attired in coat, stiff collar and top hat (Plate 67).

Bazille's letters give a rich impression of his social life in Paris in the late sixties, a life only partly shared with Renoir, Sisley and Monet. His friends numbered other painters, including Manet, Fantin and Scholderer, as well as the librettist Edouard Blau, the rich and eccentric photographer Etienne Carjat, and Joseph Fioupou, assistant head of the Exchequer who dined regularly with Degas and had been friendly with Delacroix and Baudelaire. Bazille's chief passion after painting was music, and he was friendly with Fauré, as well as with Saint-Saëns and Chabrier, a regular visitor to the Manets.

Probably his closest friend at this time was Edmond Maître (Plate 68), a man of similar background, employed by the Préfecture de la Seine, who devoted his time to art, books and, above all, music. A

66
FRÉDÉRIC BAZILLE:
View of the Village.
1864. Oil on canvas.
Paris, Musée d'Orsay

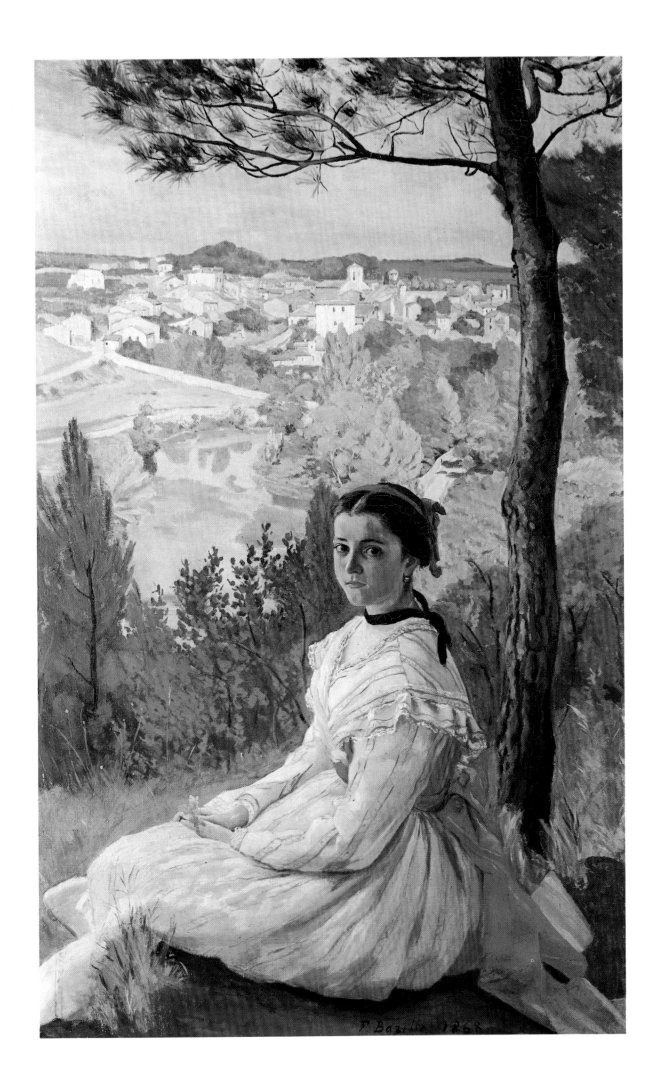

dilettante in spirit, he chose to neglect his career in favour of his cultural pastimes. He was a gifted amateur musician and a passionate admirer of Berlioz and Wagner. He corresponded with Berlioz and wrote a *Mémoire* intended for the Institut to draw attention to the merits of the composer, who he believed had been unjustly neglected. With Maître, and sometimes accompanied by Renoir, Bazille regularly attended concerts at the Conservatoire, and performances of the operas of Mozart, Cimarosa, Beethoven and Berlioz. He was enraptured by the singer La Patti, and shared Maître's enthusiasm for Berlioz's *Les Troyens* — 'my beloved *Troyens*', as he called it. When they were not listening to music, the two friends spent their evenings playing the scores of Beethoven, Schumann and Brahms on the piano in Bazille's studio, and entertaining other musical friends, with Maître's Belgian mistress, Alpha, serving refreshments.

Renoir often participated in these *soirées*, and shared Bazille's love of the theatre. Indeed, scenes of the theatre and of balls and musical entertainments were to be among Renoir's favourite themes. He had an abiding love of the music of Offenbach, whom he defended in conversation with Wagner when he painted his portrait in 1882, and he was enchanted by the spectacle of the opera. He hated the custom, introduced by Wagner, of dimming the lights in the auditorium. 'For me,' he said, 'there's just as much of a show in the audience. The public is as important to me as the actors.'

Although he had mixed feelings about Paris, Monet was attracted by the idea of painting the city streets, and trying his hand at the sort of subject that Baudelaire and the Goncourts had exhorted painters to undertake. He was given permission to work from the balcony of the Louvre and in 1867 painted views of the Church of St-Germain l'Auxerrois to the east and of the Jardin de la Princesse (Plate 69) with the river and the distant silhouette of the Panthéon on the skyline to the south. With their fragmentary compositions — like the arbitrary framing of a photograph — and briefly indicated crowds, they are among his earliest truly Impressionistic canvases, and anticipate many of the cityscapes of the 1870s. Perhaps in response to Monet's

67
FRÉDÉRIC BAZILLE:
Manet Sketching. 1869.
Charcoal on paper. New York, The Metropolitan Museum of Art

68
FRÉDÉRIC BAZILLE:
Portrait of Edmond Maître. 1869. Oil on canvas. Private Collection

69
CLAUDE MONET:
Le Jardin de la Princesse. 1867. Oil on canvas. Oberlin, Ohio, Allen Memorial Art Museum

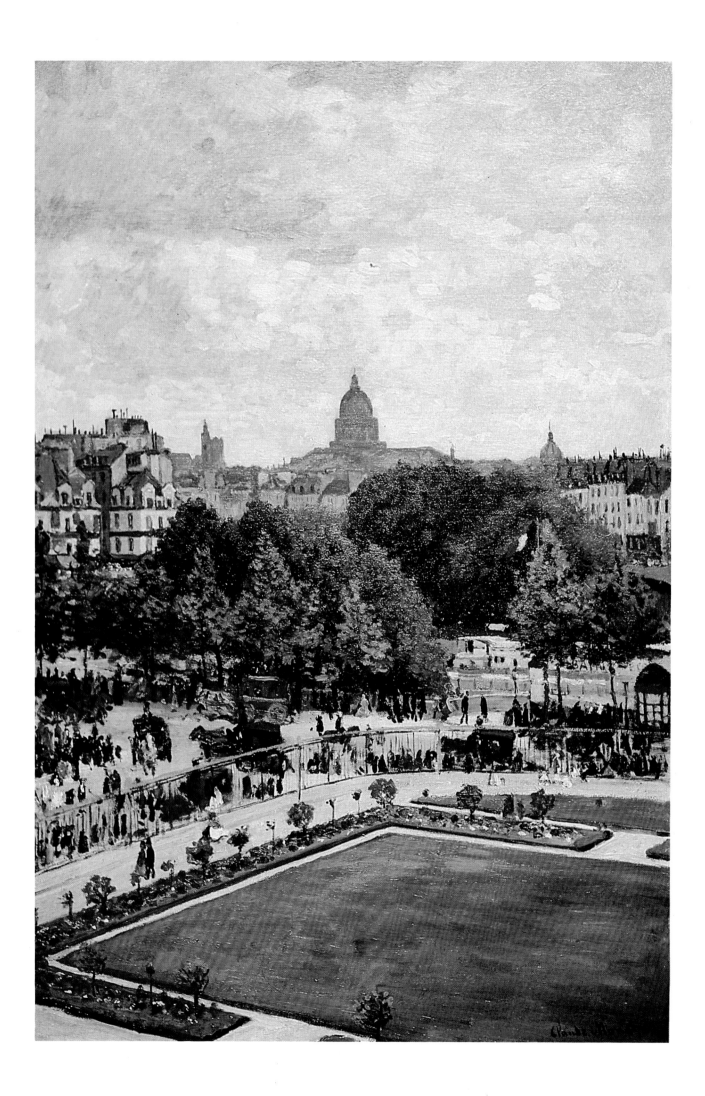

pictures, Renoir soon after painted a wide canvas of the left bank of the Seine with the Pont des Arts and the dome of the Institut (Plate 71), one of his first pictures of modern life, and richly evocative of the casual and carefree mood of the crowd promenading by the river.

In the early years Renoir's closest companion was Alfred Sisley, whose portrait he painted in 1864. In 1866 they lived together near the Port Maillot, and took a sailing-boat down the Seine to watch the regattas at Le Havre. 'The meals will be frugal,' Renoir wrote to Bazille, 'we'll have a tug-boat tow us to Rouen, and from there on, we'll do whatever we like.' The two also went on painting expeditions together in the Forest of Fontainebleau, much like Monet and Bazille. Their favourite resort was the village of Marlotte where they stayed at the Inn of Mother Anthony. Renoir left a vivid account of the place in a large painting of 1866 (Plate 70) which shows a group of artists seated at a table in the inn. Painted at about the same time as Monet's *Ladies in a Garden*, it shows a greater dependence on Courbet — in particular on his *After-dinner at Ornans* — but already reveals Renoir's fresh and original response to such figure subjects. The figures are captured in mid-movement, in natural attitudes, with the waitress clearing the table as the men casually chat. In spite of the size of the canvas, there is no sign, as in Monet's picture, of the artist straining to preserve an air of spontaneity. Renoir later identified most of the figures: at the left Mother Anthony's daughter Nana, next to her, standing, the painter Jules Le Coeur, on the right the bearded figure of Sisley, and in the background Mother Anthony herself. The white poodle was called Toto and had lost a paw in an accident, a deficiency Renoir tried to make good with a false one made of wood. The walls of the inn were covered with scribbles by the numerous artists who lodged there. Renoir himself is said to have added the caricature of Henri Murger, author of *Scènes de la Vie de Bohème*, which is visible in the painting.

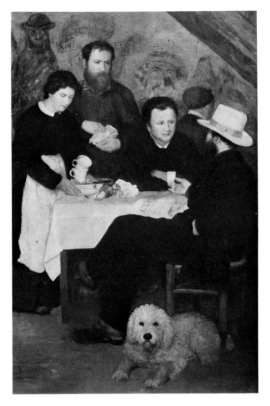

From Marlotte, Renoir, Sisley and their friend Jules Le Coeur would sally out to paint in the surrounding woods. Le Coeur, an architect-turned-painter, had a house in Marlotte and was friendly with Corot. In 1866 Renoir and Sisley spent a month with Le Coeur's family at Berck on the Channel coast, and Renoir's friendship was strengthened by his attachment to Lise Tréhot, the sister of Le Coeur's mistress, Clémence. He painted Le Coeur in the woods with his dog, and Lise became his model and his mistress. She posed for two rather academic nudes, *Diana* of 1867 and *The Bather with Griffon* of 1870, but appears most successfully in a portrait shown at the Salon of 1868, in which she stands in a white dress and holding a parasol, with sunlight filtering onto her through the trees (Plate 73). In this picture, his first successful attempt at depicting a full-scale figure in the open, Renoir tackles the same problem that Monet had faced in the *Déjeuner sur l'Herbe*, but once again achieves a much

more natural effect — perhaps because of
his obvious affection for the subject. Here
too are the transparent shadows, the re-
flections, the palpitating atmosphere of
summer afternoons that the Impressionists
so eagerly sought. As one critic acutely re-
marked: 'The effect is so natural and so true
that one might very well find it false, be-
cause one is accustomed to nature rep-
resented in conventional colours... Does
not colour depend upon the environment
that surrounds it?' Dozens of pictures tes-
tify to Renoir's fondness for Lise Tréhot
and her full, dark, almost gypsy-like figure.
(Indeed, he portrayed her twice in the dress
of an Arabian concubine.) But in April
1872, when Lise married an architect
friend of Le Coeur, their relationship
ceased and Renoir never saw her again.

At about the time Renoir met Lise, Sisley
too took a mistress, Marie Lescouezec, who
in 1866 became his wife and, the following
year, mother of his first child. Apparently
she had modelled for Renoir, who greatly
admired her. 'She had a very sensitive
nature and was exceedingly well-loved,' he
recalled. 'She had taken up posing because
her family had been ruined in some finan-
cial venture.' In 1868 Renoir painted a por-
trait of her with Alfred Sisley (Plate 72), a
work which ably testifies to the affection the
couple felt for each other, and to the artist's
fondness for them. The slight stiffness of
their poses only adds to the sense of tender-
ness and vulnerability. This picture, like
Rembrandt's *The Jewish Bride*, must rank
among the most moving portraits of a mar-
ried couple, with its hint of gallantry in the
way Sisley holds his arm for his wife's sup-
port, and the reserve, modesty and sin-
cerity of her expression. The picture takes
on an added poignancy when one brings to
it the knowledge of the disappointments
that they were to bear together, the poverty
of their later life, and the painful suffering
they both endured in their last years of
illness.

Among the artists who occasionally
joined Renoir and Sisley at Mother
Anthony's were Monet and Pissarro. The

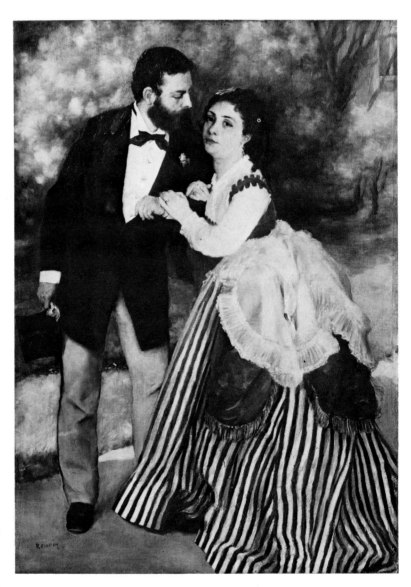

latter had been pursuing his researches,
largely independent of the others, at Pon-
toise, a town to the north-west of Paris
where he settled in 1866. He had broken
with Corot, who disapproved of the in-
fluence of Courbet and Manet on his work,
and was concentrating on large-scale can-
vases of the environs of Pontoise, princi-
pally the old rural suburb of L'Hermitage.
By painting landscapes six foot or more
wide, Pissarro was abandoning the pattern
of Corot's little studies, and aiming for a
broader effect. Two of these were shown at
the Salon of 1868 (Plates 74 and 75), where

72
AUGUSTE RENOIR:
*Alfred Sisley and his
Wife.* 1868. Oil on
canvas. Cologne,
Wallraf-Richartz
Museum

73
AUGUSTE RENOIR:
Lise. 1867. Oil on
canvas. Essen, Museum
Folkwang

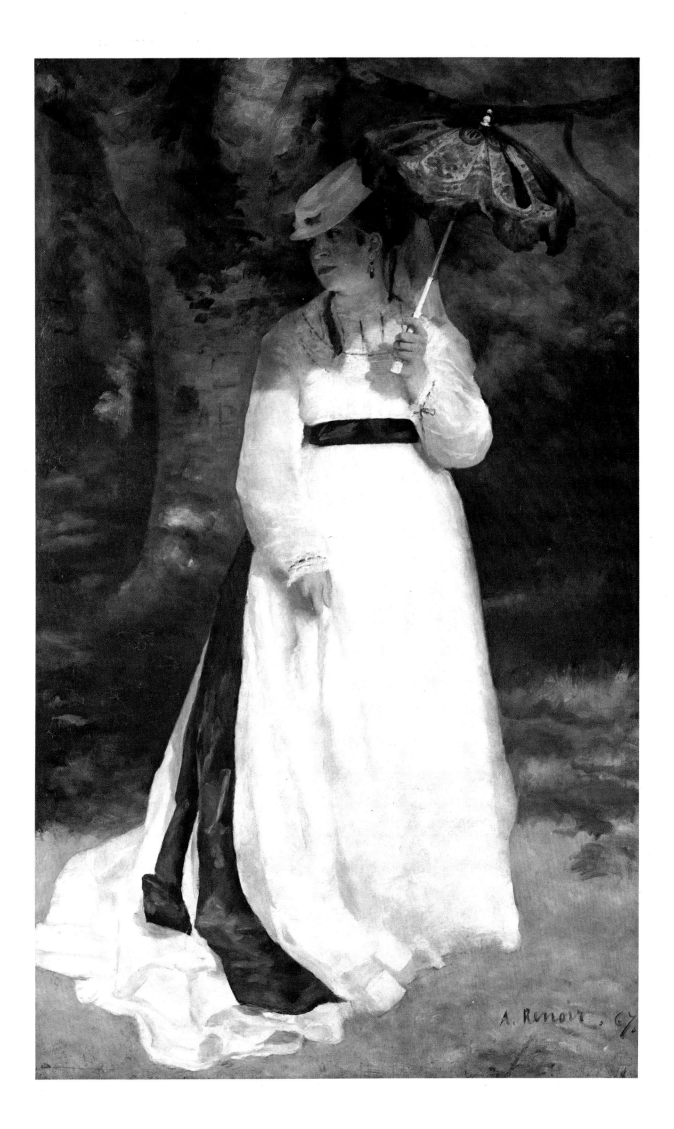

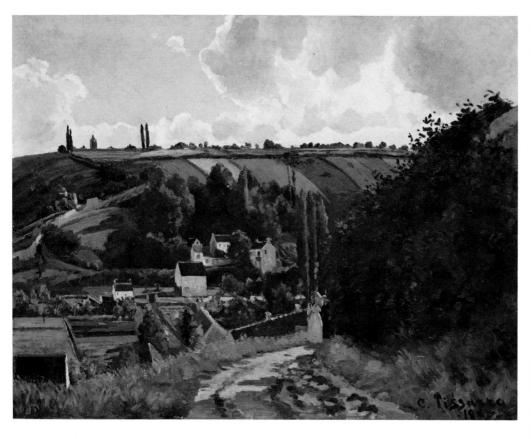

74
CAMILLE PISSARRO:
*The 'Côte du Jallais',
Pontoise*. 1867. Oil on
canvas. New York, The
Metropolitan Museum
of Art

they attracted the attention of Castagnary, and won from Zola the famous compliment, 'a fine picture by this artist is the act of an honest man'. In his L'Hermitage pictures, his first major compositions, Pissarro achieves extraordinarily radical simplifications of colour and tone, concentrating above all on structure. What the pictures thus lack in finesse, they make up for in boldness. The paint is applied thickly, in broad areas of flat colour, without any attempt to disguise the brushstrokes. It is no accident that Pissarro won a reputation for coarseness and primitiveness.

At this date Pissarro's closest friend was the painter Piette, whom he had first met in 1860. As Bazille supported Monet, so Piette, who was moderately wealthy, helped Pissarro, inviting him and his family to stay on his farm at Montfoucault in Brittany when the painter's finances were exhausted. Pissarro's pictures never sold for high figures and in 1868, to aug-

ment his income, he was obliged to join his friend Guillaumin painting blinds, as a quick oil sketch by Guillaumin records (Plate 76). The latter, whom Pissarro had met with Cézanne at the Académie Suisse in 1861 when he was twenty, was very poor and pursued his artistic career by working at night as a labourer for the Paris City Council in order to be able to paint during the day (Plate 77).

In 1869, partly through their meetings at the Café Guerbois, Pissarro became more intimate with Monet, Renoir and Sisley, and worked more often with them. He came to live closer to Paris, at Louveciennes, while Monet was staying nearby at Saint-Michel, and Renoir was living with his parents at Voisins, a hamlet on the edge of Louveciennes. The river, with its sailing-boats and Sunday trippers, was a strong attraction to them all. When Monet had worked on the Channel coast, Renoir and Bazille had often taken the train at week-

75
CAMILLE PISSARRO:
L'Hermitage, Pontoise.
1867. Oil on canvas.
Cologne, Wallraf-
Richartz Museum

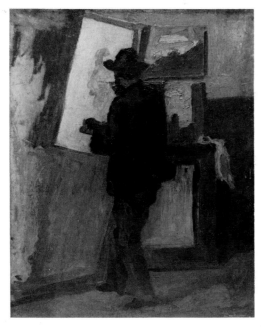

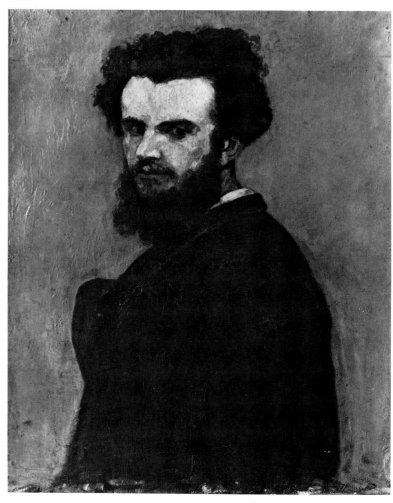

ends to amuse themselves by the river at
Bougival, where Bazille competed in the
rowing contests. They had no doubt fre-
quented the Fournaise Restaurant at Bou-
gival and the floating café at La
Grenouillère.

Situated on the wooded Île de Croissy, La
Grenouillère was a favourite bathing and
boating resort during the 1860s and 70s.
Renoir was first taken there by the Prince
Bibesco, for whom he had painted a ceiling
in his Paris residence (built by the brother
of Jules Le Coeur). During the summer of
1869 he and Monet worked there frequently
together, while Pissarro, from the opposite
bank, painted the bathing cabins overhung
by huge poplar trees.

For Monet it was still a time of hardship.
He was without money to eat, let alone
paint; but Bazille sent him canvases and
Renoir brought him scraps filched from his
parents' table. 'We don't eat every day,'
Renoir reported to Bazille, 'yet I am happy
in spite of it, because, as far as painting is
concerned, Monet is good company.'
Monet wanted to do a picture for the next
Salon, depicting the bathers by the floating
café. In August he wrote to Bazille, 'I do,
indeed, have a dream, a picture, the

bathing-place at La Grenouillère, for
which I have made some bad studies, but it
is a dream. Renoir, who has just spent two
months here, wants to do this picture too.'
The picture was painted, but the Salon jury
of 1870 rejected it and subsequently it dis-
appeared. What Monet called his 'bad stu-
dies' survive, however: one showing the
little island called, because of its shape, the
'camembert' or 'pot aux fleurs', with the
floating café on the right (Plate 79), the
other showing the bathing-cabins, the row-
ing-boats moored at the bank, and the
narrow catwalk leading to the 'camembert'
(Plate 78).

Renoir, working alongside Monet, pro-
duced paintings of almost identical views
(Plate 80), yet of a quite personal stamp.

76 *Above left*
ARMAND GUILLAUMIN:
Pissarro painting Blinds.
c. 1868. Oil on canvas.
Limoges, Musée
Municipal

77
ARMAND GUILLAUMIN:
Self-Portrait. c. 1875.
Oil on canvas. Paris,
Musée d'Orsay

78
CLAUDE MONET:
Bathers at La
Grenouillère. 1869. Oil
on canvas. London,
National Gallery

79 CLAUDE MONET: *La Grenouillère*. 1869. Oil on canvas. New York, The Metropolitan Museum of Art

80 AUGUSTE RENOIR: *La Grenouillère.* 1869. Oil on canvas. Stockholm, Nationalmuseum

While Monet looks with an eye fixed on the pattern of boats and the ripple of water, Renoir is entranced by the people. Through his eyes, La Grenouillère becomes a modern Cythera, and the riverside crowd the descendants of Watteau's aristocratic lovers. Although his perception of light and colour is no less sharp than Monet's, Renoir has a tendency to romanticize. La Grenouillère may have been popular, but it certainly was not smart. Among the habitués with whom Renoir and Monet were friendly was one Baron Barbier, a captain in Bibesco's regiment who had no interest in painting but was a great rower and womanizer. He is probably the model in Manet's picture painted later at Argenteuil, entitled *Boating*. Apparently La Grenouillère took its name, meaning 'frog-pond', not from the riverside location, nor from the bathers, but from the women of easy virtue who patronized the place and were known in Second Empire parlance as 'frogs'. Renoir remembered them as 'good types', and often found willing models among them.

The novelist Maupassant, however, when he later wrote about La Grenouillère in his stories *La Femme de Paul* and *Yvette*, painted a much blacker picture, shot through with disgust at the stupidity and vanity of the vulgar revellers:

> At the approaches to La Grenouillère a crowd of people were strolling beneath the gigantic trees which make this corner of the island the most delightful park in the world. Women, flaxen-haired girls with large breasts and buttocks, faces thick with make-up, eyes heavily shadowed and lips scarlet with lipstick, laced and strapped into fantastic dresses, trailed across the fresh grass, their skirts in execrable taste ... while beside them strutted young men, looking like models in a fashion-plate with their light gloves, patent-leather boots and thin canes, and monocles which only emphasized the fatuousness of their smiles.

Clearly the place was a low-class resort, close to the rapidly growing industrial suburbs of Paris, yet a resort to which the wealthy and the fashionable would also come to partake of the sports and the pleasures afforded there. With an eye to irony, Maupassant contrasted the beauty of the location with the vulgarity of the human activity. The painters, on the other hand, were prepared to look with a lenient eye. It is in the nature of painting to be more open-minded, to reserve judgement; and perhaps, as true bourgeois and unintellectual artists, Monet and Renoir trusted to their instincts and saw in the holiday scene nothing to censure, merely a treat for the eye. Later, although they became friendly and would meet at the Fournaise Restaurant, Renoir and Maupassant had to admit they had nothing in common. 'He always looks on the dark side,' said the painter of the writer. 'He always looks on the bright side,' the writer rejoined. Each thought the other quite mad.

Why, in his letter to Bazille, Monet called his marvellous sketches 'bad' is a mystery. Maybe it was merely casual self-deprecation, or perhaps a passing acknowledgement of the difficulty of the task he had set himself — to paint the mingled activity of La Grenouillère and the action of light, brilliant here, subdued there, filtering through the trees and reflecting on the water. His sketches are laid in with great speed. Broad brushstrokes and slabs of pure colour are all it took him to describe the varied forms of bathers thrashing in the water or seated on the banks, gaudily dressed strollers, brightly painted rowing-boats, and rippling waves reflecting the afternoon sky and heavy summer foliage. Perhaps he was surprised at his own boldness and dexterity. There is nothing of the customary finish of an exhibition picture in these sketches, and they are far broader than his earlier *plein-air* studies. They are, in effect, the first Impressionist paintings, the first in which an overall texture of fragmented brushstrokes of bright colour is used to convey the light and atmosphere of the outdoors, and give a unified surface appearance to the canvas.

Although Monet was the acknowledged

leader of the little group of landscape pain- ters and had become through his work at Sainte-Adresse and La Grenouillère the most radical and daring of them, they were all feeling their way towards a style that was capable of a more comprehensive depiction of the natural world, a style that not only could describe form, but could evoke light, atmosphere and movement through nuances of colour and touch. About this time Pissarro made note on a drawing of a landscape seen 'through a completely transparent vapour, with the colours based on one another', a statement redolent of the new atmospheric preoccupations of the Impressionist group. By 1870 they had ar- rived at the point of great discoveries, and severed the links with their masters. Fantin's picture of *A Studio in the Batignolles* and Bazille's painting of his own studio are symbolic of the new artistic fellowship which had formed, and upon which the future of each, as a painter, de- pended. 'I believed,' Manet had written, 'that if we were to remain close together and above all, not to grow discouraged, there would be a means of reacting against the mediocre crowd that is strong only be- cause of its unity.' The Impressionist ranks were formed and ready, but before the bat- tle against mediocrity and prejudice could begin in earnest, external events were to intervene, dispersing the group, and bring- ing about irreversible changes.

4 War and New Beginnings

In July 1870 it was learned in France that a Prussian prince was being proposed as a candidate for the vacant Spanish throne. Napoleon III's ministers reacted rapidly to this threat and through diplomatic negotiations secured the withdrawal of the offensive candidate. But France pressed the point too far, exerting too much authority, until worsening relations and strong public opinion led to the declaration of war on Prussia on 19 July.

This brief war, which Ollivier, the French Premier, had entered 'with light heart', was an unmitigated disaster and brought an abrupt close to the Second Empire. The French forces were poorly organized and far outnumbered by the Prussians. Defeat followed defeat until on 1 September the main French army capitulated at Sedan and the Emperor was taken captive. His regent, the Empress Eugénie, fled to England where Louis-Napoléon later joined her, and on 4 September the Republic was proclaimed in Paris (Plate 81).

Few people in France in the summer of 1870 had suspected that war was imminent; only a handful of politicians had been mindful of the Prussian threat. When war was declared, Monet was working at Trouville with Boudin. On 28 June he had married Camille and several of his paintings of the beach show his wife, alone or

81
Gambetta proclaiming the Republic in front of the Palace of the Corps Législatif. Engraving from the *Illustrated London News*, 10 September 1870

82
CLAUDE MONET:
The Beach at Trouville.
1870. Oil on canvas. London, National Gallery

with Madame Boudin (Plate 82). As the Prussian forces steadily advanced and France's defence proved ineffectual, many people fled the country. At Le Havre, Monet witnessed the steady flow of exiles boarding ships to England and in September he too fled to England to avoid conscription, leaving Camille and Jean behind. The Prussian advance drove Pissarro and his family from Louveciennes to Brittany, where they stayed with Piette. Prevented from fighting for France by his Danish nationality, Pissarro, like Monet, later crossed to England, taking his family with him, to stay with a relative in South London. At Louveciennes the Prussians turned his house into a butcher's shop and the pictures stored there, which Pissarro said represented the greater part of his work since 1855, were lost or destroyed.

Of the remainder of the group, Cézanne stayed on at L'Estaque on the Mediterranean coast with his mistress, Hortense Fiquet (Plate 83), a liaison he kept secret from his father, and Sisley, who was of British nationality, went to England with his wife; Manet, Degas, Renoir and Bazille, however, enlisted. Manet and Degas joined the artillery of the National Guard, Manet serving under Meissonier, the official painter of Napoleon III's campaigns, and Degas under a childhood friend of his, Henri Rouart, an engineer by profession and an amateur painter. Renoir was offered a place with his patron, Prince Bibesco, on the staff of General du Barrail, but turned it down. In July he was conscripted into a regiment of Cuirassiers and ended up far from the field of battle, first at Bordeaux, and later at Tarbes training horses (a task for which he had no experience) and teaching his captain's daughter painting. Bazille, however, accepted a similar offer from Bibesco and ended up at the front in a regiment of Zouaves.

Although by September France had already lost the foolhardy war, this was not the end. The emergency government of the new Republic refused to accept the terms of

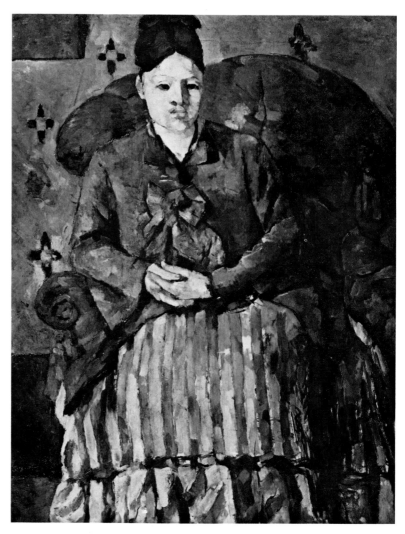

surrender demanded by the invading Prussians, and by 23 September Paris was surrounded and cut off from the world. The siege of Paris, in which almost two million people were blockaded within the city, lasted over four months, far longer than anyone had believed possible. The Republican leader Gambetta escaped from the city by balloon to organize resistance in the provinces (Plate 84), but his troops were untrained and poorly armed. They had little success against the Prussians, and on 28 January 1871 Paris and the government of France finally acknowledged defeat.

Among those trapped in Paris during the siege were Manet, Degas, and Berthe Morisot and her family, who in spite of

83
PAUL CÉZANNE:
Portrait of Hortense Fiquet. 1877. Oil on canvas. Boston, Museum of Fine Arts

84
Gambetta about to make his Escape from Paris by Balloon. Oil on canvas. Paris, Musée du Vieux-Montmartre

Manet's protestations had refused to leave. The two painters, together with Eugène Manet, were frequent visitors at the Morisots, and they continued to gather at the semi-deserted Café Guerbois.

Manet had sent his little family — his mother, his wife, and her son Léon — to the town of Oloron-Sainte-Marie, near Pau in the Basses-Pyrénées. Throughout the siege he wrote fond and lonely letters to his wife, 'ma chère Suzanne', which left Paris by balloon. He was torn between the desire to communicate the grimness of his experiences in Paris — the hunger, the sickness, the boredom and the fear — the wish to reassure her as to the safety of himself, his brothers and hers, and the need to conceal any military information lest it should fall into enemy hands. 'I have often regretted letting you go,' he wrote in October, 'that's perhaps because I feel that you are sheltered from knowing everything that may happen to us. Smallpox is raging here, and for the time being we are reduced to seventy-five grammes of meat per person; milk is being reserved for children and the sick.' In November he wrote:

> smallpox is very widespread, and particularly hits the refugee peasants ... The environs of Paris are all mined. Potatoes cost eight francs a bushel and there are now cat, dog and rat butchers in Paris. We can no longer eat anything but horsemeat, when we can get it ... Our state of boredom is such that we don't want to see anyone — always the same conversation, the same illusions. The evenings are hard to bear. The Café Guerbois is my only resource, and that grows monotonous. When will we be reunited? I long for that moment and think of you all the time. I have filled the room with pictures of you.

The bitterly cold winter added to the misery, and eventually, in January, the Prussians began to bombard Paris. The populace took to sheltering in basements while fires sprang up on the Left Bank and in the outer quarters. The capitulation of

the city at the end of the month finally put an end to those trials, but left many Parisians resentful of their leaders, who, they felt, had bungled the defence. And to their resentment was added humiliation and anger when, on 1 March, as an agreed term of the armistice, Prussian troops marched in triumph through the city.

The sufferings of the French army were no less than those of Paris. Mismanaged by their leaders, the troops were laid wide open to the German artillery (Plate 85). Bazille was of their number. Marched round in circles, he never really saw action. 'This morning, November 7, everything has changed,' he wrote home. 'We break camp, one kilometre out a counter-order sends us back to where we were yesterday. This is disgusting. How can any semblance of discipline be maintained with such leadership. It is probable that we are going to be stuck in Besançon, and like so many rabbits, then be taken prisoners.' Days later he wrote again, 'I do not have the time to tell you about what I am feeling and about my reactions to everything I see and hear. I am storing it all away; I don't know if, some day, I will have the courage to say what I think of mankind, but I am in a very harsh school.' He was never to have the chance to say what he thought. On 20 November, Frédéric Bazille was shot dead by a Prussian sniper at Beaune-la-Rolande, while in retreat.

His death at the close of the war, when all was anyway lost, came as a bitter blow to the circle of young artists to whom he had been both friend and mainstay. Among those who mourned his loss was Edmond Maître. He had heard the news from Frédéric's father, who had retrieved his son's body from under the snow and brought it back to Montpellier on a cart (Plate 86). 'The poor man wrote me a crushing letter,' Maître wrote despairingly to his father,

> I cannot put into words my anguish at the loss I have endured: I have lost half of myself. I was tied to him by a profound friendship. My dear friend was the most intelligent, my Bazille was the most

gifted, the most lovable in every sense of the word, of all the young men I knew. No one in this world will ever fill the empty place he leaves in my soul. I am broken-hearted.

Renoir did not hear of Bazille's death until he arrived back in Paris after being demobilized. Years later he still brooded over the memory of 'that gentle young knight; so pure in heart; the friend of my youth'. He too had been close to death. There had been a severe dysentery epidemic among the soldiers at Tarbes, and Renoir was taken very ill. An uncle came to his aid and took him to Bordeaux, where he recovered.

Monet and Pissarro, in comparison with their friends, were fortunate. Not only were they far removed from the fighting and the privations of war, but they were also able in London to continue their painting. There Monet met Daubigny, who introduced him early in 1871 to his dealer, Paul Durand-Ruel, another Frenchman in temporary exile. Encouraged by Daubigny, Durand-Ruel agreed to buy Monet's work and exhibit it in his new Bond Street galleries. By chance Pissarro independently approached the dealer at the same time, and Durand-Ruel was able to put him in touch with Monet, who was unaware that Pissarro was in London. Thus while Manet and Degas witnessed the fall of Paris to the enemy, Monet and Pissarro were joyfully reunited and shared the happiness of selling their works to a dealer who had faith in them.

The pictures they painted in London were confident and adventurous. 'Monet and I were very enthusiastic over the London landscapes,' Pissarro afterwards recalled. 'Monet worked in the parks, whilst I, living in Lower Norwood, at that time a charming suburb, studied the effect of fog, snow and springtime.' Among the delicate studies Pissarro painted in South London during the winter of 1870/71 were one of a street in Lower Norwood (Plate 87) lightly powdered with snow, one of the station at Lordship Lane (Plate 88) — a picture perhaps inspired by Turner's *Rain,*

85
French Prisoners. Engraving from the *Illustrated London News*, 21 January 1871

86
Burying French Soldiers. Engraving from the *Illustrated London News*, 21 January 1871

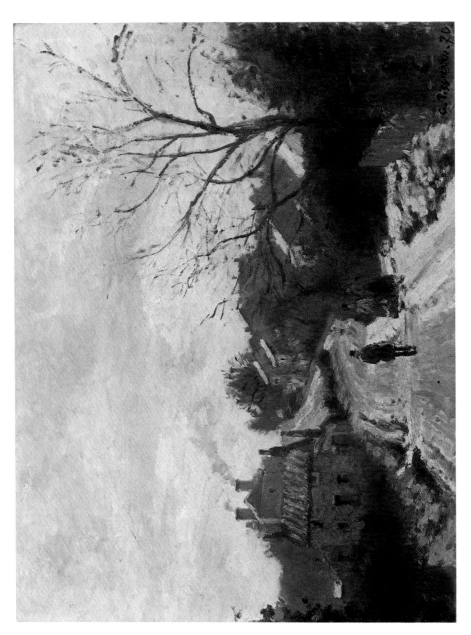

87 CAMILLE PISSARRO: *Lower Norwood under Snow.* 1870. Oil on canvas. London, National Gallery

88 CAMILLE PISSARRO: *Lordship Lane Station, Upper Norwood*. 1871. Oil on canvas. London, Courtauld Institute Galleries

89 CLAUDE MONET: *The Thames below Westminster*. 1871. Oil on canvas. London, National Gallery

90 CLAUDE MONET: *The Harbour at Zaandam.* 1871. Oil on canvas. France, Private Collection

Steam and Speed in the National Gallery —
and one of the Crystal Palace, at the site
near Sydenham to which it had been moved
after the Great Exhibition of 1851. Monet,
for his part, painted several pictures of
Hyde Park, as well as views of the river, a
subject also treated by Daubigny. *The
Thames below Westminster* (Plate 89) is re-
markable for its simplicity. The hazy grey
atmosphere of the city led Monet to con-
ceive of the scene in almost two-dimen-
sional terms, like a Japanese print, with the
bridge, the river tugs, the wooden pier and
the pinnacled structure of the Houses of
Parliament appearing in silhouette. At the
London museums and galleries, the two
Frenchmen became acquainted with the
work of the English landscape painters —
above all Turner, Constable and Crome —
which greatly impressed them, although
they later criticized Turner's romantic ex-
cesses. The city too made a powerful impact
on them, as it had previously on other
French painters, including Géricault,
Delacroix and Daubigny. Their pictures of
London are among their first thoroughly
urban subjects; the smoke of trains and
tugs, from which earlier landscape painters
had turned in horror, casts an atmospheric
veil which is the source of great beauty.
How greatly the two artists were entranced
by the city is shown by the fact that both
returned in old age to paint the same sights,
and to recapture the poetry of light per-
ceived through a shroud of fog and smoke.

Although both painters worked hard
during that first stay in London, Durand-
Ruel had no success in selling their works,
and when they submitted pictures to the
Royal Academy exhibition, they were re-
jected. England was no more ready than
France for the innovations they made, and
in June 1871 a disillusioned Pissarro re-
turned with his family to Louveciennes,
having just married Julie, his companion
and mother of his children, at Croydon.
Monet left for Holland, where he continued
at Zaandam to study reflections of light on
water, and revelled in the brightly painted
houses (Plate 90).

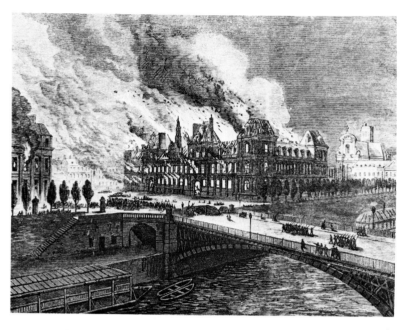

91
The Burning of the
Hôtel de Ville, Paris.
Engraving from the
Illustrated London News,
10 June 1871

92
GUSTAVE COURBET:
*Communards imprisoned
at Versailles.* Sheet from
a sketchbook. 1871.
Charcoal. Paris, Musée
du Louvre

93
The Fallen Column in
the Place Vendôme,
Paris. Engraving from
the *Illustrated London
News*, 27 May 1871

94
GUSTAVE COURBET:
*Self-Portrait at Sainte-
Pélagie. c.* 1873–4. Oil
on canvas. Ornans,
Musée Gustave Courbet

In France, the cessation of war had failed
to put an end to the country's misfortunes.
Alsace and Lorraine were lost, and an in-
demnity of five milliard francs was owed.
Then in March 1871 a newly elected
National Assembly headed by Thiers ga-
thered at Versailles, and Paris, angry at
the country's defeat and the conservative
measures of the new administration, rose
up in rebellion. The Paris Commune lasted
less than three months but it involved
France in bitter and bloody civil war.
Largely a workers' uprising, it stood for
social and political reforms, and for the
continuation of the war with Prussia. But
the war was to be with their own country-
men, and on both sides the executions and
reprisals were vast in number. The Com-

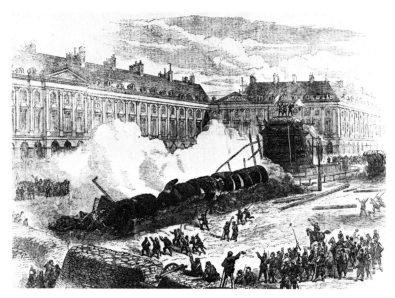

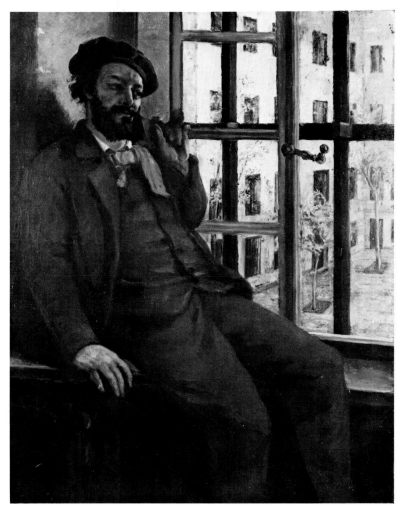

munards, however, were undisciplined and divided among themselves and stood no chance against the troops of the Versailles government, augmented in strength by newly returned prisoners of war. In the middle of May, when troops began to enter the city, the mob lost control; hostages were executed and buildings were set alight — among them the Tuileries palace and the Hôtel de Ville (Plate 91). But the Commune had fallen and in the repression that followed many thousands were executed, imprisoned or deported (Plate 92). It was a shocking outcome. In a letter to Pissarro, Théodore Duret, who himself had narrowly escaped execution, wrote, 'dread and dismay are still everywhere in Paris. Nothing like it has ever been known.'

Among those imprisoned was Gustave Courbet. During the war with Prussia he had been president of a commission to protect the nation's art treasures. He subsequently refused the *Légion d'honneur* and under the Commune was made president of a general assembly of artists, in which capacity he abolished most of the official art institutions, including the Academy and the Ecole des Beaux-Arts, as had Jacques-Louis David in similar circumstances after the 1789 revolution. Less fortunate than David, Courbet was with the losing party. Following the fall of the city he was arrested and convicted for his part in the destruction of the Vendôme Column — a symbol of Empire demolished by the Communards (Plate 93) — and imprisoned first at Versailles and later at the prison of Sainte-Pélagie (Plate 94).

Few of the Impressionists were in Paris during these stormy months. Monet and Pissarro were still out of the country; Degas was staying with his friends the Valpinçons on their country estate; Berthe Morisot and her family were in Saint-Germain with Puvis de Chavannes; and until the last days of the Commune, Manet was with his family in the south. In Paris, however, at the end of May, he witnessed the entry of government troops and the slaughter of the rebels on the barricades, recording the

event in a drawing and a lithograph (Plate 95). Renoir was trapped in the city when the insurrection began. Communards seized him as he painted by the river, convinced that he was a spy. But as they took him away to be shot, he caught sight of Raoul Rigaud, the Republican journalist he had succoured at Marlotte, now Police Commissioner of the Commune. Rigaud intervened, saved his life and gave him a pass to permit him to join his mother at Louveciennes in safety. Subsequently Renoir's friend in the other camp, Prince Bibesco, gave him a similar safe-conduct to allow him to cross the line of the Versailles troops. With these two passes Renoir was able to move freely between Paris and the country, leading a charmed life and without compromising himself with either party, for the duration of the Commune.

The disaster of the Commune so soon after the Franco-Prussian War dimmed the glory of the Third Republic. But since its most dangerous political opponents, the leaders of the extreme left, were either imprisoned or deported, the new regime was strong, and the enormous reparations imposed on the country by Prussia were paid by public subscription in a very short time. Nevertheless France had changed. The Imperial Court, which had attracted so much criticism, but which had also added lustre to the country's image during the 1850s and 1860s, was gone, and a country which since 1815 had suffered virtually no defeat in war, had to come to terms with a less glorious role in European affairs.

Circumstances had changed among the Impressionists too. Bazille was dead, and Sisley was ruined. The collapse of the family business during the war was followed by the death of his father. Henceforth he was to be as desperately needy as Monet and Pissarro, and suffer from the lack of popularity of his work. He isolated himself increasingly from other people, and immersed himself in his painting.

When Monet returned to Paris from Holland at the beginning of 1872, he and Boudin visited Courbet, who, a sick man now his hour of glory was past, was staying with a doctor at Neuilly. The decision of the Civil Tribunal of the Seine to charge the artist with the costs of the re-erection of the Vendôme Column, some 250,000 francs, was to be the final blow and drove the broken man into exile in Switzerland, where he died in 1877.

In spite of the grave effects of the war and the Commune, the 1870s were to start favourably for the reassembled band of painters. Monet and Pissarro brought with them the news of Paul Durand-Ruel's enthusiastic commitment to their work, and when they introduced Sisley and Degas to the dealer he immediately purchased pictures from them. The alacrity of this forty-year-old businessman (Plate 97) to ally himself with such uncompromising artists is surprising. 'A respectable middle-class man, a good husband, an ardent royalist, and a practising Catholic,' Renoir described him. But by his courageous support of the Barbizon painters at a time when no one would buy their pictures Durand-Ruel had already proved how discerning and

95
EDOUARD MANET: *The Barricade.* 1871. Ink and watercolour. Budapest, Museum of Fine Arts

96
EDGAR DEGAS: *The Dance Foyer at the Opéra,* Rue Le Peletier. 1872. Oil on canvas. Paris, Musée d'Orsay

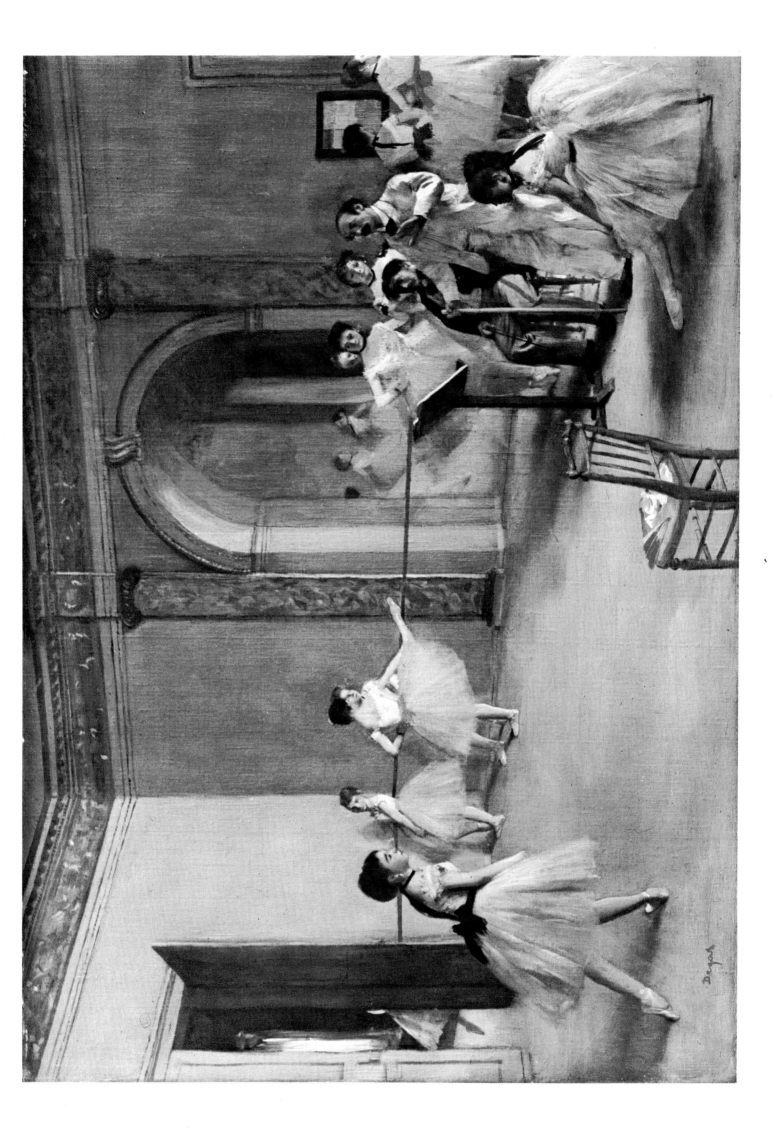

far-sighted he could be. He recognized in Monet and his friends the successors of Corot, Rousseau, Diaz and Millet, and was prepared to risk everything in promoting their work. 'A true picture dealer', he said, 'should also be an enlightened patron.' He was to remain faithful to the much-abused Impressionists through many reverses; almost twenty years later, when recognition and increasing popularity at last arrived, he was able to reap the rewards of his constancy.

Durand-Ruel's support was of the utmost importance for the Impressionists, and permitted them to pursue their own course irrespective of the views of the Salon jury and the band of conservative critics. Perhaps because of his purchases, Monet, Pissarro, Sisley and Degas submitted nothing to the 1872 Salon. They were represented, however, in the exhibitions in Durand-Ruel's new London show-room, and Durand-Ruel also bought from Renoir (whom he met in March 1872) and from Manet. His interests in landscape painting may at first have prevented him from serious consideration of Manet's work. But when early in 1872 he visited Manet's studio, led there by admiration of a couple of his pictures he had seen in the studio of Alfred Stevens, he purchased everything the painter had to show him, twenty-three canvases for a total of 35,000 francs.

Manet, an artist who was morbidly sensitive to criticism, found Durand-Ruel's support invaluable. Further encouragement followed when *Le Bon Bock*, a picture inspired by Frans Hals, whom Manet had studied in Holland during a visit in 1872, achieved a great success at the Salon of 1873. It was purchased by Faure, a leading baritone at the Paris Opéra, who also bought *Lola de Valence* and the *Déjeuner sur l'Herbe* from the artist, and was to become a major collector of Impressionist paintings.

For Degas also, the post-war period was especially fruitful. It was at this time, in 1871 and 1872, that he began to paint his first pictures of ballet dancers, studying them in performance from the wings of the

97
MARCELLIN DESBOUTIN:
Portrait of Paul Durand-Ruel. 1882. Paris,
Bibliothèque Nationale,
Cabinet des Estampes

stage of the Opéra, or at practice and at rest in the rehearsal rooms (Plate 96). Music offered as great an attraction for the painter as dance. His father's house was the constant venue of singers and musicians, among them a bassoonist in the Opéra orchestra, Désiré Dihau. With the assistance of Désiré, Degas was able to sketch without hindrance in the wings and orchestra pit of the Opéra, and the portrait of his friend is prominent in one of several canvases he painted of the orchestra (Plate 98), with the brilliantly lit dancers appearing above the musicians' heads. To the left of Dihau is the cellist Pillet, to the right the flautist Altès, and Gouffé, the double-bass player. In the box, top left, is the composer Chabrier. For Degas in particular it must have been a dreadful loss when the old opera house in the Rue Le Peletier, the scene of these early pictures, was destroyed by fire in 1873.

Degas was a frequent visitor at the house of Désiré Dihau and his sister Marie, a talented pianist and singer, whose portrait Degas painted on more than one occasion. It was at their house that he was introduced to Henri de Toulouse-Lautrec, a young

98
EDGAR DEGAS: *The Orchestra of the Paris Opéra.* 1868-9. Oil on canvas. Paris, Musée d'Orsay

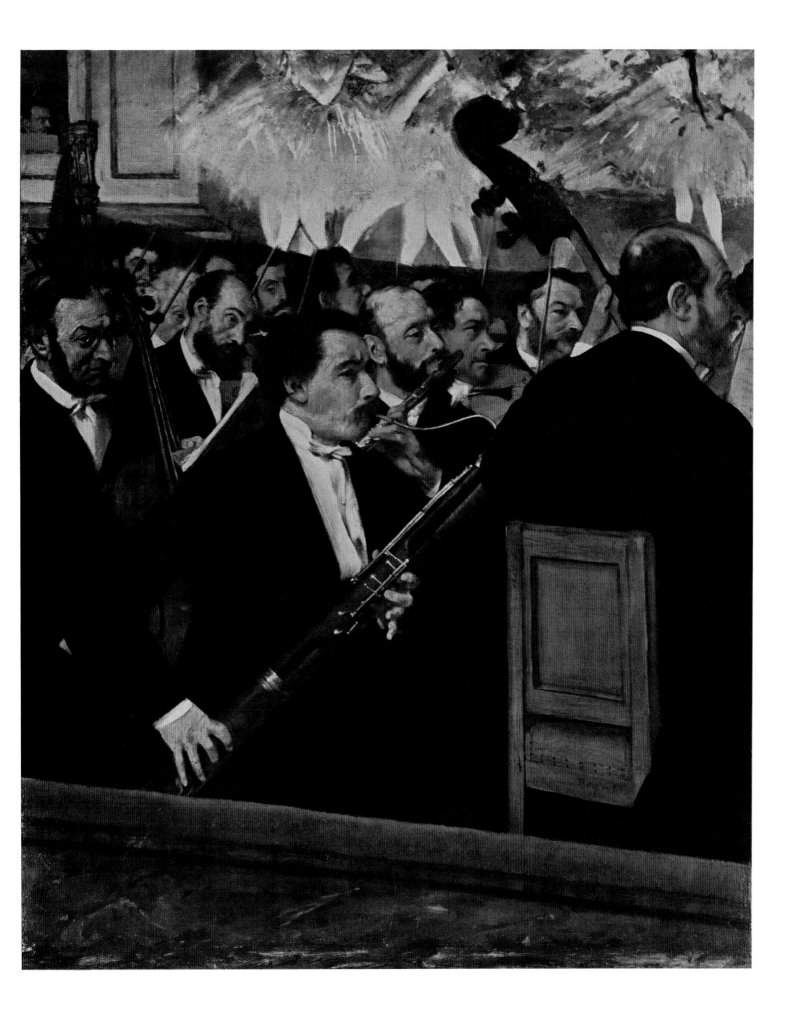

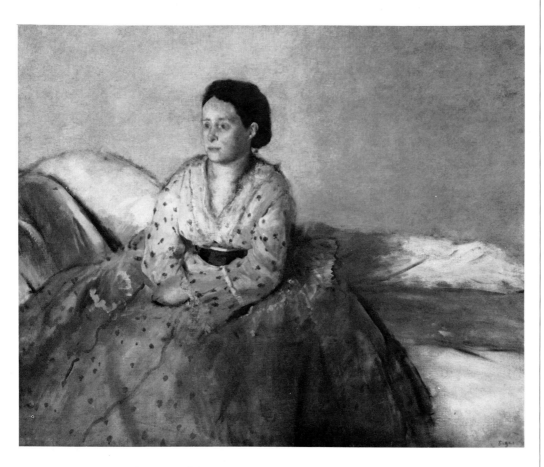

99
EDGAR DEGAS: *Estelle
Musson (Madame René
De Gas)*. 1872–3. Oil on
canvas. Washington,
National Gallery of Art

painter who was to be one of his greatest admirers and followers.

In the autumn of 1872, Degas made a visit to New Orleans, the home of his mother, where two of his brothers were involved in the cotton trade. While there, he painted one of the most significant canvases of modern life to date — a scene in the New Orleans Cotton Exchange (Plate 100). The business of nineteenth-century commerce is here transformed into material for art through Degas's extraordinary ability to observe clearly and capture so many subtle nuances of character, pose and gesture, and to avoid facile moralizing on the evils of industry and trade. Instead, his feeling for textures and shapes, for architecture, furniture, costume and the everyday effects of an office, give to the scene a visual coherence which defies analysis. Among the company of businessmen and clerks are the painter's uncle — seated in the foreground

— and his brother René, reading a paper. While in New Orleans, Degas painted other portraits of his relations, including one of Estelle Musson, his blind cousin (Plate 99), who was married to René. As the work of a man who was so often reserved and cruel towards others, it is remarkable for the great tenderness and sympathy with which it is painted.

Although he was captivated by the colourful sights of New Orleans, it became increasingly apparent to Degas that his art needed to stem from what he knew and understood intimately: 'One likes and one makes art only of that to which one is accustomed.' Consequently, on his return, he concentrated most of his energies on the study of a handful of motifs: dancers, horses and jockeys, laundresses, milliners and bathers. Working out of doors was a distraction to him, and he preferred to work in his studio in the Rue Blanche, where he

100
EDGAR DEGAS: *The Cotton
Market*. 1873. Oil on
canvas. Pau, Musée des
Beaux-Arts

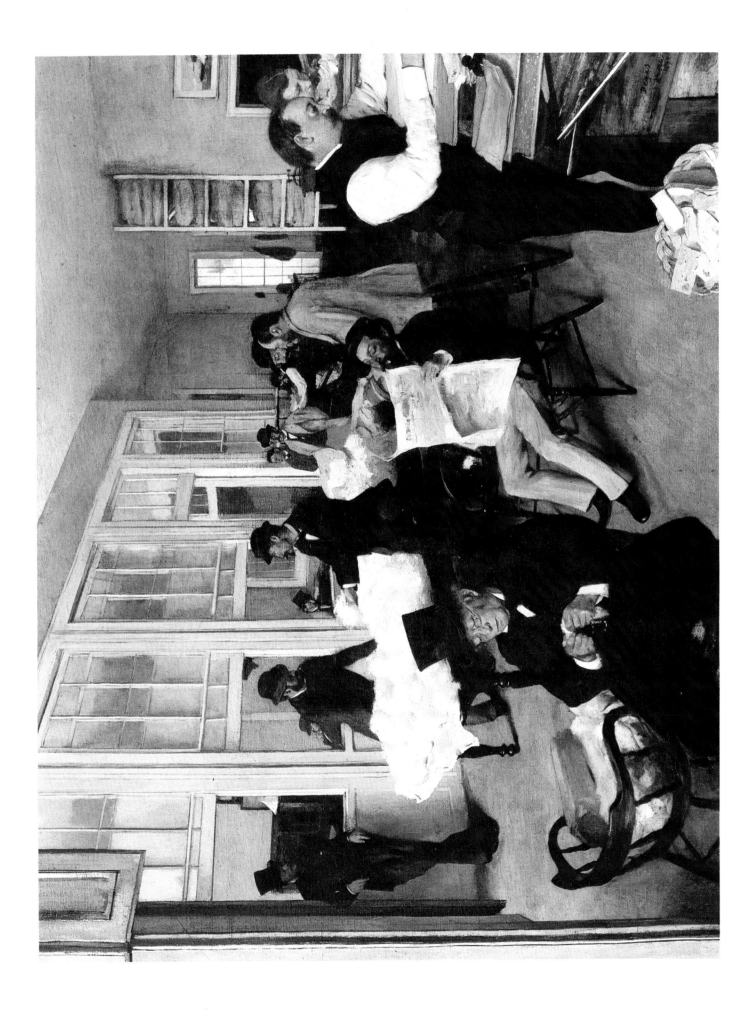

101 CAMILLE PISSARRO: *The Crossroads, Pontoise.* 1872. Oil on canvas. Pittsburgh, Museum of Art, Carnegie Institute

102 CAMILLE PISSARO: *Entry to the Village of Voisins*. 1872. Oil on canvas. Paris, Musée d'Orsay.

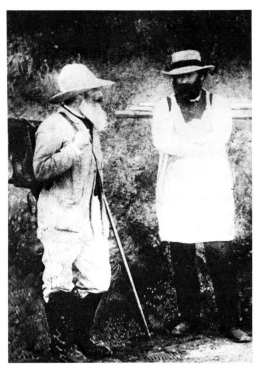

103
Camille Pissarro and
Paul Cézanne at Auvers.
1872–6. Photograph.
Paris, Viollet
Collection

104
Dr Paul-Ferdinand
Gachet. Photograph.
Amsterdam,
Rijksmuseum Vincent
Van Gogh

devoted himself to pictures which he could not bear to finish or to part with. The singer Faure had actually to take Degas to court when the artist failed to return some pictures which he had borrowed back for reworking.

While Degas pursued his studies in the studio, the others pushed further their *plein-air* researches. On his return to France, Pissarro settled with his family at Pontoise, where for the next ten years he was frequently to work in the company of Cézanne and Guillaumin. In the pictures he painted there (Plate 101), he achieved a new delicacy of touch, derived perhaps from greater familiarity with Monet's work, and combined this in such paintings as the *Entry to the Village* (Plate 102) with the strong sense of compositional structure which he had inherited from Corot. He found new buyers for his work, including Faure and the bankers Achille Arosa and Albert and Henri Hécht, and among his younger artist friends took on the role of teacher and adviser. Cézanne, who came to stay nearby at Auvers in 1872, especially

benefited from his advice, and his admiration for Pissarro's direct approach to nature was more than repaid by the older artist's confidence in him. 'Our friend Cézanne raises our expectations,' he wrote to the painter Guillemet, 'If, as I hope, he stays some time at Auvers, where he is going to live, he will astonish a lot of critics who were in too great haste to condemn him.' As they painted side by side in the lanes and fields around Pontoise (Plate 103), Cézanne adopted a more objective way of seeing, and harnessed his intense artistic sensibilities through the orderly analysis of structure and tonal values (Plate 105).

At Auvers, Cézanne was a close neighbour of Dr Gachet (Plate 104), a friend of Pissarro, who often looked to him for medical help for his family. The doctor, a former habitué of the Andler Keller and the Café Guerbois, was an ardent *amateur* of modern art, a practitioner as well as a collector. While continuing his medical practice in Paris, he had established his sick wife and two children at Auvers, and there pursued

105
PAUL CÉZANNE:
*Dr Gachet's House at
Auvers. c.* 1872. Oil on
canvas. Paris,
Musée d'Orsay

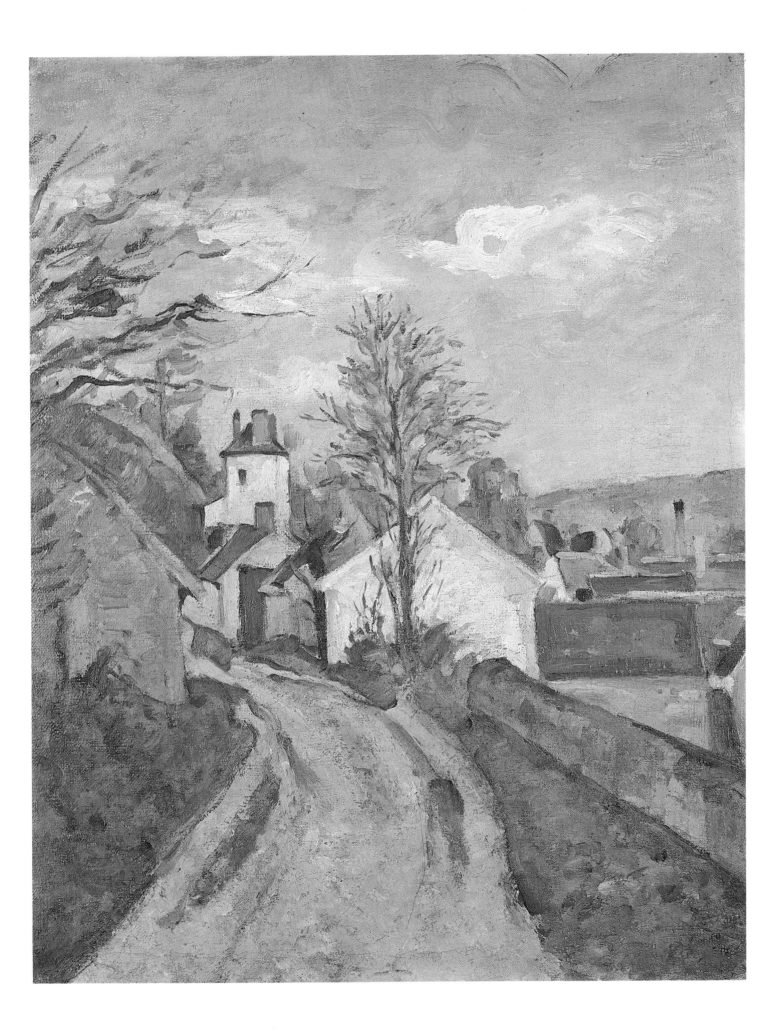

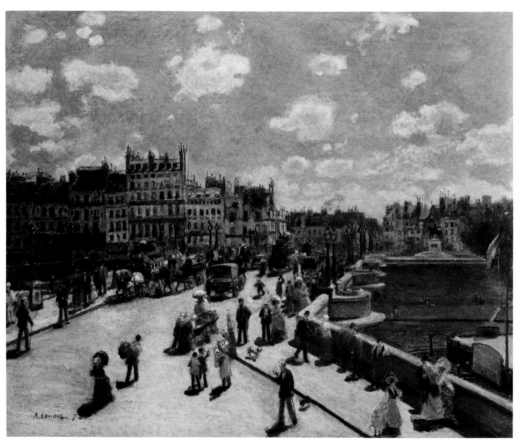

106
AUGUSTE RENOIR: *The
Pont Neuf.* 1872. Oil on
canvas. Washington,
National Gallery of Art

his artistic inclinations. He was parti-
cularly interested in etching and had
created a printing studio, which he wil-
lingly shared with Pissarro and Cézanne.
Through Pissarro, Dr Gachet also became
familiar with Monet, Renoir and Sisley,
and became a keen collector of their work.

Meanwhile Cézanne gained in control
and self-confidence. 'I am beginning to
consider myself stronger than all those
around me,' he wrote to his mother in 1874.

> I must always work, but not in order to
> achieve the polish which is admired by
> imbeciles. The finish which is commonly
> so much appreciated is really only the re-
> sult of handwork and renders all work re-
> sulting from it inartistic and common. I
> must strive to complete a picture only for
> the pleasure of giving added truth and
> mastery.

While Manet travelled to Holland, Degas
to America and Berthe Morisot to Spain,

and while Pissarro and Cézanne worked at
Pontoise and Auvers, Renoir remained in
Paris seeking buyers and commissions. He
continued to paint views of the city as
he had done before the war. At a café
overlooking the Pont Neuf, he found a
comfortable corner and for the price of a
cup of coffee stayed there for hours paint-
ing studies of the bridge (Plate 106). His
younger brother Edmond, a journalist and
defender of Impressionism in print, was his
constant companion and later recalled:

> From here Auguste dominated the bridge
> and, after having outlined the ground, the
> parapets, the houses in the distance, the
> Place Dauphine and the statue of Henri IV,
> took pleasure in sketching the passers-by,
> vehicles and groups. Meanwhile I scrib-
> bled, except when he asked me to go on the
> bridge and speak with passers-by to make
> them stop for a minute.

At which Renoir would hurriedly sketch

107
CLAUDE MONET: *The
Bridge at Argenteuil.*
1874. Oil on canvas.
Washington, National
Gallery of Art

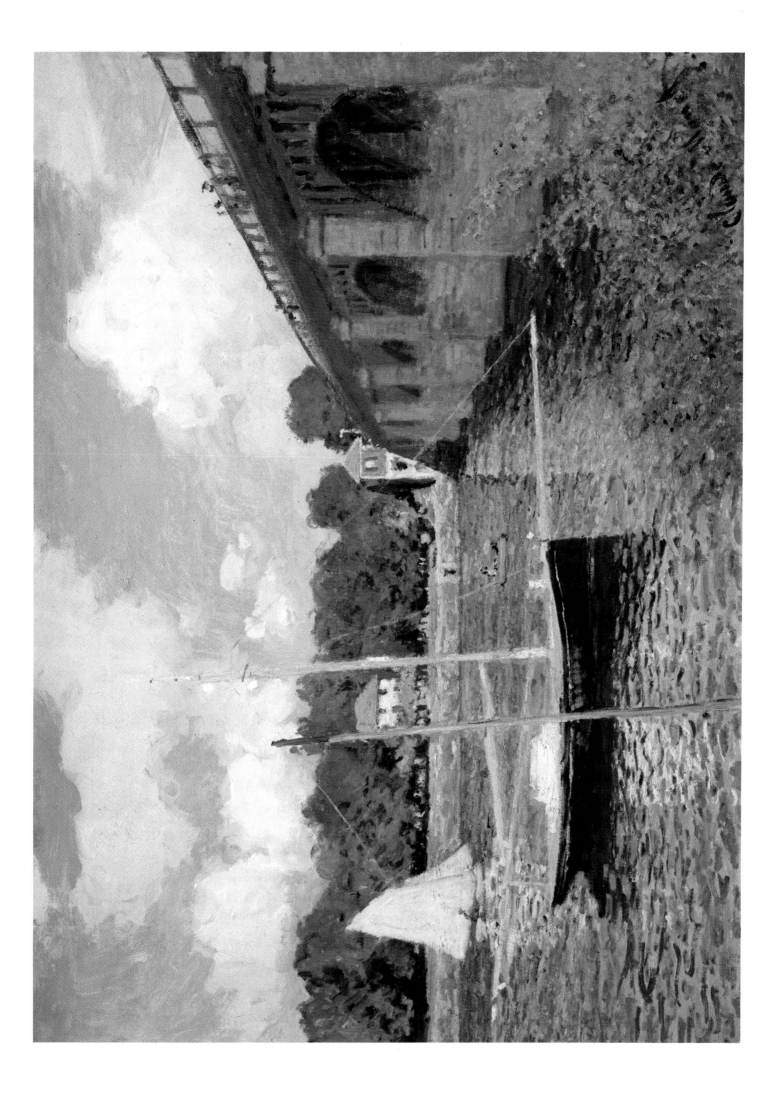

108
AUGUSTE RENOIR:
*Monet painting in his
Garden.* 1875. Oil on
canvas. Hartford,
Conn., Wadsworth
Atheneum

them in, no doubt including the figure of
Edmond several times in his pictures.

Renoir would also venture out of Paris to
paint in the company of his friends, work-
ing with Sisley in the spring of 1873 and
frequently joining Monet at Argenteuil. A
small town on the Seine above Bougival and
Chatou, Argenteuil became a centre of
great importance for the Impressionists in
the years following the war, principally be-
cause of Monet's ascendancy as the leader
of the group. He had moved there in 1872
with his family, and was often visited by
Renoir, Sisley and Manet, who owned a
property across the river at Gennevilliers.
In the pictures painted at La Grenouillère,
in London and in Holland, Monet had
developed the Impressionist technique of
small touches of pure high-keyed colour.
He now employed it with masterly as-
surance on the abundance of subjects that
presented themselves at his new riverside
location: the river itself in its many aspects,
traversed by road and rail bridges (Plate
107), bordered by footpaths and houses
(Plate 109), and busy with pleasure craft,
and the colourful garden of his house. So
effective was this style in capturing the
light and atmosphere of a given moment,
that the others rapidly picked it up too,
modifying it according to their own tem-
peraments, but nevertheless aiming for the
same luminosity, the same ease and the
same mood of unforced lightheartedness.
Sisley, in particular, came very close to
Monet's manner in the pictures he painted
at Argenteuil (Plate 111). Pissarro, in a
letter to Théodore Duret, defined it thus: 'a
highly conscious art based upon observa-
tion and derived from a completely new
feeling; it is poetry through the harmony of
true colours.'

109
CLAUDE MONET:
Argenteuil. 1872. Oil on
canvas. Washington,
National Gallery of Art

110
EDOUARD MANET:
*Banks of the Seine at
Argenteuil.* 1874. Oil on
canvas. London, Private
Collection (on loan to
the National Gallery,
London)

Especially close was the little group of Monet, Renoir and Monet's wife Camille, who often posed for both painters, in the house and out of doors. Renoir also painted portraits of Monet himself at Argenteuil, including one of him at his easel in the garden (Plate 108). A marvel of Impressionist technique, conveying all the sparkling atmosphere of the sunlit suburban garden, this picture is also a worthy testament to the leadership provided by Monet, who produced some of the most joyous, clear-sighted paintings of the century in such simple surroundings as these.

In 1874 trouble with his landlord forced Monet to move, and Manet helped him to find other lodgings in Argenteuil. Enchanted like the others by the spell of his friend's painting, Manet joined the group at Argenteuil that summer, painting out of doors. Since before the war he had been seeking greater truth to atmosphere in his work and in 1869 had painted in the open at Boulogne, sketching the beaches and the crowds on the cross-Channel steamers. He now adopted the rapid technique of broken brushstrokes and the brighter palette of Monet in painting views of the river. The woman and child in *Banks of the Seine at Argenteuil* (Plate 110) are very probably Camille and little Jean. On one occasion he arrived at Monet's house while Renoir was painting mother and son seated on the grass in the garden (Plate 112), and borrowing paints and canvas from Monet, he too sketched the scene with great verve, including the person of Monet tending his garden (Plate 113). The latter recalled that Manet kept eyeing Renoir's picture and whispered to Monet, no doubt in jest, that the 'boy' had no talent at all and ought to give up painting.

Manet's Argenteuil pictures differ from Monet's in being principally studies of figures in the open, rather than atmospheric landscapes. One shows a man and a woman in a boat, viewed from above against the surface of the water, with the edge of the sail cutting the corner of the canvas (Plate 114). The simplicity of the composition is striking, and gives a flat, Japanese-like effect, which is enhanced by the bold contrast of large areas of blue, white and dark brown. The man at the tiller may be the Baron Barbier that Monet and Renoir had known at La Grenouillère, who was a friend

111
ALFRED SISLEY:
Footbridge at Argenteuil.
1872. Oil on canvas.
Paris, Musée d'Orsay

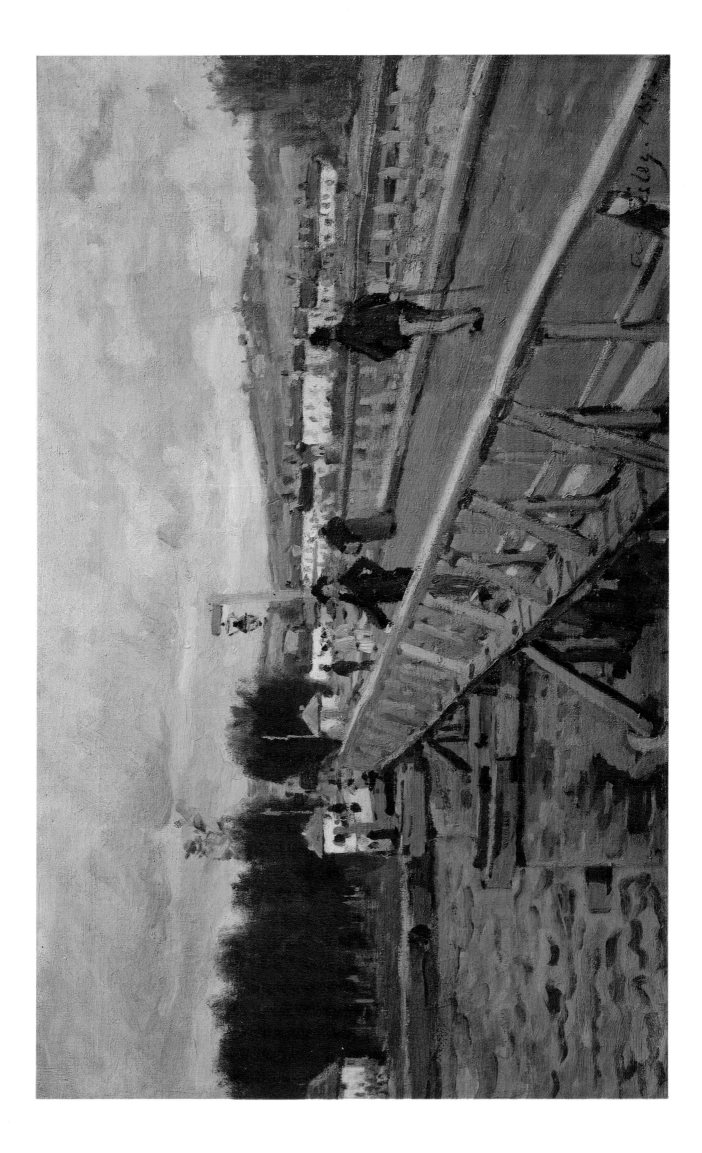

112 AUGUSTE RENOIR: *Madame Monet and her son, Jean.* 1874. Oil on canvas. Washington, National Gallery of Art

113 EDOUARD MANET: *The Monet Family in their Garden.* 1874. Oil on canvas. New York, The Metropolitan Museum of Art

114 EDOUARD MANET: *Boating*. 1874. Oil on canvas. New York, The Metropolitan Museum of Art

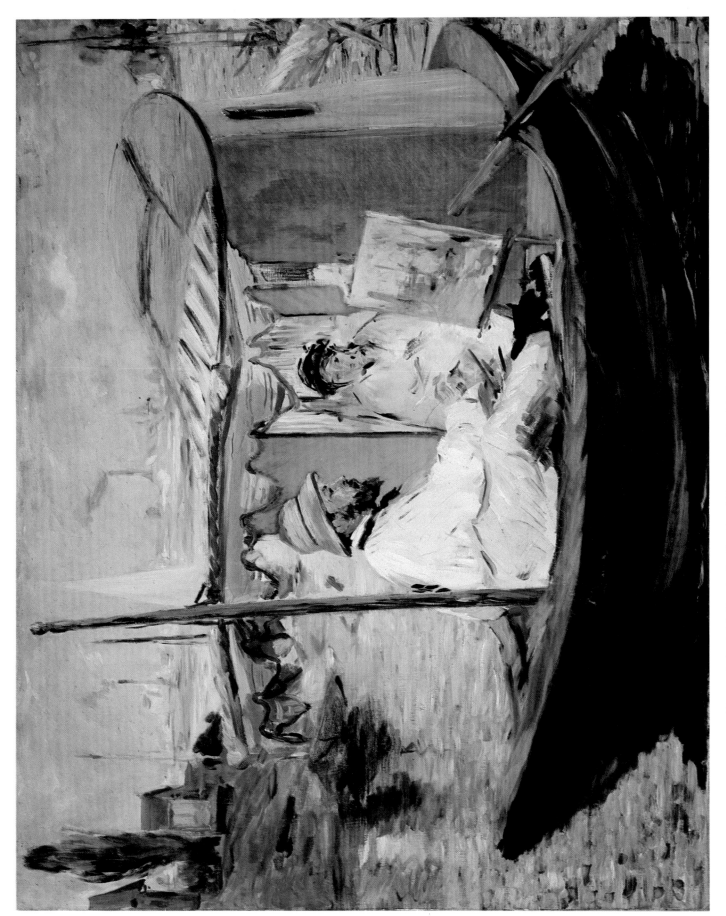

115 EDOUARD MANET: *Monet painting in his Floating Studio.* 1874. Oil on canvas. Munich, Bayerische Staatsgemäldesammlungen, Neue Pinakothek

of Maupassant. A similar, rather more sketchy picture of Monet painting on a boat with Camille seated near him (Plate 115) shows how many of Monet's pictures of the river were in fact achieved — from close quarters, actually floating in a boat on the river surface. The boat was specially constructed, no doubt in imitation of Daubigny's floating studio, with which Monet was familiar. It has often been said that Monet was helped in its construction by the painter Gustave Caillebotte. But Caillebotte, a pupil of Bonnat, who travelled in Italy with de Nittis in 1872, did not work at Argenteuil until after 1880, when he bought a large house at Petit-Gennevilliers nearby. He was introduced to Monet and Renoir in about 1874 by Degas and Lepic (whose social equal he was), and through these new friendships became passionately involved with the Impressionist cause. He exhibited with them from 1876 and began eagerly to collect their works, amassing probably the finest Impressionist collection of his time. A single man, modest, sensitive and wealthy, he provided invaluable support to his friends, filling the role of artist-companion and patron left vacant since Bazille's death.

Although on occasions he worked at Argenteuil, Sisley's preferred haunts were Bougival, Louveciennes and Marly. Nevertheless, his paintings of the early 1870s come closer to Monet's than those of any other Impressionist. He did virtually nothing but landscapes and rarely included more than one or two figures. The quiet, unspectacular tenor of his work may account for the lack of demand for his pictures and their low prices, but underestimated though he was, Sisley consistently succeeded at this time in conveying with the greatest delicacy and subtlety the exact qualities of atmosphere of a particular scene; the serene calm of a summer's day by the river (Plate 116), the overcast skies above the hills at Marly (Plate 117), and autumn mist in a kitchen garden, where the damp air still half-obscures the sunlight (Plate 118). It is not surprising, considering these pictures, that Sisley preferred to work alone. They are the result of quiet contemplation of nature. What they lack of Monet's boldness is more than compensated for by intensity of feeling, by a kind of joy of perception that is conveyed in the deft and harmonious placing of colours, so that skies glow, shadows vibrate with reflected light, and rivers shine with a glassy translucence.

116
ALFRED SISLEY:
The Île Saint-Denis.
1872. Oil on canvas.
Musée d'Orsay

117 ALFRED SISLEY: *Louveciennes. Hill-tops at Marly.* 1873. Oil on canvas. Musée d'Orsay

118 ALFRED SISLEY: *Misty Morning*. 1874. Oil on canvas. Musée d'Orsay

5 Exhibitions and Collectors

By the early 1870s the Impressionists had been pursuing their careers as painters for at least ten years. In 1874 Degas was forty, Manet forty-two, and Pissarro forty-four and the father of five children. Yet for most of them the years of struggle were far from over. The press remained hostile and their pictures were still rejected by the Salon. The year 1873, which saw the success of *Le Bon Bock*, also witnessed a large number of rejections and, as a result of the storm of protests, a revival of the Salon des Refusés. Although Monet, Sisley and Pissarro had not submitted anything, Renoir, Jongkind, Eva Gonzalès and Henri Rouart were among those rejected.

The continuing resistance of the Salon to new tendencies made it difficult for the Impressionists to find the buyers they so badly needed. Only a few dealers were prepared to handle their works and, without a sure market, would only pay low prices. Père Martin had dealt with them since before the war, but had little faith in what they produced and offered derisory sums. In 1874 he objected to Pissarro's 'heavy common style' and refused to handle him anymore. Père Tanguy (Plate 119), a more sympathetic dealer, but a man of small means, seldom sold what he acquired. Before the war he had been a travelling colour-grinder and salesman, and a familiar figure among the artists at Barbizon and Marlotte. He fought with the Communards, was subsequently condemned, and was only spared from execution at the intervention of Henri Rouart. For a time he was deported; on his return to Paris he set up a shop in the Rue Clauzel. On Pissarro's recommendation, he agreed to accept Cézanne's work — for which there

was virtually no market at all — in exchange for materials, and he regularly did the same for others, not having the means to do more.

The dealer in whom all the Impressionists placed their hopes was Durand-

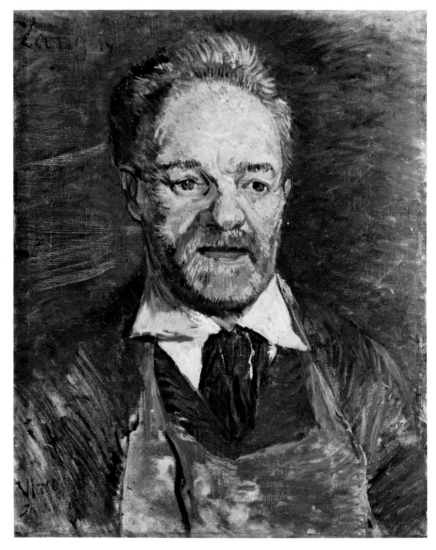

119
VINCENT VAN GOGH:
Père Tanguy. 1887. Oil on canvas. Copenhagen, Ny Carlsberg Glyptotek

Ruel. Although buyers were few, he was prepared to pay good prices and show their works, trusting that the tide would eventually turn. In 1873 he compiled a huge illustrated catalogue in three volumes of the finest works in his possession, which included pictures by Manet, Monet, Pissarro, Sisley and Degas, as well as the established masters of the Barbizon school. The poet and critic Armand Silvestre contributed an introduction, which argued that the Impressionists were perpetuating a tradition founded by Corot, Courbet and the Barbizon school. He was careful to distinguish between the members of the group. 'M. Monet is the most adept and daring, M. Sisley the most harmonious and hesitant, M. Pissarro the most genuine and naive,' he wrote. 'What apparently should hasten the success of these newcomers is that their pictures are painted according to a singularly cheerful scale. A ''blond'' light floods them, and everything in them is gaiety, clarity, spring festival.'

While Silvestre's analysis was acute, his forecast of a speedy success proved false. The general economic recovery that had followed the peace of 1871 was succeeded in 1874 by a depression, and Durand-Ruel was forced to suspend his purchases. Furthermore, instead of winning support for his new artists, his recent activities had only lost him the custom of former clients, who no longer trusted his judgement.

It was under these circumstances that Monet took up the idea of holding an independent exhibition of the Impressionists — as they were shortly to be christened. The idea was not new. Monet and Bazille had considered it in 1867, when the Salon jury had again been arbitrary and severe. 'It is really too ridiculous for a considerably intelligent person to expose himself to administrative caprice,' Bazille had written to his mother. 'A dozen talented young people agree ... We have therefore decided that each year we will rent a large studio where we will exhibit our works in as large a number as we wish.' Support was promised from Courbet, Corot, Diaz and Daubigny, but the scheme foundered through lack of funds.

An independent exhibition was a risk. Buyers still had to be found. But the relatively high prices fetched by some of their works at the auction, early in 1874, of the collection of Ernest Hoschedé, director of a Paris department store, were encouraging, and Monet found plenty of support for the scheme among his friends. There was also the problem of who should exhibit, and whether the exhibition might seem to the public like another Salon des Refusés. They resolved to boycott the Salon and open before it, on 25 April 1874, and at Degas's insistence they recruited some established names to lend the show respectability and credibility. The exhibition was held in a grand suite of rooms just vacated by the photographer Nadar on the second floor of a building in the Boulevard des Capucines (Plate 120), which he lent them without charge. Thirty artists participated in what was cautiously promoted as the exhibition of 'An Anonymous Society of Painters, Sculptors and Engravers etc.' Monet, Renoir, Pissarro, Sisley, Degas, Berthe Morisot and Guillaumin were among the founding members of the Society and its principal organizers. Other participants included Degas's friends Vicomte Lepic, Henri Rouart (Plate 121) and Félix Bracquemond, the engraver, and Pissarro's friend Béliard. Among the more established exhibitors were the landscape and genre painter Félix Cals, the fashionable Italian painter de Nittis, the sculptor Ottin, and Monet's old friend Boudin. The most surprising absentee was Manet, whom press and public had long identified as the leader of the gang of rebels. He refused to exhibit with Cézanne, and believed that the Salon was the only true testing ground, as did his friend Théodore Duret. Abstention from that, he believed, was an admission of defeat. Furthermore, as an artist covetous of official recognition and honours, he still recognized the authority of the Salon.

Other painters, less closely associated with the group than Manet, also refused to

join the rebels for fear of being dubbed such themselves. Fantin kept well clear, and Degas's friends Tissot and Legros declined his invitations to participate. Guillemet also declined, and Corot, who disagreed with the recent tendencies of Monet and Pissarro, wrote to him approvingly, 'you have done very well to escape from that gang'.

In the event the pessimists were proved right. The press was either hostile, mocking or indifferent, sales were few, and the whole enterprise was a financial flop. The very term 'Impressionists', with which they were dubbed, was coined for a satirical and scathing review, entitled 'Exhibition of the Impressionists', in the *Charivari*. In the review, the influential critic Louis Leroy describes the appalling effects of the exhibition on his companion M. Vincent, an elderly and much-honoured landscape painter. He finds the legs of Renoir's *Dancer* (Plate 122) as cottony as her skirts; he can make no sense of the 'innumerable black tongue-lickings' representing crowds of people in Monet's *Boulevard des Capucines* (Plate 123); and 'the stupendous impasto' of Cézanne's *House of the Hanged Man* (Plate 124) makes him delirious. Finally the old man, driven completely insane, cries out, 'Hi-ho! I am impression on the march, the avenging palette knife, the *Boulevard des Capucines* of Monet, the *House of the Hanged Man* and *Modern Olympia* of Cézanne. Hi-ho! Hi-ho!'

The name 'Impressionists' was taken by Leroy from one of Monet's pictures, a misty view of Le Havre harbour, called *Impression: Sunrise* — a title apparently chosen in haste for the catalogue. However, the term 'Impression' was not in fact new. It had been used to describe the effect of pictures of the Barbizon school, especially Daubigny, and Manet himself had used it of his own work. Leroy, however, turned it into a term to describe and deprecate a movement. It was immediately taken up by all parties. Days after the appearance of the offending article, Castagnary, reviewing the exhibition in *Le Siècle*, wrote:

The common concept which united them as a group ... is the determination not to search for a smooth execution, but to be satisfied with a certain general aspect ... If one wants to characterize them with a single word that explains their efforts, one would have to create the new term of Impressionism. They are impressionists in the sense that they render not a landscape but the sensation produced by a landscape.

If the exhibition won the Impressionists a name, it gained them little else, other than

120
Nadar's studio, 35 Boulevard des Capucines, where the first Impressionist exhibition was held. Photograph by Nadar. Paris, Bibliothèque Nationale, Cabinet des Estampes

121
EDGAR DEGAS: *Portrait of Henri Rouart.* 1875. Oil on canvas. Pittsburgh, Museum of Art, Carnegie Institute

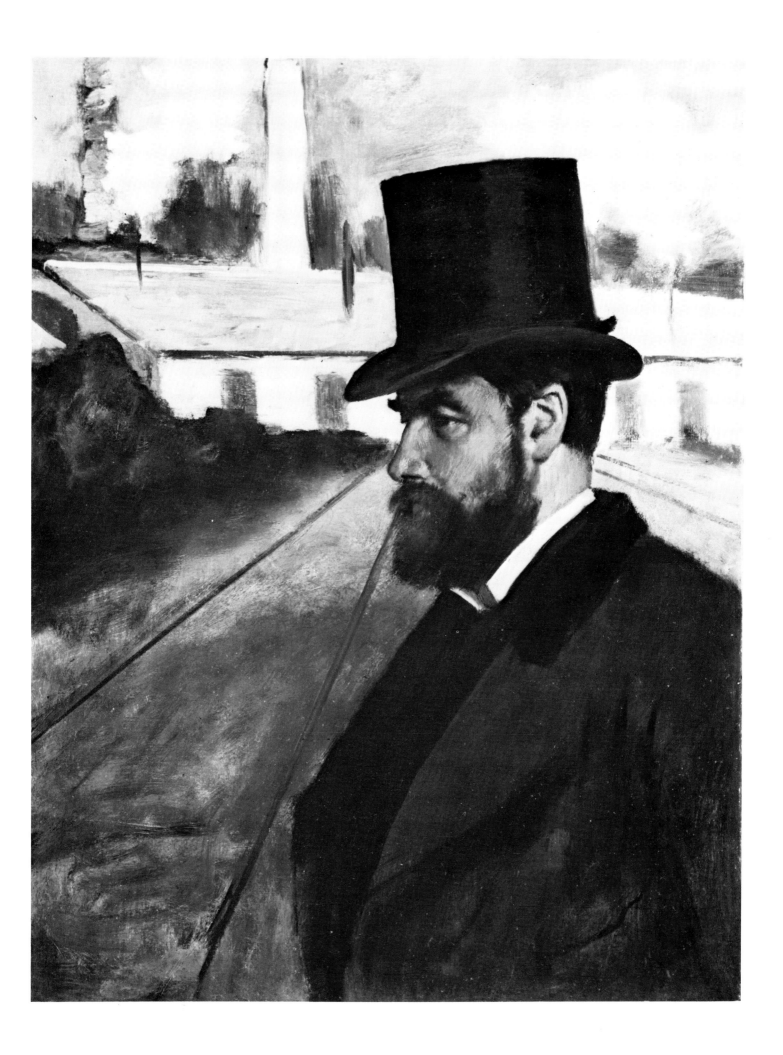

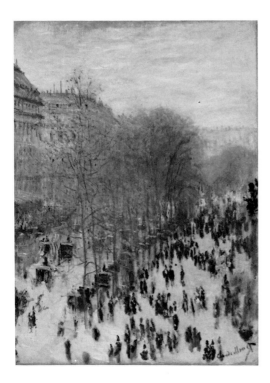

notoriety. The press was full of jibes, and over and over again it was Cézanne and Monet, the least compromising of all, who got the worst of it. The adverse publicity was not in itself such a disaster. The Impressionists were talked about and people came to the exhibition — if only to poke fun — but its material effects were grave. It could serve only to discourage potential buyers, and indeed few works were purchased. Boudin, Degas and Berthe Morisot sold nothing at all, even though the show included some of Degas's earliest and most finely executed ballet scenes, and one of Berthe Morisot's most beautiful pictures, *The Cradle* (Plate 125), depicting in delicate harmonies of black and white her sister, Edma Pontillon, watching over her new-born baby. Renoir did little better, failing to find a purchaser for *La Loge* (Plate 127), perhaps his first indubitable masterpiece. It depicts his brother Edmond and a new model called Nini seated in the box of a theatre, but it represents far more. Renoir here achieves the full expression of the Baudelairian ideal of modern beauty, the celebration of the attractions of a sophisticated *femme du monde*, décolletée,

122 *Above left*
AUGUSTE RENOIR:
The Dancer. 1874. Oil on canvas. Washington, National Gallery of Art

123 *Below left*
CLAUDE MONET:
The Boulevard des Capucines. 1873. Oil on canvas. Kansas City, Missouri, Nelson Gallery–Atkins Museum

124 *Above right*
PAUL CÉZANNE:
The House of the Hanged Man, Auvers. 1873–4. Oil on canvas. Musée d'Orsay

125
BERTHE MORISOT:
The Cradle. 1873. Oil on canvas. Musée d'Orsay

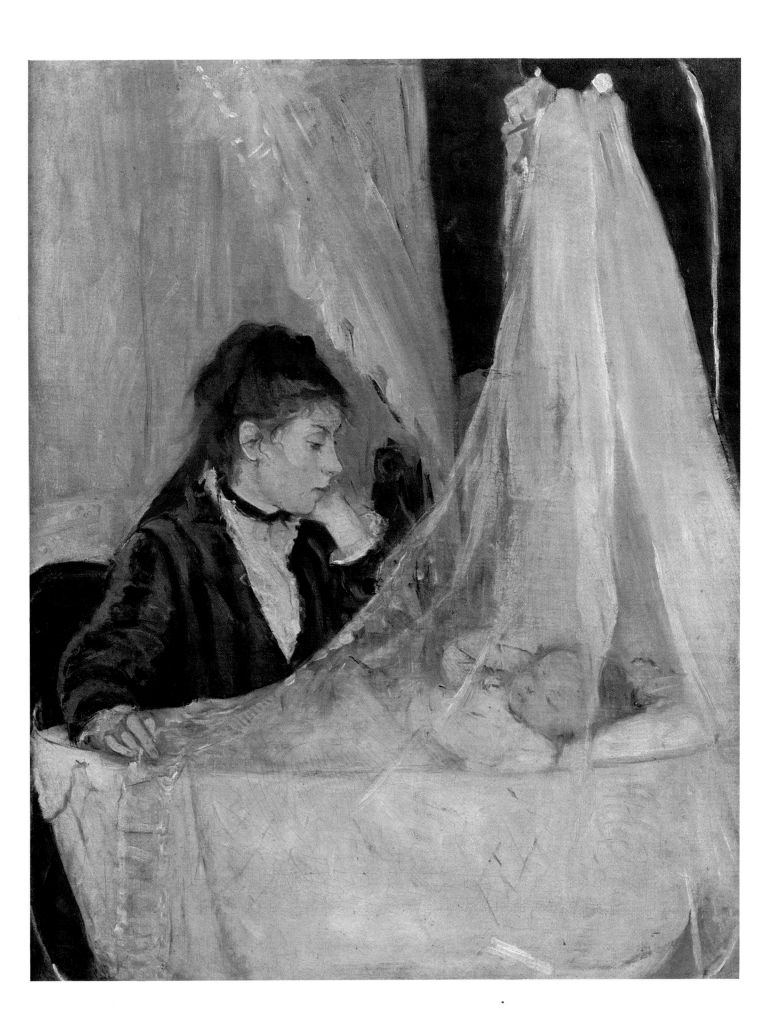

bejewelled, and fashionably attired in rich and splendid fabrics. Yet no one was prepared to pay the asking price of 500 francs, and only after a struggle did Renoir manage to persuade a reluctant Père Martin to give him 425 francs for it.

Hostile criticism, at a time of economic depression, was a threat to sales, and also to morale. But in spite of the widespread lack of understanding of their aims, the Impressionists continued to work hard together, depending all the more on each other for support and friendship. In 1875 they tried another scheme to raise money and win esteem. Remembering the success of the Hoschedé sale, they organized an auction at the Hôtel Drouot. Renoir, Monet, Sisley and Berthe Morisot contributed pictures, and Manet appealed to Albert Wolff, the influential critic of *Le Figaro*, to write a word of support for the venture. Wolff, who was renowned for his caustic wit, responded in print: 'the impression which the impressionists achieve is that of a cat walking on the keyboard of a piano or of a monkey who might have got hold of a box of paints.'

The auction was an unqualified disaster, and provoked such an outcry that the police had to be summoned to control the crowd. The bids were scarcely high enough to cover the cost of frames, and half of Renoir's pictures failed even to reach a hundred francs. The artists themselves — and Durand-Ruel, who acted as official expert — were forced to buy back many pictures which would otherwise have been knocked down for next to nothing. There were of course some buyers present, but their numbers were too few to push the prices up. Indeed, the crowd was incensed by the bidding and tried to obstruct the sale. Among the band of supporters were Rouart, Hecht, Monet's patron Houssaye, the critic Chesneau, Ernest Hoschedé, and Eugène Manet who bought back certain works by his wife, Berthe Morisot. Also present was the leading publisher Georges Charpentier, who bought Renoir's enchanting little *Fisherman* (Plate 129) for 180 francs, a purchase

which was to mark the beginning of his highly fruitful association with the Impressionists, and Renoir in particular.

It was vital for Renoir, Monet, Pissarro and Sisley to sell their works if they were to be able to continue painting. In a letter to a collector written in 1875, Monet begged for help complaining that once again he was threatened with eviction. 'Once on the street and with nothing left, there will only be one thing for me to do: to accept an employment, whatever it may be. That would be a terrible blow.' On such occasions it was the wealthier members of the group who came to the rescue. Manet bought pictures from his friends, especially from Monet and Sisley, and in 1877, when Monet's fortunes were again at a low ebb and Camille was expecting a second child, Manet devised a scheme to help him. He agreed to pay him 1000 francs 'against merchandise', and this enabled Monet to clear his debts and rent a house at Vétheuil, further down the Seine. Pissarro repeatedly applied to his painter friend Piette for assistance. Once again, with his finances in a parlous state, he and his family took refuge at Piette's farm in Brittany (Plate 126). Théodore Duret also helped when he was

126
LUDOVIC PIETTE:
Portrait of Camille Pissarro painting out of doors. c. 1870. Gouache on canvas. Private Collection

127
AUGUSTE RENOIR:
La Loge. 1874. Oil on canvas. London, Courtauld Institute Galleries

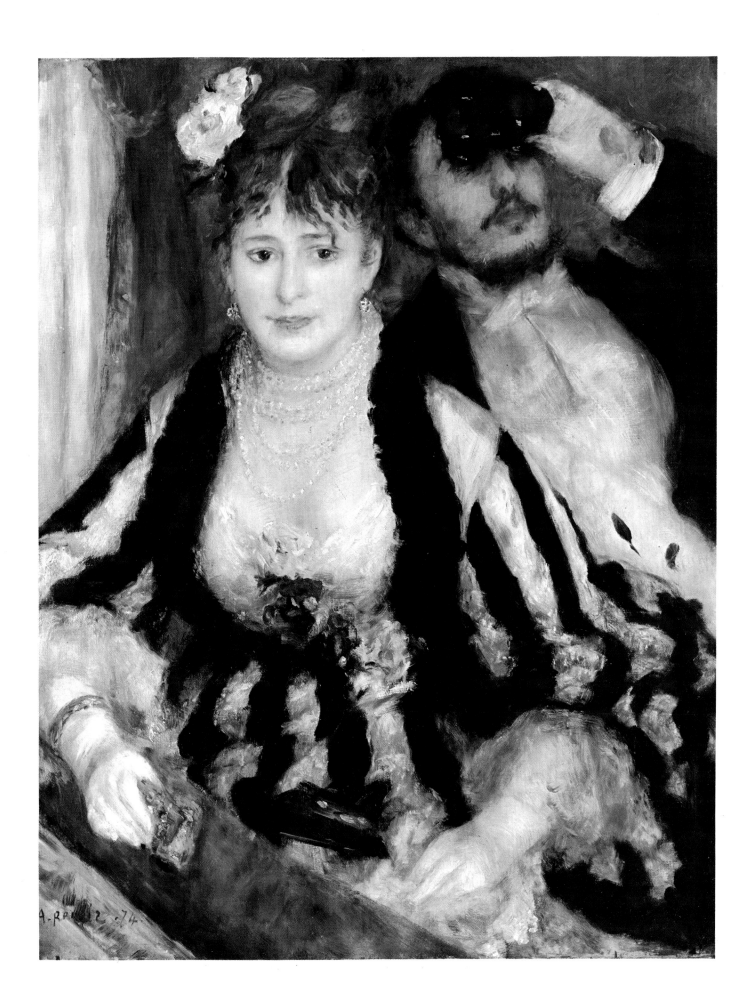

able, and used his business connections to find purchasers for the more needy painters.

The writers of the group — Duret, Duranty, Zola, Silvestre, Edmond Renoir and Renoir's friend, Georges Rivière — served their painter friends by promoting their efforts and aims in print. In 1876 Duranty published *La Nouvelle Peinture*, a pamphlet which stressed the importance of the Impressionists as painters of modern life and rated Degas particularly highly. It was to be expected that, being a novelist of the Realist school, he should sympathize most with Degas, but his lukewarm enthusiasm for landscape painting annoyed Monet and Renoir. In 1877, for the duration of the Impressionist exhibition of that year, Rivière brought out a periodical entitled *L'Impressionniste*, in which he defined the new style: 'Treating a subject in terms of the tone and not the subject itself, this is what distinguishes the Impressionists from other painters.' A year later Duret made his contribution to the literature on Impressionism and published *Les Peintres Impressionistes*, singling out Monet, Sisley, Pissarro, Renoir and Berthe Morisot as the true Impressionists, the painters of light and atmosphere, and the leaders of the movement. His defence of the group was the most articulate and enthusiastic the Impressionists had yet received, and won their deep gratitude.

In arguing the case of the rebels, Duret pointed to their growing band of supporters as a sure indication of their eventual success and recognition. Those early collectors who were prepared to buy Impressionist works when the press and the public still dismissed the painters as lunatics, were truly remarkable people. Their support often extended to offers of hospitality, financial assistance and much-needed encouragement. Dr Gachet welcomed painters into his house, made loans, and ministered to their medical needs. In the winter of 1878/9 he cared for a model of Renoir's called Margot, who was suffering from smallpox and to whom the painter was

128
Dr Georges de Bellio.
c. 1865. Photograph

greatly attached. Gachet could do little to help the girl, but he supported Renoir in his grief.

When Gachet himself was taken ill with lumbago, Dr de Bellio, a Roumanian homoeopath, came to ease the girl's last hours. Georges de Bellio (Plate 128) was one of the collectors cited by Duret in his book. A wealthy bachelor, he had lived in Paris since 1851, collecting paintings, furniture and *objets d'art*. He was probably introduced to Monet and Renoir by Prince Bibesco, a relation of his, and after the Impressionist exhibition of 1876 he started to buy their works. He thus became one of those to whom they turned in times of need. They wrote to him for loans, or else would catch him at the Café Riche to sell him their pictures. In 1877 he also bought works from Pissarro, Berthe Morisot and Sisley (including the latter's *Men sawing Wood*, Plate 130), and the following year he became friendly with Manet, who painted the portrait of his grandniece Lise Campineano. He was one of the doctors to minister to

129
AUGUSTE RENOIR:
The Fisherman. 1874. Oil
on canvas. Private
Collection

130
ALFRED SISLEY:
Men sawing Wood. 1876.
Oil on canvas. Paris,
Musée du Petit Palais

Manet during his last illness, and in 1899 he was the first to contribute to the subscription launched by Monet for the purchase of *Olympia* for the State. 'This idea will have the triple merit', he wrote to Monet, 'of being a just tribute of homage to the memory of the poor, beloved Manet, of coming to the aid of his widow in a discreet manner and, lastly, of preserving for France a truly valuable work.'

The singer Faure, encouraged by Duret and Durand-Ruel, continued to buy Impressionist paintings, and in 1874, after the close of the first Impressionist exhibition, he invited Sisley to accompany him to England. Sisley's English relatives would have nothing to do with him at this time, but Faure provided the support he needed and purchased five of the pictures painted during the contented and fruitful months of his stay. As, in France, Sisley chose riverside locations on the fringes of Paris, so, in England, he painted on the Thames outside London at Hampton Court. In his pictures of the regattas (Plate 131) and the bridges (Plate 133) he achieved some of his most forceful effects, capturing the brilliance of sunshine with vivid scribbles of paint.

One of the oddest recruits to the Impressionist circle during the 1870s was Victor Chocquet, an official in the customs service. His ruling passion was for furniture and *objets d'art* of the eighteenth century, a taste he shared with de Bellio. So that he could devote his meagre income to his collection, he lived in a garret and went about in rags, much to the disapproval of his employers. At first regarded only as an eccentric, Chocquet's standing rose as the taste for eighteenth-century art revived. He owned Watteaus, bought for next to nothing before the artist was fashionable, and commodes, clocks, pier-glasses and chandeliers which became the talk of Paris.

The spirit of the eighteenth century lived

131
ALFRED SISLEY:
Regatta at Molesey.
1874. Oil on canvas.
Musée d'Orsay

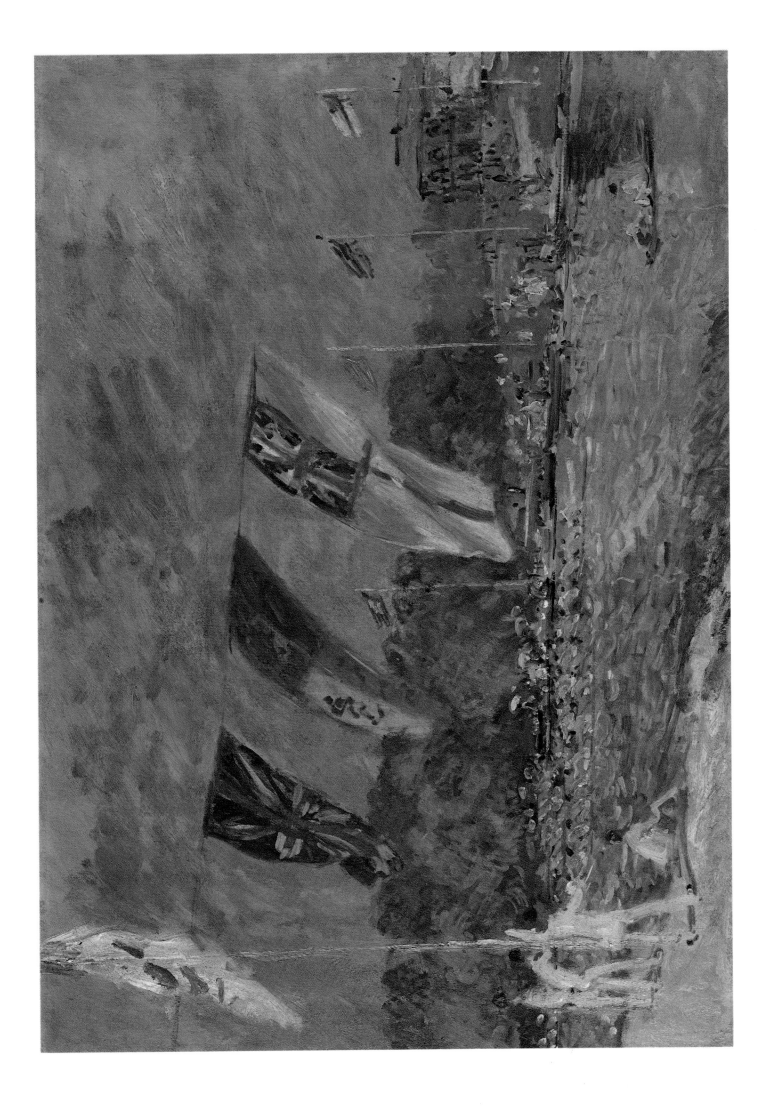

132
AUGUSTE RENOIR:
*Portrait of Madame
Chocquet.* 1875. Oil on
canvas. Stuttgart,
Staatsgalerie

on, Chocquet believed, in Delacroix, and he owned a number of his works — chiefly drawings and oil-sketches. When he saw Renoir's paintings at the auction of 1875 he recognized in them the same spirit, and having sought out the young artist, commissioned him to paint his wife, with one of his little pictures by Delacroix behind her (Plate 132). 'I want to have you together, you and Delacroix,' he said. Chocquet's sincere appreciation of beautiful things made him a warm friend as well as a loyal supporter. Aware of Cézanne's need for such encouragement, Renoir took Chocquet to Père Tanguy's to see Cézanne's pictures. Chocquet immediately purchased one and, through Renoir, met the artist himself. Both artists painted portraits of

133
ALFRED SISLEY:
*Bridge at Hampton
Court.* 1874. Oil on
canvas. Private
Collection

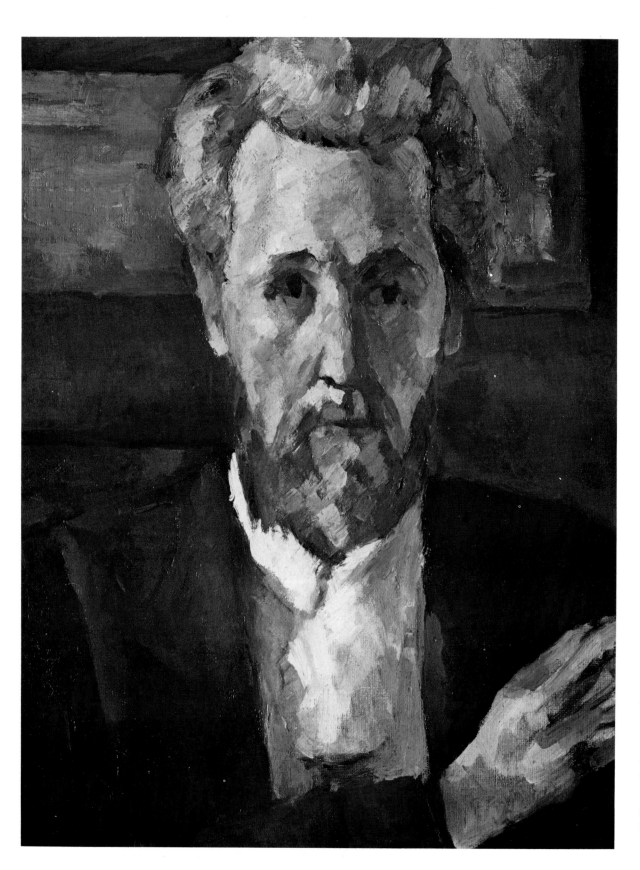

134
PAUL CÉZANNE:
*Portrait of Victor
Chocquet.* 1879–82. Oil
on canvas. Upperville,
Va., Collection of Mr
and Mrs Paul Mellon

135
AUGUSTE RENOIR:
*Portrait of Victor
Chocquet.* 1876. Oil on
canvas. Winterthur,
Oskar Reinhart
Collection

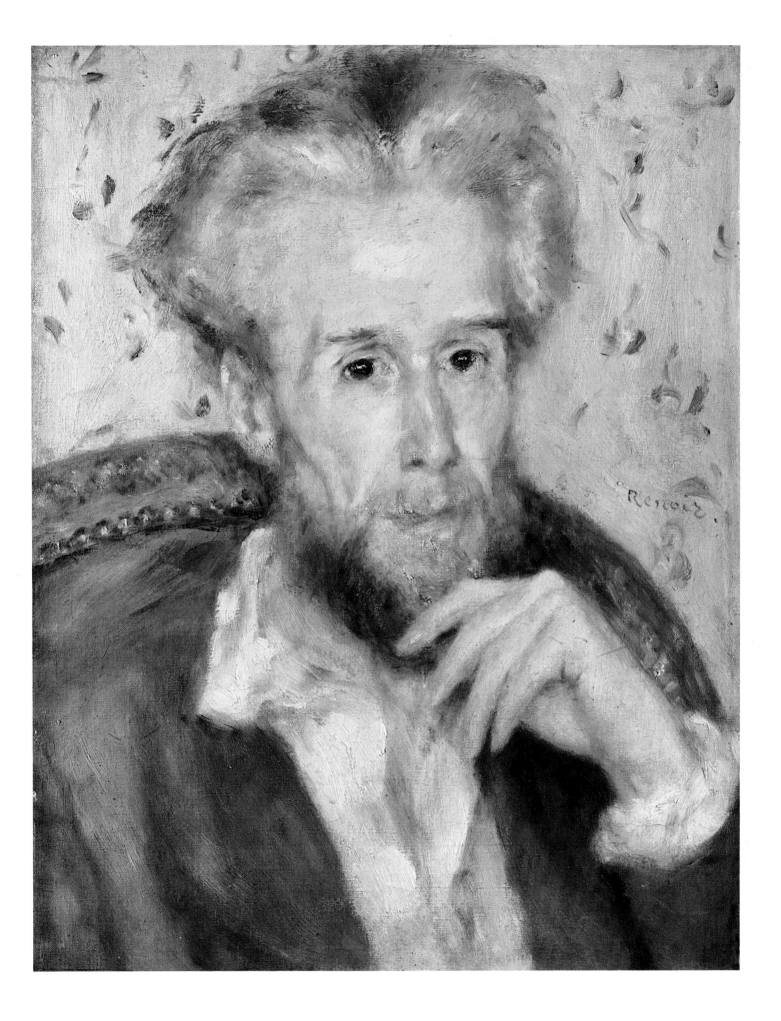

the eccentric customs officer (Plates 134 and 135), and together these works reveal the rare blend of sensitivity and tenacity that constituted Chocquet's remarkable character. When Cézanne introduced him to Monet, the collector was moved to tears; at the Impressionist exhibitions of 1876 and 1877 he regularly put in an appearance to defend the pictures on exhibition against the insults of the visitors. 'He challenged the laughers, made them ashamed of their jokes, lashed them with ironical remarks,' Georges Rivière later recalled.

> In animated, daily repeated discussions, his adversaries never had the last word. Scarcely would he have left one group when he would be discovered some place else, dragging a perverse art lover almost by force before the canvases of Renoir, Monet or Cézanne and trying to make the other share his admiration for these disgraced painters ... Persuasive, vehement, domineering in turn, he devoted himself tirelessly, without losing the urbanity which made him the most charming and formidable of opponents.

Pissarro's chief benefactor in the late 1870s, especially after the death of Piette, was Eugène Mürer, a pastry-cook and restaurateur who had been at school with Guillaumin (Plate 136). Together with Renoir, Pissarro painted his shop and Mürer bought canvases from them, sometimes providing meals in exchange. He had none of Chocquet's artistic sensibility, and perhaps failed to appreciate the quality of his friends' work. He often quibbled over their prices, yet in a sincere desire to help he had the idea late in 1877 of hanging a series of Sisleys in his house, in the hope of selling them, and he organized a lottery with a picture by Pissarro as first prize. Sadly, the winner, a maid-servant, preferred to have one of Mürer's cream cakes. When times were bad, Mürer loaned money to both Pissarro and Monet, and his home became a regular meeting-place, the venue each Wednesday for dinners attended by Renoir, Pissarro, Monet, Sisley, Guillaumin, Eva Gónzalès' husband Henri Guérard, and Père Tanguy. Less frequent guests included Dr Gachet, Hoschedé and Cézanne.

Since the auction of 1875, when Georges Charpentier had purchased the *Fisherman*, Renoir had enjoyed both the friendship and the patronage of the publisher, and had become a frequent visitor to the Charpentier *salon*, a distinguished gathering of writers, artists, musicians, intellectuals and men of affairs. Charpentier had the distinction of being the leading publisher of the modern Realist school, and Zola, Maupassant, the Goncourts and Daudet were among the habitués of his mansion in the Rue de Grenelle. The political bias of the Charpentier circle was radical, corresponding to its artistic leanings, and such leading Republicans as Gambetta, Clemenceau and Geoffroy attended the gatherings. Charpentier hoped to win for Renoir commissions from Gambetta's government, but although he admired his paintings Gambetta could offer Renoir nothing, since such radical preferences in art would weaken the Republic. 'You are revolutionaries,' the politician complained, 'that's the trouble. ... It is better for the Republic to live with bad painting than to die for the sake of great art.'

Nevertheless, Charpentier supplied commissions which were to make Renoir's reputation. He painted various portraits of Madame Charpentier and her children, one of which achieved a notable success at the 1879 Salon (Plate 138). It shows the publisher's wife in a long black gown by Worth, reclining with her children in her fashionable 'Japanese' drawing room with its bamboo furniture and oriental silks. Her three-year-old son Paul sits beside her, and her eldest daughter Georgette is seated on their dog Porto. No doubt the picture owed some of its success to the eminence of the *salon* hostess; Renoir clearly tempered his palette and his technique to the demands of a stately society portrait. It apparently required almost forty sittings and not surprisingly has little of Renoir's customary spontaneity. It nevertheless has great

136
AUGUSTE RENOIR:
Portrait of Eugène Mürer. 1877. Oil on canvas. Mrs. Enid A. Haupt.

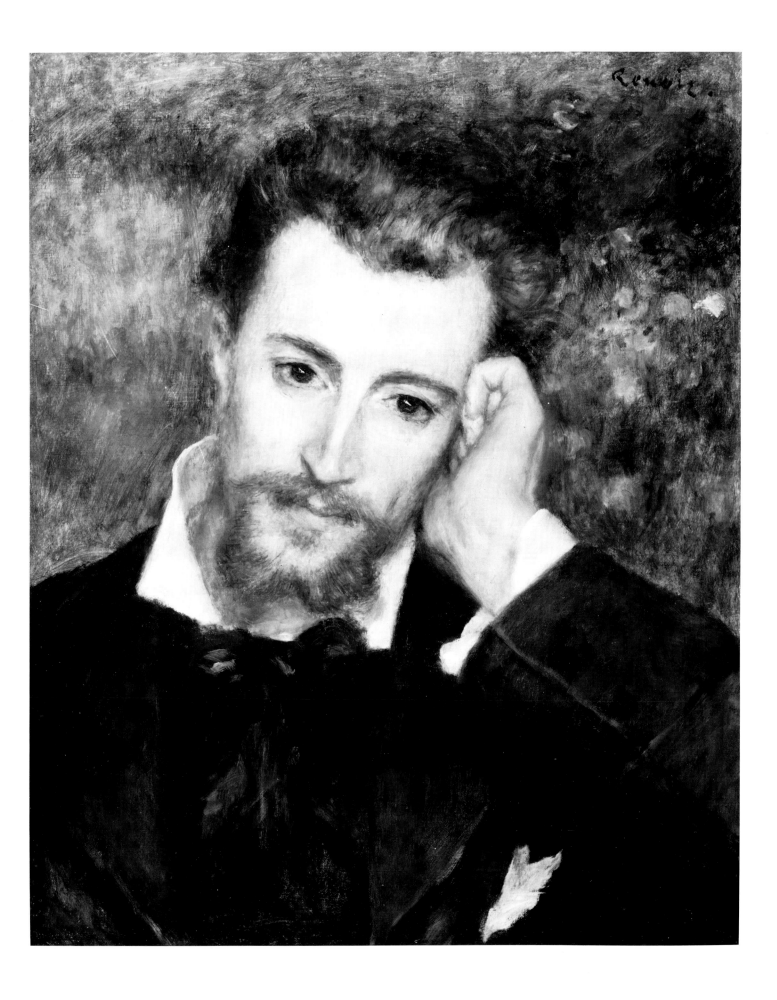

137
AUGUSTE RENOIR:
*The Children's Afternoon
at Wargemont.* 1884. Oil
on canvas. Berlin,
Gemäldegalerie,
Staatliche Museen
Preussischer
Kulturbesitz

charm and won the artist fame, and a much-appreciated fee of 1000 francs. It also placed him in an enviable position in relation to his colleagues and restored his confidence. As he said, 'I can't paint if it doesn't amuse me. And how can you be amused when you're wondering if what you're doing is making people grind their teeth?'

At the Charpentier *salon* Renoir met Paul Béraud, who was to become a close friend, as well as a major patron of the artist. In the years to come Renoir was to be a frequent guest at the Bérauds' château at Wargemont, near Dieppe, and was often to paint the family of his friend (Plate 137).

Renoir's brother Edmond also benefited from the Charpentiers' patronage. He became a contributor to a new periodical, *La Vie Moderne*, devoted to artistic and literary life, set up by Charpentier in the spring of 1879. He also instigated a series of one-man exhibitions held on the editorial premises. In the initial years, Renoir,

Monet, Sisley, Odilon Redon and de Nittis were among the artists who showed there.

Towards the end of the 1870s Renoir (Plate 139) saw rather less of his Impressionist colleagues and attracted around him a small circle of young admirers — painters, writers and musicians. The closest of them were Georges Rivière, a civil servant in the Ministry of Finance, and a painter, Cordey, who had been a pupil at Gleyre's studio. Among the others were Lhote, who worked in the Havas News Agency, the painter Frank-Lamy, and Lestringuez, whose chief passion was the occult sciences. Lestringuez got involved in experiments of all kinds and amused the others with his attempts at hypnotism. He brought along the composer Chabrier to their gatherings, and another musician, Cabaner, who earned his living playing the piano in cafés, was also of their number. Renoir had known him since before the war. Cabaner had apparently once stopped Cézanne in the street, curious to see the

138
AUGUSTE RENOIR:
*Madame Charpentier and
her Children.* 1878. Oil
on canvas. New York,
The Metropolitan
Museum of Art

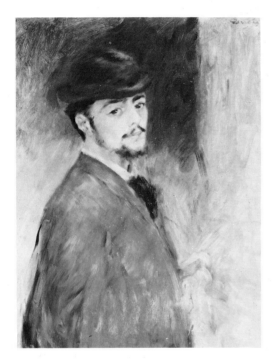

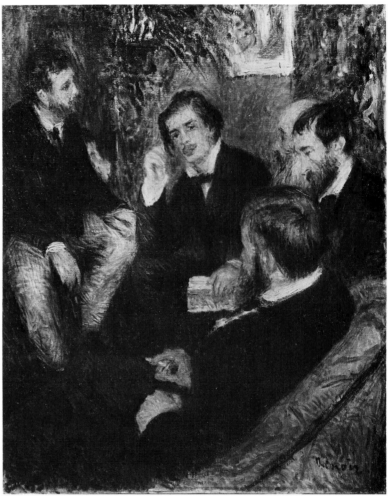

picture he was carrying, and, fired with en-
thusiasm, had promptly bought it from
him. In the late afternoons, the friends
would meet in Renoir's studio in the Rue
Saint-Georges, and in 1876 the artist pain-
ted a group portrait of them there, together
with Pissarro (Plate 140). On the left is
Lestringuez, centre is Rivière, on the right
is Pissarro, almost hidden by Cabaner,
while Cordey is seated in the foreground.

With Charpentier's help Renoir man-
aged to rent a house with a garden in the
Rue Cortot, in the old hilly quarter of
Montmartre. In the overgrown garden he
pursued his studies of figures in the open,
using his friends as models. Here he pain-
ted the celebrated picture, *The Swing*
(Plate 141), for which the actress Jeanne
Samary, one of his favourite models, posed.
Entranced by the effects of sunlight filter-
ing through foliage, Renoir sought to re-
create in his paintings the dappled patch-
work of warm and cool tones made by the
light. A picture of a nude beneath trees
(Plate 142), the shadows of her flesh blue
and green with the reflections from the
leaves, was shown at the 1876 Impressionist
exhibition and described by Albert Wolff as

a 'mass of flesh in the process of decom-
position with green and violet spots'. No
comment could have been more stubbornly
blind. Renoir has avoided the porcelain-
like finish favoured by academic painters of
the nude, and captured the soft trans-
parency of the girl's body and its response
to the enveloping atmosphere. 'I have a
horror of the word "flesh", which has be-
come so shopworn,' Renoir is quoted as
saying. 'Why not "meat", while they're
about it? What I like is skin, a young girl's
skin that is pink and shows that she has
good circulation. But what I like above all is
serenity.'

Renoir's finest essay in this vein was a
large picture of the crowds at the Moulin de
la Galette, a café and dance-hall in Mont-

139
AUGUSTE RENOIR:
Self-Portrait. 1876. Oil
on canvas. Cambridge,
Mass., Fogg Art
Museum

140
AUGUSTE RENOIR:
*The Artist's Studio in
the Rue Saint-Georges.*
1876. Oil on canvas.
Private Collection

141
AUGUSTE RENOIR:
The Swing. 1876. Oil on
canvas. Paris,
Musée d'Orsay

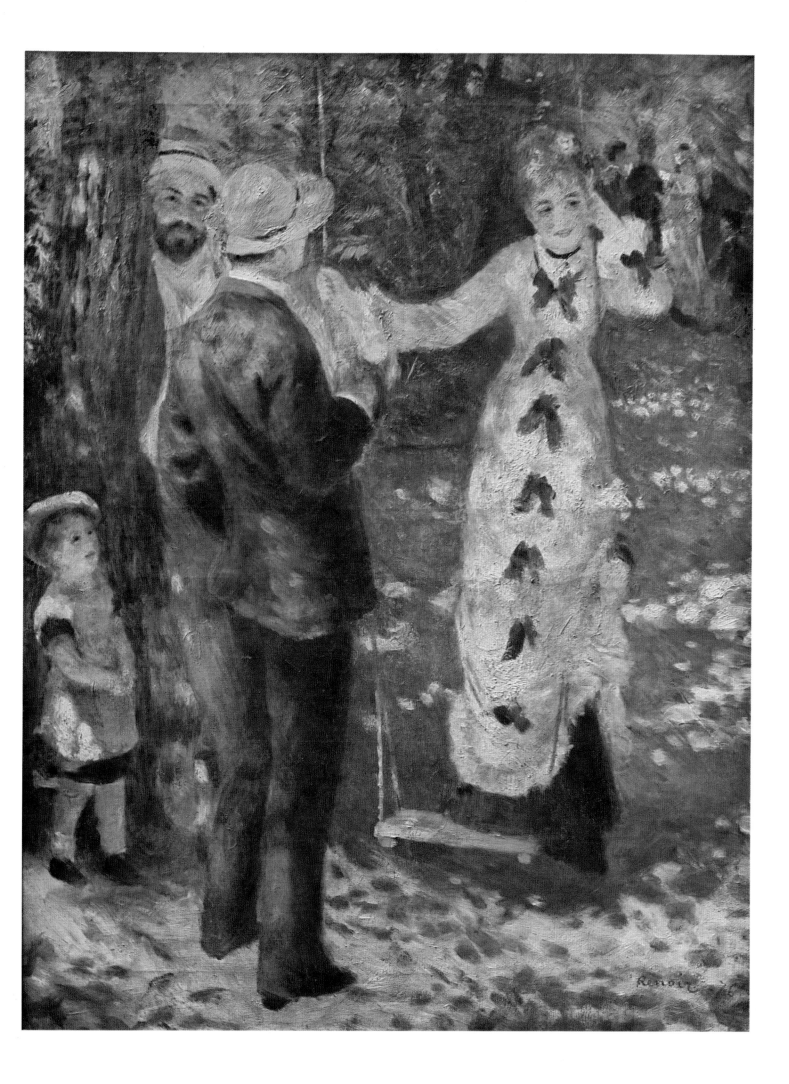

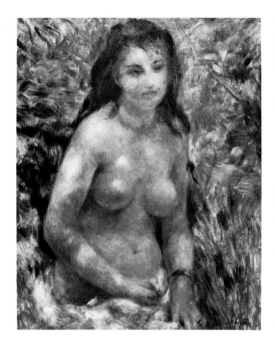

martre, not far from his house. The place consisted of a garden with acacia trees, a large shed, and two windmills, which had only recently ceased turning out flour (Plate 143). It was a popular haunt for the low life of the quarter, pimps, prostitutes and rogues of all kinds, and on Sundays especially, a place where the factory work-

ers and shop girls from the neighbouring districts would come to dance and eat the home-made girdle cakes, or 'galettes'. The shabbiness of the building and the un-sophisticated clientele did not deter Re-noir. He was charmed by the young girls in their pretty dresses, the air of innocent fes-tivity and the changing pattern of light and shade as the dancers moved beneath the trees (Plate 144). Each day Renoir's friends helped him carry his big canvas up to the Moulin from his house, and posed for him. As for the female figures, the girls of the district were all too ready to pose, as was Jeanne Samary's sister Estelle, who is seated on the bench in the foreground.

Renoir's picture was one of the major exhibits at the Impressionist exhibition of 1877, and the object of lavish praise in Georges Rivière's Impressionist *Journal*. 'Never has he been more inspired,' he wrote. 'It is a page of history, a precious monument to Parisian life, done with rigorous exactitude. No one before him had thought of portraying an event in ordinary life on a canvas of such big dimensions; it is an act of daring which will be rewarded by success, as is fitting.' Perhaps, in *The Ball at the Moulin de La Galette*, Renoir finally

142
AUGUSTE RENOIR:
Nude in Sunlight.
c. 1876. Oil on canvas.
Paris, Musée d'Orsay

143
The Moulin de la
Galette at Montmartre.
From a contemporary
engraving.

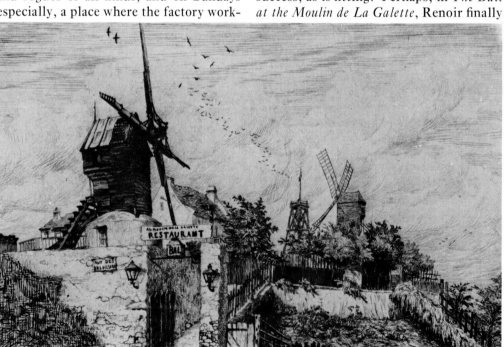

144
AUGUSTE RENOIR:
*The Ball at the Moulin
de la Galette.* 1876. Oil
on canvas. Musée d'Orsay

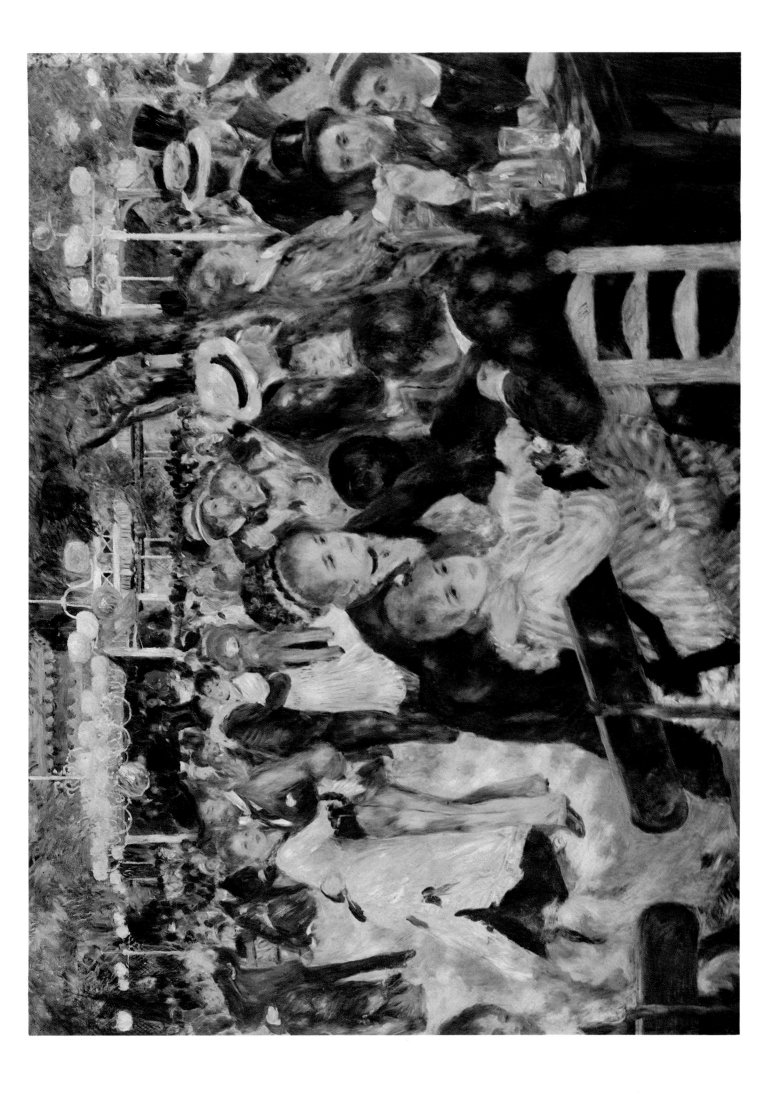

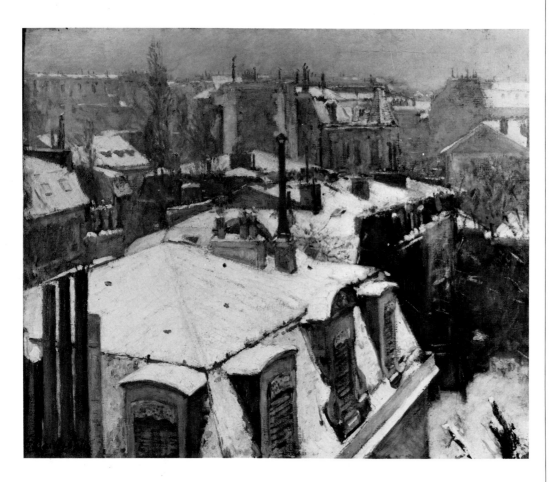

145
GUSTAVE CAILLEBOTTE:
Roof-tops in the Snow.
1878. Oil on canvas.
Paris, Musée d'Orsay

succeeded at what Monet, over ten years earlier, had vainly striven for in the large, abandoned *Déjeuner sur l'Herbe.*

Renoir's canvas was bought by Gustave Caillebotte, as too were *The Swing* and *Nude in the Sunlight.* Caillebotte thus used his wealth to buy major Impressionist works, providing the painters with an income and building up a collection which he intended for the Louvre. As a painter, he had learned most from Degas and Monet, adopting a technique of light broken brushstrokes, and searching for novel subjects in the city, views of the boulevards and rooftops (Plate 145).

Monet's most ambitious urban subjects to date were a series of canvases of the Gare Saint-Lazare, painted from within the station (Plate 146) and just outside, with the Pont de l'Europe and the surrounding apartment buildings, which he exhibited in 1877 in the same exhibition as Renoir's *Ball.* Renoir greatly admired Monet's uncompromising originality. No one before had painted views of the brand new iron and glass stations, with their form and structure virtually obliterated by the dense atmosphere of smoke and steam. And he admired Monet's gall, his ability to persuade the station-master that he was doing the railway an honour by his desire to paint there, and thereby gaining permission to paint in the station when and wherever he wished.

Monet's pictures came as a shock at the 1877 exhibition. In depicting the great steam locomotives that had so transformed the shape of the modern world, Monet drew no morals or lessons, and put before the public, without comment, something most people of taste believed to be irredeemably ugly. Georges Rivière struggled without

146
CLAUDE MONET:
The Gare Saint-Lazare.
1877. Oil on canvas.
Paris, Musée d'Orsay

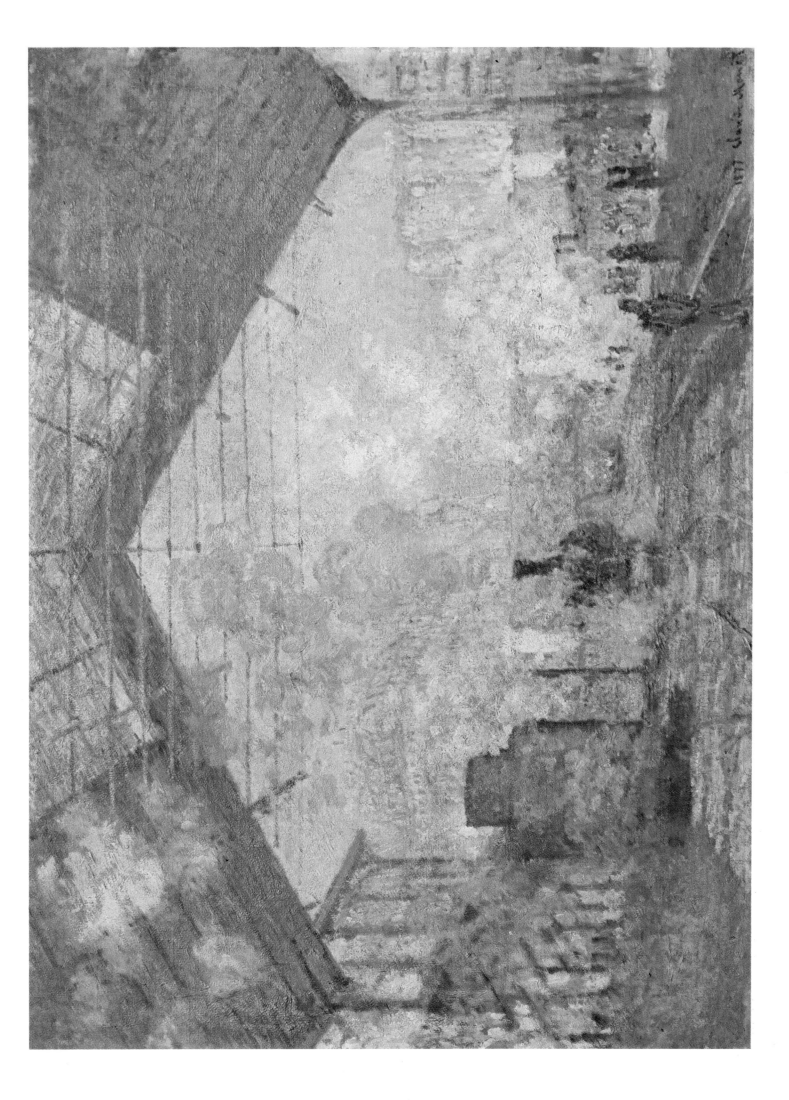

success to find a way of describing these pictures. They are 'enormously varied' he wrote, 'in spite of the monotony and the aridity of the subject'. In his literary evocation of the station, he resorts to the comparison of a train with 'an impatient and temperamental beast', shaking 'its mane of smoke', while 'around the monster, men swarm on the tracks like pygmies at the feet of a giant.' How much more discreet are Monet's canvases, which convey all the rich atmosphere of the station, without the fanciful exaggeration of Rivière's metaphors. For Monet, the subject is as rich and as beautiful as the artist's penetrating vision of light, form and movement can make it. Perhaps de Bellio and Caillebotte did grasp the full import of Monet's pictures, for they were among those who eagerly purchased works from the Gare Saint-Lazare series.

A major patron of Monet during the 1870s was Ernest Hoschedé, whom he visited at his home, the Château de Rottenbourg, at Montgeron, outside Paris. Manet and Sisley were also among Hoschedé's guests. In 1876 Monet produced a series of decorative panels for him, including one of a hunting party, one of a woman fishing at a pond, and one of turkeys on a bank with the house itself in the background (Plate 147). In these large pictures there emerges for the first time that preoccupation with a web of colour spun across the surface of the canvas, and its decorative possibilities, which Monet was to pursue later in life in the huge canvases of waterlilies painted at Giverny.

It was during a long visit to Montgeron in 1876 that Monet developed an attachment to Hoschedé's wife, Alice. Their secret liaison was unexpectedly favoured by events. In 1877 Ernest was declared bankrupt. In 1878 his collection was auctioned and the Hoschedé family moved in with the Monets at Vétheuil. Since Ernest Hoschedé was almost permanently absent in Paris, Monet became the head of the household of two women and eight children. His second son had been born shortly

before the move to Vétheuil, and Camille, who was suffering from a cancer of the uterus, was never to recover from the strain of the birth. Alice Hoschedé helped Monet care for the ailing woman, and after Camille's death in September 1879, took her place, even though Ernest did not renounce her as his wife for at least another two years.

The dramatic change in Monet's circumstances caused him no little strain. The responsibility of caring for such a ménage demanded that he sell his work, and his stay at Vétheuil was peppered with frequent visits to Paris, pictures in hand, in the search for customers. The pressure affected his work, much of which at this time is hurried and unresolved, as though he no longer knew what he was doing. Camille's dreadful sickness also caused him distress. When she died, he painted a moving picture of her on her deathbed, in which her gaunt figure seems to dissolve in the frantic scribble of coloured brushwork (Plate 148). Above all, the picture conveys the distress of a guilt-stricken man suddenly wrenched apart from a woman he has wronged. Since she always, perhaps, took second place to his painting, so, in the moment of death, painting acted as a necessary release to the artist's emotion and, at the same time, as an obstacle, preventing him from accepting the knowledge of her death. Monet suddenly discovered that in becoming too much an artist he had failed as a man. At the bedside of his dead wife, he found himself

in the act of automatically searching for the succession, the arrangement of colour gradations that death was imposing on her motionless face ... That was the point I had reached ... Even before I had the idea of recording those features to which I was so profoundly attached, my organism was already reacting to the colour sensations, and in spite of myself, I was being involved by my reflexes in an unconscious process in which I was resuming the course of my daily life.

But Monet's analysis is not wholly correct. The picture is charged also with the bitter

147
CLAUDE MONET:
Turkeys at Montgeron.
1876-7. Oil on canvas.
Paris, Musée d'Orsay

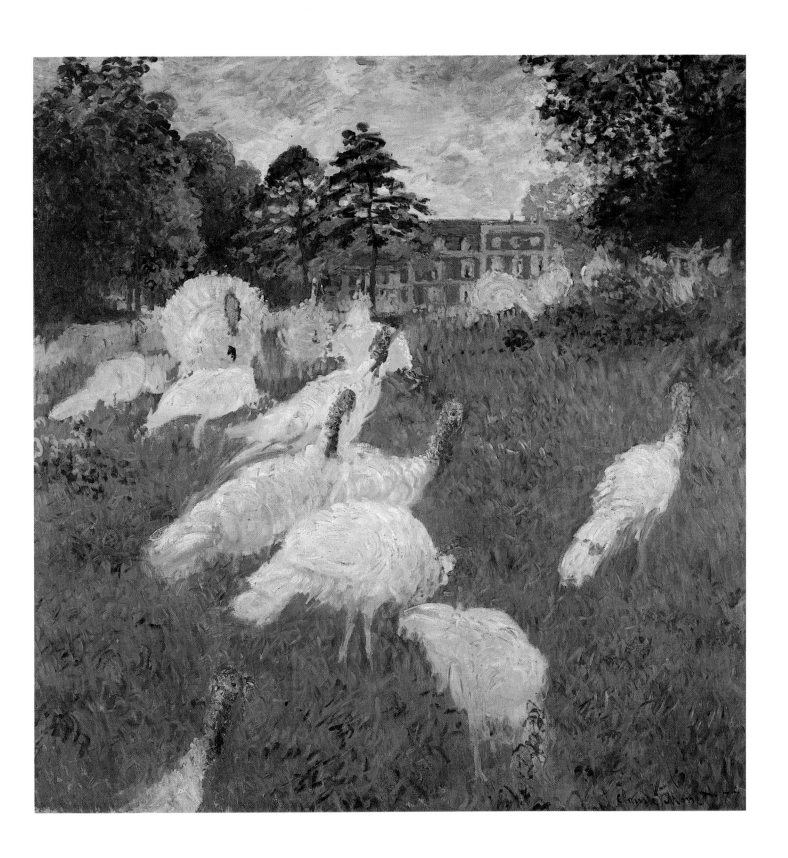

emotion he felt as a result of his awareness of this predicament.

At the end of the 1870s Monet was troubled by a sense of purposelessness, a feeling that he had lost his way. He wrote to de Bellio, begging his help, 'otherwise I shall lose all courage, and there will be nothing left for me but to put an end to an intolerable existence'. Later he wrote again:

> I am completely disgusted and demoralized by the existence I have been leading for so long ... Each day brings its torments and each day new difficulties arise from which we will never escape. That's why I am giving up the struggle as well as all hope; I don't have the strength anymore to work under these conditions.

After a decade of constant struggles and few rewards, his despair was shared by almost all the Impressionists. The exhibitions of 1874, 1876, 1877 and 1879 had brought few benefits, and in the face of continued opposition, first Renoir and then Sisley and Monet decided to submit their work to the Salon again. 'I am tired of vegetating, as I have been doing for so long,' Sisley wrote to Duret in 1879. 'We are still far from the moment when we shall be able to do without the prestige attached to official exhibitions. I am, therefore, determined to submit to the Salon.' Pissarro, who had always been more committed to the independent exhibitions, did not quit them for the Salon, though he too was close to despair. 'What I suffer at this actual moment is terrible, much more than when I

was young, full of enthusiasm and ardour, convinced as I am now of being lost for the future,' he wrote to a friend. They had all arrived at a point of crisis, in their art and in their lives, and the Impressionist group was at the point of breaking up, defeated by bigoted opposition. To make matters worse, their own camp was weakened by squabbles and divisions. As the painters pushed their Impressionist work further, their supporters in the press defected, no longer able to understand their aims. Zola had enthusiastically defended the group exhibitions, especially praising Cézanne and Monet. Then, in 1880, he too began to vindicate the Salon as the only valid showplace, and criticized Monet's hasty productions. He concluded his review of the 1880 exhibition with a rejection of Impressionism which deeply hurt the painters. 'They are all forerunners,' he wrote:

> The man of genius has not yet arisen. We can see what they intend, and find them right, but we seek in vain the masterpiece that is to lay down the formula ... This is why the struggle of the Impressionists has not reached a goal; they remain inferior to what they undertake, they stammer without being able to find words.

False though Zola's judgement was, his prediction of the break-up of the group was soon fulfilled. By 1880 the close unity of purpose that had held the artists together had vanished; from this time on they sought personal solutions and pursued them in increasing isolation.

148
CLAUDE MONET:
Camille on her Deathbed.
1879. Oil on canvas.
Paris, Musée d'Orsay

6 The Dispersal of the Group

In 1880 and 1881 only three of the original leaders of the group participated in the Impressionist exhibitions: Degas, Pissarro and Berthe Morisot. The others, while hoping for a better reception at the Salon, abstained in defiance of Degas's increasing domination of the group shows. 'I see only very rarely the men and women who are my colleagues,' Monet commented in 1880. 'The little clique has become a great club which opens its doors to the first-come dauber.' A division which had been felt from the start in the method of Degas's work and the aloofness of his person, had developed into a major rift. He had always objected to the label Impressionist, and had introduced so many of his own followers to the exhibitions that two camps had emerged, one headed by Degas (Plate 149), the other (in the absence of Monet) by Pissarro and Berthe Morisot.

Degas's art had made enormous strides during the 1870s, but except for an originality of execution and a modernity of conception, it bore little relation to that of his colleagues. He sought out striking modern subjects and treated them with increasing economy. His method was opposed to that of the other Impressionists, being based chiefly on working from memory:

> It is all very well to copy what you see but it is much better to draw only what you still see in your memory. This is a transformation in which imagination collaborates with memory. Then you only reproduce what has struck you, that is to say the essential, and so your memories and your fantasy are freed from the tyranny which nature holds over them.

149
WILHELM EMILE DE SPECHT: *Portrait of Edgar Degas.* 1878. Drawing. Private Collection

Many of his pictures of the early 1870s, such as *The Cotton Market* and the ballet scenes, take in a wide field and are full of detail. As time passed, Degas chose to concentrate on smaller fragments, isolating figures in striking poses that sum up an individual's character or trade. A single, brilliantly illuminated dancer advances towards us across a steeply tilted expanse of stage (Plate 150); a circus performer, suspended by her teeth from a rope, pivots above our heads against the vaults of a cir-

150
EDGAR DEGAS:
Dancer on the Stage. 1878. Pastel on paper. Paris, Musée d'Orsay

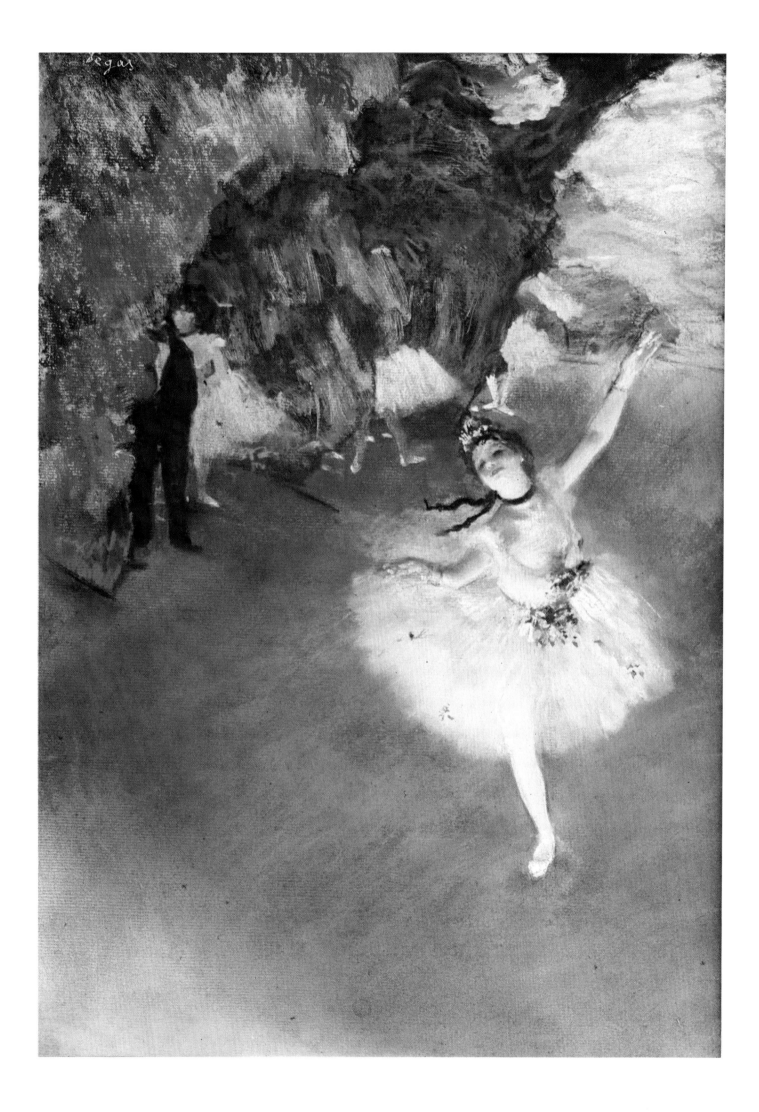

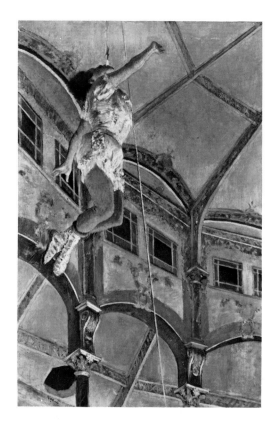

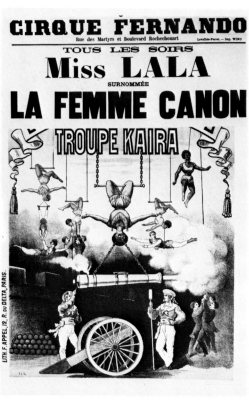

151
EDGAR DEGAS: *La La at
the Cirque Fernando.*
1879. Oil on canvas.
London, National
Gallery

152
Poster advertising Miss
La La at the Cirque
Fernando. Paris,
Bibliothèque Nationale,
Cabinet des Estampes

cus dome (Plate 151); a gaudily dressed
singer brazenly flaunts herself on the stage
of a café-concert (Plate 153). Degas's imag-
ination lights upon the meaningful gesture,
and his exact and expressive drawing sets it
down without exaggeration or distortion,
excluding irrelevant detail, and abruptly
truncating peripheral activity. In *The Star*
and *Café-Concert at 'Les Ambassadeurs'* the
medium of pastel allowed him to draw in
colour, so that no linear clarity is lost in the
development of the image. As he grew older
and his sight began to fail, pastel permitted
him increasing brilliance of colour and
freedom of drawing.

Like Monet at the Gare Saint-Lazare,
Degas looked for subjects hitherto un-
treated by painters. His ballet scenes show
professionals at work, and reveal, in the
scenic flats and backstage apparatus, all the
mechanics of the spectacle. La La, a mul-
atto performer well known for her acrobatic
feats (Plate 152), is shown in the new Cirque
Fernando, a vulgarly decorated structure of

iron and concrete lit by gas. Like Monet,
Degas passes no comment and is content to
reveal the beautiful in unexpected places,
in the sights proffered by modern Paris.

At the time he was working on these pic-
tures, Degas was often to be seen at the Café
de la Nouvelle-Athènes, in the Place
Pigalle, a slightly quieter location than the
Batignolles. Before the war the café had
been a famous meeting-place for members
of the Republican opposition, such as Gam-
betta and Duranty, but the political ha-
bitués had since been replaced by Degas
and Manet and their following. While the
other Impressionists rarely visited the
Nouvelle-Athènes, Degas's circle of artist
supporters regularly made an appearance.
Prominent among them were Rouart,
Forain, Raffaëlli and Zandomeneghi, all of
whom exhibited at the Impressionist exhi-
bitions. Another regular was Marcellin
Desboutin, an engraver and former pupil of
Couture who had lived many years in
Florence. Manet had painted his portrait in

153
EDGAR DEGAS: *Café-
Concert at 'Les
Ambassadeurs'.*
c. 1876–7. Pastel on
paper. Lyons, Musée
des Beaux-Arts

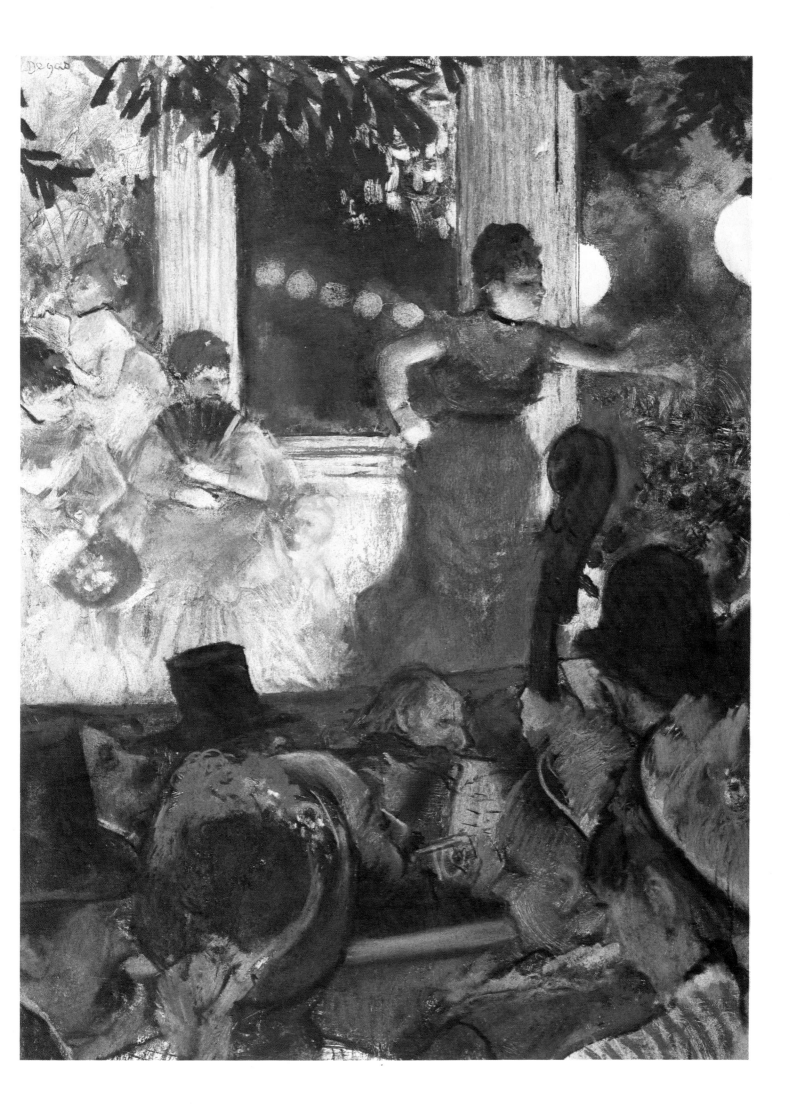

1875, and in 1876 Degas painted him with
the actress Ellen Andrée at the Nouvelle-
Athènes, in the picture popularly known as
L'Absinthe (Plate 156). In spite of the mood
of *ennui*, Desboutin's flamboyant, bo-
hemian character is evident in his shaggy
profile and the rakish tilt of his hat. He also
appears in another painting by Degas with
Lepic, the former colleague of Monet and
Bazille from Gleyre's studio (Plate 155). As
in the old days at the Café Guerbois, the
artists were joined by writer friends, among
them Silvestre, Alexis (a friend of Zola),
the Irish writer George Moore (Plate 154),
who had given up painting for criticism,
and, until his sudden death in 1880,
Edmond Duranty.

Degas's witty, ironic conversation made
him a prominent figure at the Nouvelle-
Athènes — especially since ill-health gra-
dually forced Manet to keep away — but his
argumentative nature caused offence
among his former colleagues and ag-

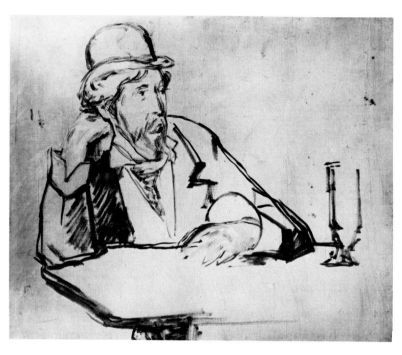

154
EDOUARD MANET:
*George Moore at the
Nouvelle-Athènes.* 1879.
Oil on canvas. New
York, The Metropolitan
Museum of Art

155
EDGAR DEGAS:
*Marcellin Desboutin and
Vicomte Lepic. c.* 1876.
Oil on canvas. Nice,
Musée des Beaux-Arts

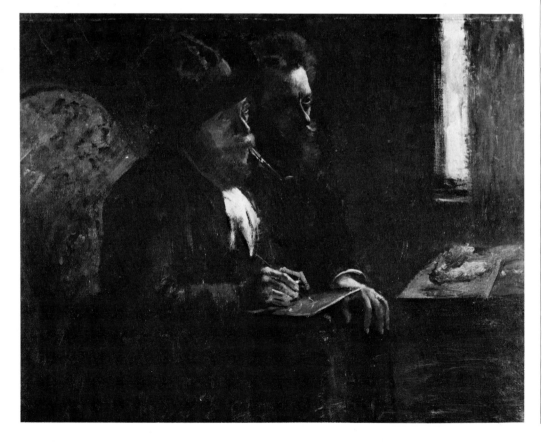

156
EDGAR DEGAS:
L'Absinthe. 1876. Oil on
canvas. Paris, Musée
d'Orsay

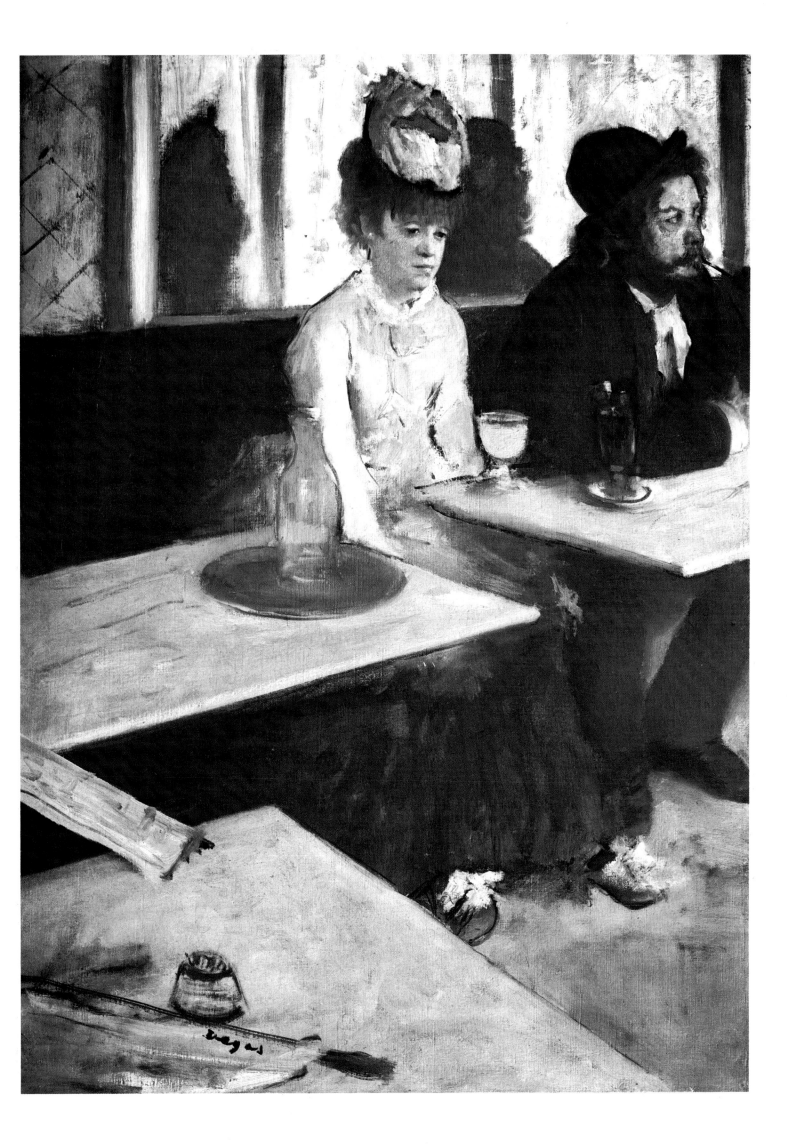

gravated the differences within the group. Monet and Renoir were incensed by his introduction of so many new participants to the exhibitions, men like Raffaëlli and Vidal, who they considered lacked talent and compromised the movement, while Degas criticized them as renegades for returning to the Salon. Pissarro and Caillebotte strove against all odds to hold the group together. They tried to persuade Degas to give up his circle of camp followers in order to induce Monet, Renoir and Sisley to return, but without success. Angered by Degas's stubbornness, and by the fact that he contributed so little to the shows and was arbitrary and unreliable in his support, Caillebotte urged Pissarro in 1881 to join him in organizing an exhibition without Degas. 'Degas introduced disunity into our midst,' he wrote to his friend.

> It is unfortunate for him that he has such an unsatisfactory character. He spends his time haranguing at the Nouvelle-Athènes or in society. He would do much better to paint a little more ... No, this man has gone sour. He doesn't hold the big place that he ought according to his talent and, although he will never admit it, he bears the whole world a grudge ... He has almost a persecution complex. Doesn't he want to convince people that Renoir has Machiavellian ideas? Really, he is not only not just, he is not even generous. As for me, I have no right to condemn anyone. The only person, I repeat, in whom I recognize that right is you. I say the only person, I do not recognize that right in Degas, who has cried out against all in whom he admits talent, in all periods of his life. One could put together a volume from what he has said against Manet, Monet, you ...

But in spite of his impassioned and convincing arguments, Caillebotte could not persuade Pissarro to renounce Degas, and in 1881 he joined the growing band of defectors from the exhibition.

Among those who did exhibit was a new woman recruit, a great admirer of Degas, the American painter Mary Cassatt. She had met him in 1877 and under his influence renounced the tame academic figure style in

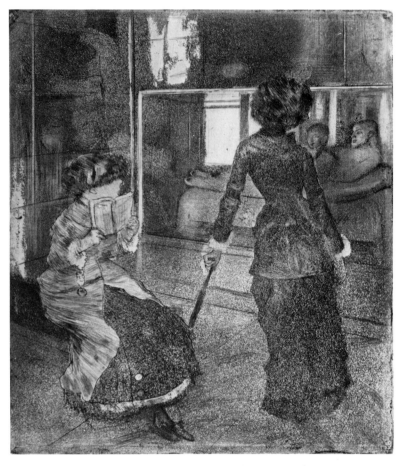

which she had been trained by Chaplin (Eva Gonzalès' former teacher) for more daring subjects, bolder draughtsmanship and purer colour. Like Berthe Morisot she particularly excelled at domestic subjects, pictures of young girls (Plate 158), and mothers with their children. The daughter of a wealthy banker, she had the means to pursue a career as an independent painter. Later she was instrumental in finding American support for Impressionist painting, and provided financial backing for Durand-Ruel's attempts to sell Impressionism to the USA. Mary Cassatt, far from condemning Degas for his irritability and misanthropic outbursts, pitied him and offered her friendship. She became his frequent companion, and posed for portraits and figure subjects (Plate 157).

Of the Impressionists who had abandoned the group exhibitions the most for-

157
EDGAR DEGAS:
Mary Cassatt at the Louvre (Cabinet des Antiques). 1879–80. Etching and aquatint. Paris, Bibliothèque Nationale, Cabinet des Estampes

158
MARY CASSATT:
Five o'clock Tea. 1880. Oil on canvas. Boston, Museum of Fine Arts

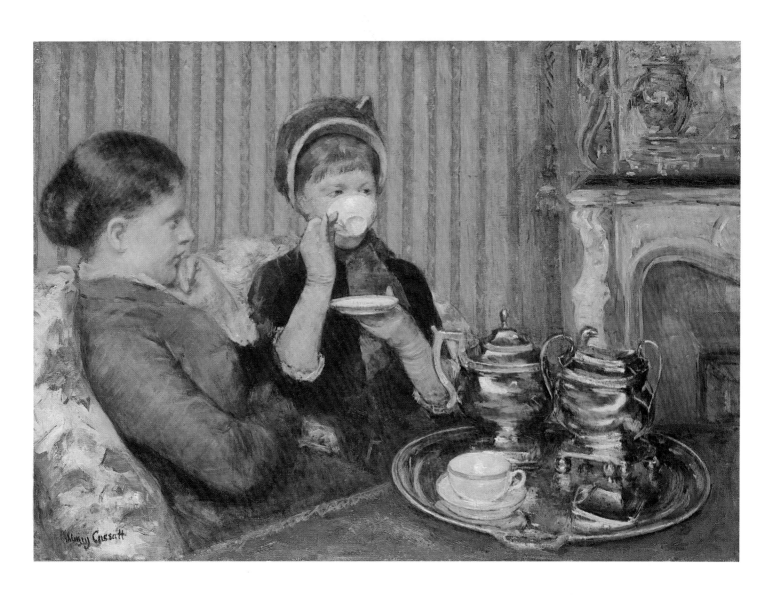

tunate was Renoir, who enjoyed a healthy demand for his work since the success of *Madame Charpentier and her Children* at the Salon of 1879. The income from this and similar commissions enabled him to travel widely for the first time, to Italy and Algiers in 1881 and again to Algiers in 1882.

Nevertheless, this was a difficult period for him, as it was for his friends. At the very moment that success was his, he became plagued by doubt and dissatisfaction. 'I had gone to the end of Impressionism,' he later recalled, 'and I was reaching the conclusion that I didn't know how either to paint or to draw. In a word, I was at a dead end.' The crisis coincided with a critical illness. Early in 1882, after several months travelling through southern Italy and Sicily, he returned by sea to Marseilles, and joined Cézanne at L'Estaque, where he caught pneumonia. Cézanne and his mother nursed the painter back to health, but the letters he wrote to Caillebotte and Durand-Ruel at the time show that his spirits were at the lowest ebb. He had no wish to participate in the new group exhibition they were planning, and was completely disillusioned with his life's work.

Renoir's artistic re-emergence was a slow and painful process. He felt that in turning to nature alone as his guide, he had forsaken the time-hallowed principles of art. He had been deeply struck by the frescoes of Raphael in the Vatican ('they are full of knowledge and wisdom', he wrote to Durand-Ruel) and by the ancient Roman wall paintings in the museum at Naples, and hoped to achieve an equivalent classical style of his own, with something of the same purity of line and strength of form. But he laboured with difficulty: 'I am still suffering from experimenting. I'm not content and I am scraping off, still scraping off.'

Of no less importance to him than Raphael, was Paul Cézanne (Plate 159), who since 1877 had ceased participating in the group exhibitions and, except for odd visits to Chocquet at Hattenville and Zola at Médan, spent his time around Aix and L'Estaque. He too had been seeking an alternative to the Impressionist moment in time, in which a rapid execution and touches of pure colour are used to catch fleeting appearances. 'Motifs can be found here which would require three or four months work, and that is possible because the vegetation doesn't change,' he wrote to Chocquet from L'Estaque. 'It is composed of olive and pine trees which always preserve their foliage. The sun is so terrific that it seems to me as if the objects were silhouetted not only in black and white, but in blue, red, brown and violet.' Thus in pictures of the mountainous Provençal landscape and the brilliant orange-tiled houses of L'Estaque against an ultramarine sea (Plate 160), Cézanne evolved an approach that subordinated fleeting atmospheric effects to underlying structure. He developed a method of parallel hatchings of paint to represent planes, which instead of creating an illusion of reality results in a surface pattern of harmonious colours, a synthetic image. Art, he claimed, constituted for him 'a harmony running parallel to nature' and not an imitation of nature. With this new 'synthetic' style Cézanne believed he could render depth and form without resorting to traditional illusionistic devices. The right juxtaposition of tones within the overall texture of hatchings was sufficient to create recession. Nowhere does this more apply than in the pictures of the Montagne Sainte-Victoire, the first of which were painted between 1885 and 1887 (Plate 161).

Staying with Cézanne at Aix, Renoir was greatly impressed by the country, by the light and by his friend's recent work, which few had seen. He too was to adopt a similar hatched technique in certain pictures. 'I am in the process of learning a lot,' he wrote to Madame Charpentier. 'I am staying in the sun not to do portraits in full sunlight, but while warming myself and observing a great deal, I shall, I believe, have acquired the simplicity and grandeur of the ancient painters.' Thus the lessons of Raphael and Cézanne and the South came together in his mind as the pursuit of classical economy in the rendition of form.

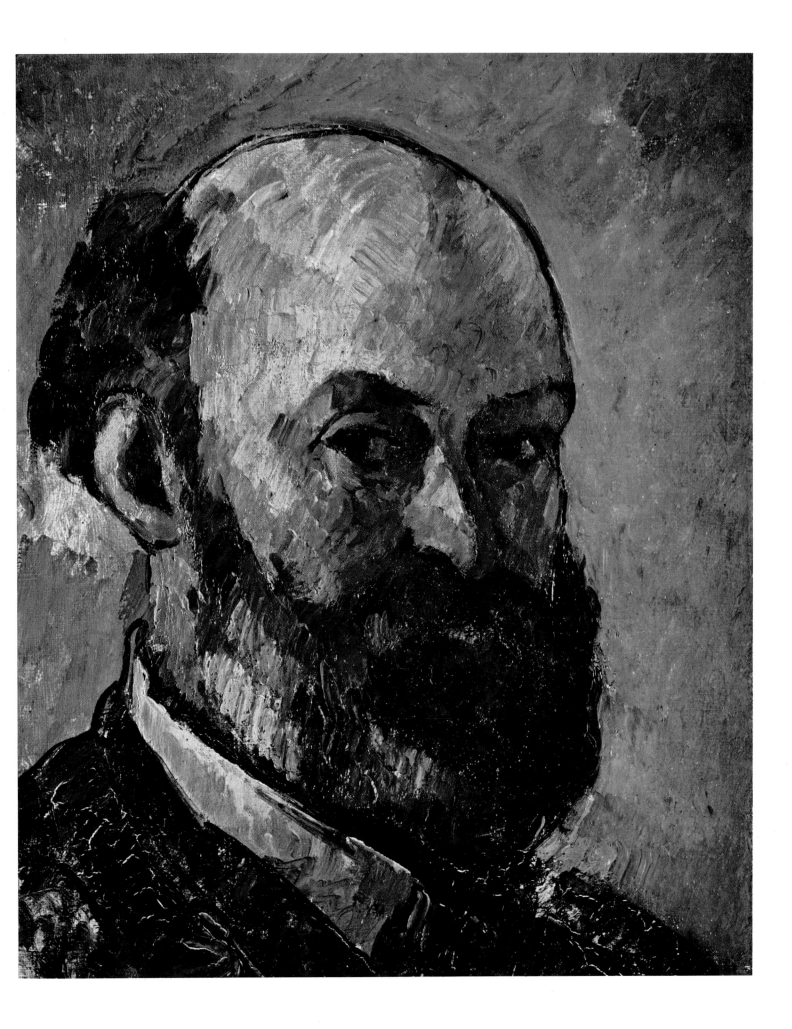

160 PAUL CÉZANNE: *The Bay of Marseilles from L'Estaque.* 1886–90. Oil on canvas. The Art Institute of Chicago

161 PAUL CÉZANNE: *La Montagne Sainte-Victoire.* 1885–7. Oil on canvas. New York, The Metropolitan Museum of Art

Renoir's major compositions of the early 80s were worked on over a long period, and show him struggling to master a new manner. *The Umbrellas* (Plate 162) is in fact painted in two different techniques, the woman and children on the right in the soft merging colours of his Impressionist years, the girl on the left and the umbrellas in a new linear style with subdued colour and clearly defined forms. The different fashions of the women's clothes suggest that a considerable period, perhaps as much as five years, elapsed before he completed the picture in about 1886. The later parts clearly show an observance of planes derived from Cézanne. The hatched brushwork of the trees at the back comes especially close to his style.

In an effort to get away from the painterly facility of his Impressionist canvases, Renoir turned to strict and exact drawing, and in his paintings applied colour thinly to carefully prepared designs in pen and ink. In a fierce reaction against Impressionism, he destroyed earlier pictures, and looked to the art of the past, not to nature, for themes and guidance. *The Large Bathers* (Plate 166), a picture on which he worked from 1884 to 1887, takes its subject and composition from a bas-relief by the seventeenth-century sculptor Girardon, and in complete opposition to Manet's *Déjeuner sur l'Herbe* avoids any reference to the present. As a result, it is an uneasy mixture of academic figure drawing and Impressionistic landscape painting, smacking greatly of the studio. Renoir confuses reminiscences of Boucher, Fragonard and Ingres, and fails to find a personal idiom.

This indecision marked only a phase, from which Renoir was to emerge into a new era of confident full-blooded work, recovering the spontaneity and warmth he had temporarily suppressed. He was helped in this by a change in circumstances, for in 1890 he married Aline Charigot, a pretty seamstress from Essoyes in Burgurdy, over twenty years his junior. He had first met her before his travels to Italy and Algiers, when she modelled for some of the pictures he painted at Bougival, Chatou and Asnières. When Monet was working further afield at Vétheuil, Renoir continued to paint the rowers and pleasure parties on the river (Plate 163). His inveterate companions were Caillebotte, Lestringuez and Lhote, all of whom appear in *The Luncheon of the Boating Party* (Plate 164), which he painted at the Fournaise Restaurant on the island of Chatou in 1881. Aline is seated at the table on the left, fondling a dog. She was a simple provincial woman, who would not give up her accent in spite of attempts by Renoir's actress friends, Ellen Andrée and Mme Henriot, to 'improve' her, and she made Renoir a completely devoted wife. In later years she, with her sons Pierre, Jean and Coco, and her cousin and maid Gabrielle, became the artist's constant models and source of inspiration, replacing the influences of Raphael and Pompeian wall-painting that had filled his mind since Italy.

Renoir's marriage loosened his ties with his Impressionist colleagues, and in 1885 he moved away from Paris to La Roche-Guyon, and later to Essoyes, his wife's birthplace. Monet had always been happier on his own, away from Paris. After visiting the Côte d'Azur with Renoir in 1883, he planned to return alone, and confessed to Durand-Ruel, 'nice as it has been to make a pleasure trip with Renoir, just so would it be upsetting for me to travel with him to work. I have always worked better alone and from my own impressions.' From Vétheuil Monet moved to Poissy, and in 1883 he settled further still from Paris, half-way to Rouen at Giverny, where he lived with Madame Hoschedé, who in 1892 became his second wife. Her children and his were now his colleagues and acolytes (Plate 165). Maupassant described seeing him at Etretat in 1885 on the beach 'followed by children who carried his canvases, five or six canvases representing the same subject at different times of day.' Blanche Hoschedé was the most devoted to him. A painter herself, she worked alongside Monet, and his close friend, the American

162
AUGUSTE RENOIR:
The Umbrellas.
c. 1881–6. Oil on canvas. London, National Gallery

163 AUGUSTE RENOIR: *The Seine at Asnières* (*'La Yole'*). *c.* 1879. Oil on canvas. London, National Gallery

164 AUGUSTE RENOIR: *The Luncheon of the Boating Party*. 1881. Oil on canvas. Washington, The Phillips Collection

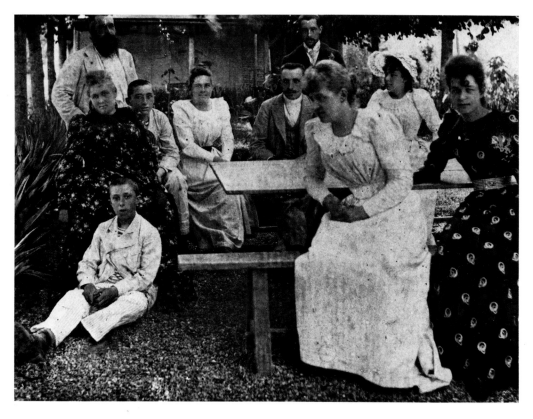

165
The Monet-Hoschedé
family at Giverny. Left
to right: Claude Monet
(top), Alice Hoschedé,
Michel Monet (at her
feet), Jean-Pierre
Hoschedé, Blanche
Hoschedé, Jean Monet,
Jacques, Marthe,
Germaine, and Suzanne
Hoschedé. Photograph.
Philippe Piguet
Collection

John Singer Sargent, in the last years of the century, helping her aging step-father with his materials, observing his methods, and learning from them.

The other Impressionists moved further afield, too, so that the break-up of the group was accompanied by physical dispersal. Sisley moved in 1882 to Moret, beyond the Forest of Fontainebleau on the south side of Paris, but failed to induce Monet to join him. Pissarro moved in the same year to Osny and, in 1884, further north still to Eragny, while Cézanne led an increasingly hermit-like existence in Provence. In 1886 he at last married Hortense Fiquet, and when in October his father died he inherited a large fortune and the house, the Jas de Bouffan near Aix, which was to be his refuge until his death.

The last occasion on which the Impressionists appeared before the public as a united group was in 1882 when Caillebotte, Pissarro and Durand-Ruel succeeded, in the face of considerable reluctance, in persuading the disheartened and estranged friends to exhibit again together. Nine participated altogether: Caillebotte himself, Berthe Morisot, Pissarro and his friends Guillaumin, Gauguin and Vignon, Monet, who had not shown with the group since 1879, and Renoir and Sisley who had abstained since 1877. Degas refused to join in because the others insisted on the exclusion of his band of followers. Never before had the exhibition had such a homogeneous character. 'This is the first time that we do not have any too strong strains to deplore,' wrote Pissarro to de Bellio, and their efforts were rewarded by more favourable press comment and increased sales. Nevertheless, Renoir stayed in Marseilles, recuperating from his illness, Monet remained in Vétheuil and Berthe Morisot was absent in the South. Her husband Eugène Manet wrote to her from Paris about the exhibition: 'Sisley is the most complete and shows great progress ... Pissarro is more uneven ... Monet has some weak things

166
AUGUSTE RENOIR:
The Large Bathers.
1884–7. Oil on canvas.
Philadelphia Museum of
Art

next to some excellent ones ... The picture of *Boaters* [Plate 164] by Renoir looks very well; the views of Venice are wretched like real knitwear.' He also spoke to her of his brother Edouard, whom Pissarro had failed to persuade to join them. 'I believe he now bitterly regrets having declined. He seems to have hesitated a good deal.'

Manet thus sadly missed the last opportunity to exhibit publicly with the group to whom he was so intimately allied personally and artistically. By 1882 he was seriously ill, suffering from locomotor ataxia, a disease of the nervous system, and on his doctor's advice spent less time in Paris. In 1880 he stayed at Bellevue; in 1881 he rented a house at Versailles, where he painted small canvases of the pretty walled garden, and later still he retired to Reuil, near Malmaison. He missed the animated discussions at the Café de la Nouvelle-Athènes, but assembled round him a circle of devoted friends to relieve his boredom — his wife Suzanne, the poet Stéphane Mallarmé, whose portrait he had painted in 1876 (Plate 167), and many beautiful lady friends, foremost among them the actress and courtesan Méry Laurent, whom he persuaded to pose for him. For these portraits he often used pastel, both for simplicity and to achieve the refinement and elegance of the eighteenth-century pastellists. It was as if in his illness he was more intent on courting beauty, producing works like the portrait of Méry Laurent as Autumn (Plate 168) which aspire to an ideal of woman as the glorious and artificial creation of fashion — the absolute antithesis of Degas's unglamorous pictures of women at their ablutions. Méry Laurent is shown richly attired in a black fur-lined cloak by Worth, like an icon — the personification of autumn and sophisticated womanhood — against a flat decorative background of flowers. It is as though once again at the end of his life Manet had been mindful of the words of his old friend Baudelaire, who in *The Painter of Modern Life* described 'Woman' as 'a general harmony, not only in her bearing and in the way she walks and moves, but also in

167
EDOUARD MANET:
Portrait of Stéphane Mallarmé. 1876. Oil on canvas. Museé d'Orsay

the muslins, and gauzes, the vast iridescent clouds of stuff in which she envelops herself, and which are as it were the attributes and the pedestal of her divinity.'

Even in his illness Manet did not entirely neglect the wider modern world which had become his speciality. In many paintings of the 1870s he had focused on one or two individuals in a particular milieu, a waitress in a brasserie, a courtesan, *Nana*, in her boudoir, or a couple in a conservatory. At the Salon of 1882, the last at which he was to exhibit, he showed *The Bar at the Folies-Bergère* (Plate 169), the final haunting masterpiece of this series, which portrays a bored young waitress standing at a marble-topped bar with, behind her, a mirror reflecting like a tableau the glittering spectacle of the café. In spite of the brilliant description of surfaces and objects, the picture shares, in a sense, the decorative mode of the portrait of Méry Laurent, in which a figure is formally posed against an evocative backdrop. The device of the mirror adds a special note of mystery to the picture. The reflections and the spatial arrangement are in any case difficult to explain, but what is clear is that the girl, standing centrally behind the bar staring blankly at us, is the only palpable flesh and

168
EDOUARD MANET:
Autumn. 1882. Oil on canvas. Nancy, Musée des Beaux-Arts

blood. The rest is an illusion, from which she, psychologically, is isolated, an individual among many others, but still ultimately alone.

The Bar at the Folies-Bergère, which cost the suffering Manet so much effort, was greeted at the Salon with critical acclaim, and at last, thanks to the support of his friend Antonin Proust, the new Minister of Fine Arts, he was created a *Chevalier de la Légion d'honneur*. But he was not long able to enjoy his success. By the end of the year his condition had greatly deteriorated. He was unable to walk and paralysis in his legs led to gangrene. In April, against the advice of Dr Gachet, his left leg was amputated, but the operation failed to save him, and on 30 April 1883 he died. At his funeral on 3 May, Monet, Zola, Duret and Fantin-Latour helped to carry the coffin, and Pissarro and Cézanne joined his family among the mourners.

The death of Manet came as a bitter blow to the Impressionist circle, and brought an end to an era of magnificently fruitful group activity, which had lasted just over twenty years. Ironically, the attitude of the public and the press towards Manet's work rapidly changed after his death. Less than a year elapsed before he was granted the honour of a large retrospective exhibition at the Ecole des Beaux-Arts, and at the sale of his studio early in 1884 prices far exceeded expectations. Among the buyers were many old friends. Caillebotte purchased *The Balcony* (Plate 50) with the intention of securing it for the State through his bequest, and Chocquet bought the painting of Monet in his floating studio (Plate 115). Although he had never shown with the Impressionists, Manet had been at the centre of their circle, and with his death the circle fragmented. As a renegade in the 1860s, he had become the figure-head of modern painting, and the public had continued to recognize in him the guiding spirit behind the independent exhibitions of the seventies. Furthermore it was he, above all, who socially and in his work bridged the gap between Degas, the urbane figure painter, and the *plein-air*

landscapists, Monet, Pissarro and Sisley. 'He was greater than we thought,' Degas lamented. For him Manet's death meant not only the loss of a close friend, but also the disappearance of the bond that linked him with the Impressionist painters, the most vital artistic force of the day.

Degas remained in Paris when the others moved away, and without family and plagued by fears of blindness, he became increasingly morose and isolated. In 1884 he wrote to a friend:

> One cuts off everything around one and when quite alone expires, in a word, kills oneself, out of disgust ... I hoarded all my plans in a cupboard, the key of which I always carried with me, and I've lost the key. I feel that the state of coma I am in I shan't be able to throw off. I shall keep myself occupied, as those who do nothing say, and that will be all.

In spite of his depression Degas continued to work, embarking in about 1883 on a series of nudes observed with cool detachment in natural poses and activities, washing themselves, combing their hair, draped in towels, sitting on beds, kneeling in baths (Plate 170). As his sight weakened, his handling grew broader and his colour more brilliant. When, at the turn of the century, he could no longer see to paint, he worked with his hands, modelling dancers and horses in clay, not from life but from the vast knowledge of form and movement accumulated in his memory.

Degas relied increasingly in his old age on those trusted friends who in spite of his alienating behaviour liked him — Henri Valpinçon and his family, with whom he had stayed after the siege of Paris, the sculptor Bartholomé, and above all the Rouarts. In 1886, shortly before the death of Madame Rouart, Degas planned to paint a picture of his friend Henri with his wife and daughter, but in view of Madame Rouart's ill-health, he painted the daughter Hélène, alone, in a room of her father's house on the Rue de Lisbonne (Plate 171). Although Henri is not present in person, the picture nonetheless touchingly evokes

169
EDOUARD MANET:
The Bar at the Folies-Bergère. 1882. Oil on canvas. London, Courtauld Institute Galleries

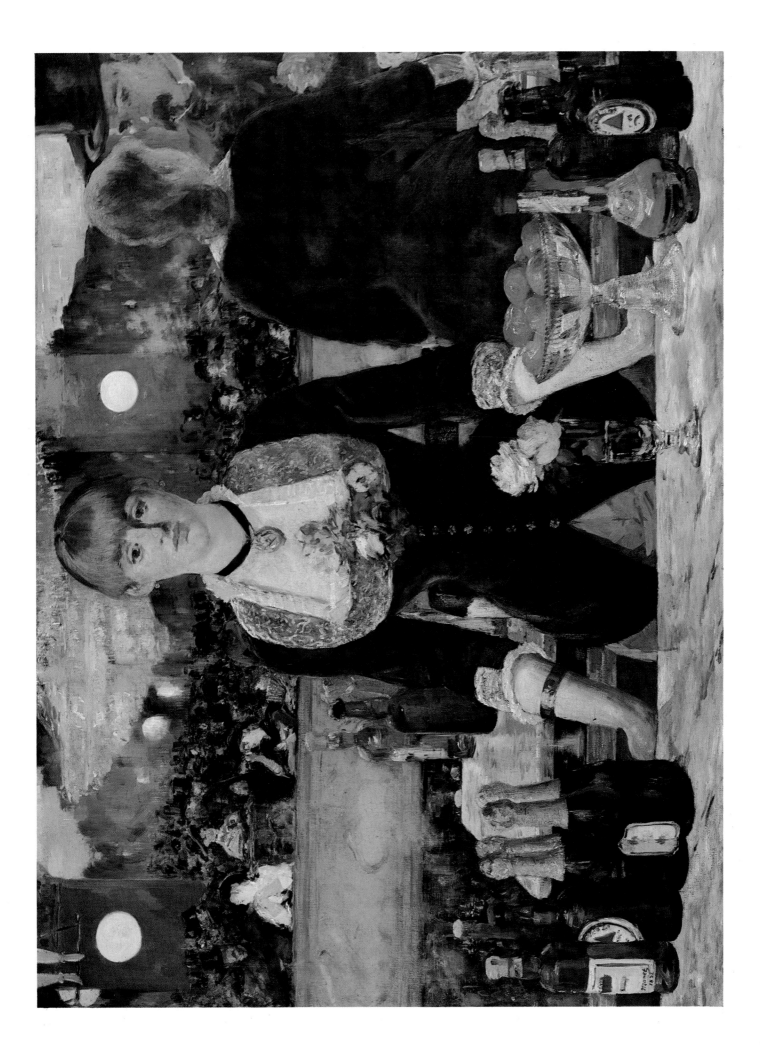

the relationship of father and daughter, for Hélène is shown surrounded by his collection of pictures and antiquities — Egyptian wood statues, a Chinese silk wall hanging, an early Corot of *The Bay of Naples* and a Millet drawing. His presence is suggested by the objects he loved (like Degas he especially admired Corot and Millet) and by the large vacant chair upon which Hélène gently rests her hands. With her steady glance and dignified bearing, she is shown as a person of refinement and sensitivity, raised in a highly cultivated environment. But there is an ambiguous note in her curiously crooked smile, which suggests that the situation of the young Hélène, on the verge of womanhood, is reflected by the statue in the glass case, that she is confined within the protective care of an overfond father.

As the Impressionist painters disbanded and dispersed, each with his own interests or family preoccupations, a younger generation was emerging to develop their discoveries along new paths. The chief link between the two generations of painters was Pissarro. Of all the Impressionists, he was the most interested in the ideas of younger artists and most open to their influence. They felt free to come to him for advice and instruction, and he recognized their talent and listened to their theories. Just as he had been instrumental in Cézanne's development, so he became mentor to the young Paul Gauguin (Plate 172), a stockbroker-turned-painter and a keen collector of Impressionist pictures, whom he met in 1877 and invited to exhibit from 1879 in the group exhibitions.

Gauguin's earliest paintings are landscapes in a rather heavy Impressionist mode (Plate 173), reminiscent of Pissarro's own early efforts. However, the influence of Cézanne, whom he greatly admired, soon led him away from Impressionism towards a more structured, synthetic art.

In 1885 Pissarro met Paul Signac and Georges Seurat and he not only invited them to exhibit in 1886 in the last Impressionist exhibition, but was also won over to

the latter's scientific theories of colour separation and to *divisionnisme*, his method of painting in dots of pure colour. He also befriended the Dutchman, Vincent Van Gogh (Plate 174), who had arrived in Paris in 1886 drawn there by reports from his brother Theo enthusing over Impressionist painting. Theo worked for the picture dealer Boussod et Valadon and introduced Vincent to Pissarro. Pissarro's fondness for the sensitive and excitable Van Gogh was mingled with pity. He called him a 'five-footed sheep' and predicted that he 'would either go mad or leave the Impressionists far behind'. Pissarro recommended Van Gogh to Père Tanguy as he had Cézanne, and it was also he who persuaded Dr Gachet to take him into his care at Auvers shortly before Van Gogh shot himself in July 1890.

Pissarro's friendliness towards younger painters did not enhance his standing with his old colleagues. Monet and Renoir particularly deplored the new elements he introduced into their exhibitions. But the 1880s

170
EDGAR DEGAS:
After the Bath. 1886.
Pastel on cardboard.
Paris, Musée d'Orsay

171
EDGAR DEGAS:
Hélène Rouart in her Father's Study. 1886.
Oil on canvas. London, National Gallery

gas's influence that induced him to concentrate on figure subjects, chiefly peasant girls in a variety of postures (Plate 175) — the rural equivalents of Degas's dancers and laundresses. However, his method — a technique of small strokes of thick paint — owes more to Cézanne. This style itself underwent radical revision when Pissarro came under Seurat's influence. The *Woman in a Field* (Plate 176) is one of the finer examples of his divisionist work, a short-lived phase which earned him the criticism of his former admirers, and with which he himself was soon to tire. Although in this picture he adheres to the principle of applying colour in separate dots, his pointillism is less uniform than Seurat's and retains much Impressionist spontaneity. Nevertheless, referring to himself as a 'scientific Impressionist', he criticized the methods of his old colleagues, the 'romantic Impressionists', and deepened the rift opening between them.

The exhibition of 1886 was scarcely an Impressionist exhibition at all, consisting for the most part of Degas's following and the new band of 'divisionists'. Monet, Renoir, Sisley, Cézanne and Caillebotte all abstained, as they had in 1881. There were to be no further shows; the group that had initiated them had ceased to exist. Furthermore, by 1886 there was no shortage of places to exhibit. Two years earlier, hundreds of artists rejected by the Salon had

172 *Above left*
PAUL GAUGUIN:
Self-Portrait. 1885. Oil on canvas. Berne, Private Collection

173 *Above*
PAUL GAUGUIN:
The Lake in the Plain. 1873. Oil on canvas. Cambridge, Fitzwilliam Museum

174 *Left*
JOHN P. RUSSELL:
Portrait of Vincent Van Gogh. 1886. Oil on canvas. Amsterdam, Rijksmuseum Vincent Van Gogh

175
CAMILLE PISSARRO:
The Shepherdess. 1881. Oil on canvas. Paris, Musée d'Orsay

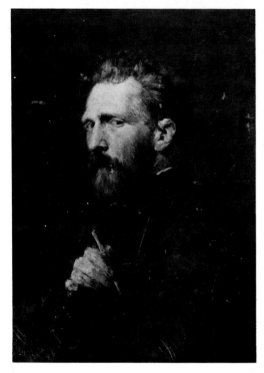

were a difficult period for Pissarro (as they were for Renoir), a time of crisis during which he frantically searched for new ways and means of working. Early in the decade he and Gauguin joined Degas on various printing projects, and it was probably De-

176
CAMILLE PISSARRO:
Woman in a Field. 1887.
Oil on canvas. Paris.
Musée d'Orsay

come together and exhibited under the title, *Groupe des Artistes Indépendants.* The exhibition constituted in effect an unofficial Salon open to all comers. Guillaumin showed there, as did Odilon Redon, one of the leaders of the new Symbolist tendency, and so too did Signac and Seurat. The latter showed a large canvas of bathers on the banks of the Seine at Asnières (Plate 177). Painted prior to his formulation of the strict technique of *divisionnisme*, it already shows him searching for a more monumental and structured interpretation of nature than that of the Impressionists.

The new exhibition achieved formal status and a constitution in June 1886, when the *Société des Artistes Indépendants* was founded as a regular exhibiting society under Redon's presidency, 'to help artists to freely present their work before the bar of public opinion'. A similar society called

Les Vingt was founded in Brussels in the same year and attracted support from many Symbolist artists and critics. In Paris there continued to be small independent exhibitions on the premises of *La Vie Moderne.* Following Durand-Ruel's lead, other dealers were mounting exhibitions of modern artists, and in the 1880s both Monet and Renoir began to sell to Durand-Ruel's greatest rival, Georges Petit. They justified their desertion by claiming that their work would be more readily accepted if handled by more than one dealer. Saddened by their lack of faith and on the verge of ruin himself, Durand-Ruel concentrated all his efforts on establishing a market in America. In 1886 he took an exhibition of over three hundred pictures to New York, including at Pissarro's request some pre-divisionist works of Signac and Seurat such as *Bathers, Asnières.* The show was well received. 'New

177
GEORGES SEURAT:
Bathers, Asnières.
1883–4. Oil on canvas.
London, National
Gallery

York has never seen a more interesting exhibition than this,' one paper proclaimed, and the first American buyers made their appearance.

The year 1886 not only witnessed the last Impressionist show and Durand-Ruel's New York exhibition, it also saw the appearance of two notable publications. The critic Félix Fénéon brought out a pamphlet, *Les Impressionnistes en 1886*, which announced his admiration of Seurat and 'neo-impressionism', as he termed his style. While he praised the achievement of the old Impressionists and acknowledged them as the source of Seurat's innovations, he in effect relegated the movement to the past, by heralding the arrival of a new one as its successor. The second publication had a more personal impact on the Impressionists. Emile Zola's novel *L'Oeuvre* is the history of a young painter, who is driven to suicide by his inability to realize his aims. The artist is represented as an Impressionist, a *plein-air* painter whose unconventional work earns him the opposition of the Salon jury and the mockery of the public, and Zola drew heavily upon his intimate knowledge of Manet and Cézanne for the creation of the hero, Claude. The Impressionists were quick to recognize the author's loss of faith in them, and his tacit condemnation of their efforts. Cézanne, the lifelong friend of Zola, who had not yet achieved recognition (he had not exhibited in Paris since 1877), was particularly hurt by the book and never saw the writer again. Renoir, Pissarro and Monet also broke with him. 'I have been struggling fairly long,' wrote Monet, 'and I am afraid that in our moment of succeeding, our enemies may make use of your book to deal us a knockout blow.'

If Zola chose to look on his former friend Cézanne condescendingly as a hopeless case, others were beginning to recognize in him an innovator of enormous importance. While the Impressionist aesthetic came under attack, Cézanne's painfully forged reconstructions of nature were admired by the younger generation as the foundation of a new synthetist art. Although he was rarely seen in Paris, his pictures were scrutinized at old Père Tanguy's shop, where Gauguin and Van Gogh had admired them. Gauguin owned various pictures by Cézanne, including a still-life of a fruit-dish (Plate 178) which he included in the background of his portrait of Marie Lagadu of 1890. The simplified, faceted modelling of Cézanne's later work is in fact the chief source of Gauguin's *cloisonné* style with its clearly defined areas of hatched paintwork. The same still-life with a fruit-dish is also included in another tribute to Cézanne, Maurice Denis's *Hommage à Cézanne* (Plate 180), which was exhibited at the Salon of 1901. It shows the Nabis, a group of painters dedicated to spiritual and synthetist art, including Vuillard, Bonnard and Denis, with the dealer Vollard, gathered round Cézanne's picture. In the absence of Cézanne (whom Denis had never met) Odilon Redon, another much-admired father-figure of modern art, seems to receive the ovation of the young men in his stead.

Cézanne himself became in his last years an object of pilgrimage, as enthusiasts sought him out at Aix to discuss his art. Maurice Denis recorded one such visit in a lighthearted oil-sketch showing the master at work in the open, surrounded by his disciples, with the Montagne Sainte-Victoire in the distance behind (Plate 179). Emile Bernard, the former friend of Gauguin, came too and noted Cézanne's advice to 'see in nature the cylinder, the sphere, the cone, putting everything in proper perspective so that each side of an object or a plane is directed towards a central point'. But although he found himself at the centre of a new cult, Cézanne's loyalties remained firmly attached to his old Impressionist friends. He praised Monet and Renoir to young painters at the expense of Gauguin and Van Gogh, and when he exhibited with a group of Aix artists in 1902 and 1906, reverently labelled himself 'pupil of Pissarro'.

Even though new circles and new friend-

178
PAUL CÉZANNE:
Still-Life with Fruit-Dish. 1879–82. Oil on canvas. Private Collection

ships were formed and new artistic directions taken, the original group remained bound together by the memory of the struggles they had shared and by inextinguishable loyalties. During the early 1890s they met monthly at 'Impressionist dinners' at the Café Riche and they continued to visit each other. Berthe Morisot's house in the Rue de Villejust was a regular meeting-place. Renoir, who adored her, came often in spite of his dislike for artistic and literary sets, and Mallarmé was her frequent guest. Even Degas, Renoir said, became more civil under her influence.

Renoir was with Cézanne in the Midi in 1895 when he learned of the death of Berthe Morisot, the member of the Impressionist group to whom he had remained most close. The news reached him as he was working in the open. He immediately packed up his painting things and left for the station. 'I had a feeling of being all alone in a desert,' he recalled. 'We were all one group when we first started out. We stood shoulder to shoulder and we encouraged each other. Then one fine day there was nobody left. The others had gone. It staggers you.'

Sisley died in January 1899 of throat cancer. In his isolation at Moret he had grown misanthropic and envious, yet in his last hours he called for Monet, who came to his side. His wife, his constant companion, had died only four months before from a similar disease.

Pissarro died in 1903, Cézanne in 1906, Degas in 1917, Renoir, crippled with arthritis, in 1919 and Monet in 1927. But in an unexpected way the circle that had been was perpetuated. Before she died, Berthe Morisot had asked Renoir to look after her daughter Julie Manet and her nieces Jeannie and Paule Gobillard. They continued to live in the Manet house, and 'the little Manet girls' as they were called carried on the family tradition of hospitality, forging new bonds among artists and kindred spirits. Jeannie was to marry the poet Paul Valéry, and Julie Manet married Ernest Rouart, the son of Henri Rouart and an artist himself, thus linking the Manet, Morisot and Rouart families, to all of whom the person of Degas was equally dear. The Rouarts remained in touch with Renoir's sons, including Jean Renoir, the filmmaker. They in turn remained friends of Cézanne's son, Paul, who married Renée Rivière, the daughter of Renoir's old friend, and settled next door to 'Les Collettes', Renoir's home near Cagnes.

The bond which linked these later generations consisted of far more than merely circumstantial connections. They shared and perpetuated the memory of a group of men and women, their parents, who had fought together for the survival of their art, and, thanks to the strength of their fellowship, had finally succeeded in overcoming prejudice and resistance.

179
MAURICE DENIS:
A Visit to Cézanne at Aix. 1906. Oil on canvas. Private Collection

180
MAURICE DENIS:
Hommage à Cézanne. 1900. Oil on canvas. Musée d'Orsay

List of Illustrations

Selected Bibliography

General

Bazin, G., *French Impressionists in the Louvre,* New York, 1958

Boime, A., *The Academy and French Painting in the 19th century,* New York, 1970

Brettel, R., et al., *A Day in the Country: Impressionism and the French Landscape,* ex. cat., The Los Angeles County Museum of Art, The Art Institute of Chicago, and The Grand Palais, Paris, 1984-85

Bruce, B., *The Impressionist Revolution,* London, 1986

Courthion, P., *Impressionism,* New York, 1971

Duranty, E., *La Nouvelle Peinture,* edited with notes by M. Guérin, Paris, 1946

Duret, T., *Histoire des Peintres Impressionnistes,* Paris 1906

Fénéon, F., *Les Impressionnistes en 1886,* Paris, 1886

Gachet, P., *Lettres Impressionnistes en Dr. Gachet et à Mürer,* Paris, 1957

Gaunt, W., *The Impressionists,* London, 1970

Hemmings, F.W.J., and Neiss, R.J. (eds), *Emile Zola Salons,* Geneva and Paris, 1959

Herbert, R.L., *Impressionism. Art, Leisure and Parisian Society,* New Haven and London, 1988

Moffet, C.S., et al., *The New Painting: Impressionism,* ex. cat., The National Gallery of Art, Washington, and The Fine Arts Museum of San Francisco, 1986

Rewald, J., *The History of Impressionism,* 4th rev. edn. London, 1973

Rewald, J., *Studies in Impressionism,* London, 1985

Venturi, L., *Les Archives de I'Impressionnisme,* 2 vols, Paris and New York, 1939

Vollard, A., *Recollections of a Picture Dealer,* Boston, 1936

White, B.E., *Impressionism in Perspective,* Englewood Cliffs, N.J., 1978

Works on Individual Artists

BAZILLE

Daulte, F., *Frédéric Bazille et son temps,* Geneva, 1952

Marandel, J.P., et al., *Frédéric Bazille and Early Impressionism,* ex. cat., The Art Institute of Chicago, 1978

Poulain, G., *Bazille et ses amis,* Paris, 1932

CAILLEBOTTE

Berhaut, M., *Caillebotte, sa vie et son oeuvre,* Paris, 1978

Varnedoe, K., *Gustave Caillebotte,* New Haven and London, 1987

CASSATT

Breeskin, A.D., *Mary Cassatt:* A Catalogue Raisonne of the Oils, Pastels, Watercolours, and Drawings, New York, 1948

Sweet, F.A., *Miss Mary Cassatt: Impressionist from Pennsylvania,* Norman, Okla., 1966

CÉZANNE

Bernard, E., *Souvenirs sur Paul Cézame,* Paris, 1921 Dorival, B., *Cézanne,* Paris and New York, 1948

Huyghe, R., *Cézanne,* Paris, 1936

Kendall, R., *Cézanne by himself,* London, 1988

Rewald, J., *Paul Cézanne: Letters,* London, 1941

Rewald, J., *Cézanne,* New York, 1986

Rubin, W., et al., *Cézanne. The Late Work,* London, 1978

Shiff, R., *Cézanne and the End of Impressionism,* Chicago, 1984

Venturi, L., *Cézanne, son art, son oeuvre,* Paris, 1936

Vollard, A., *Paul Cézanne, His Life and Art,* New York, 1926

DEGAS

Boggs, J.S., *Portraits of Degas,* Berkeley — Los Angeles, 1962

Boggs, J.S., et al., *Degas,* ex. cat., The National Gallery of Canada, Ottawa, The Metropolitan Museum of Art, New York, and The Grand Palais, Paris, 1988

Dunlop, I., *Degas,* London, 1979

Gordon, R., and Forge, A., *Degas,* New York, 1988

Guérin, M.(ed), *Lettres de Degas,* Paris, 1931

Halévy, D., *Degas parle ...,* Paris and Geneva, 1960

Kendall, R., *Degas by himself,* London, 1987

Lafond, P., *Degas,* 2 vols, Paris, 1918-19

Lemoisne, P.A., *Degas et son oeuvre,* 4 vols, Paris, 1946-9

Reff, T., *Degas: The Artist's Mind,* London, 1976

Reff, T., *The Notebooks of Edgar Degas,* 2 vols, Oxford, 1976

Vollard, A., *Degas,* Paris, 1924, 1938

GUILLAUMIN

Gray, C., *Armand Guillaumin*, Chester, Conn., 1972

MANET

Bataille, G., *Manet*, Geneva, 1955

Cachin, F., Moffet, C.S., et. al., *Manet*, ex. cat., The Grand Palais, Paris, and The Metropolitan Musem of Art, New York, 1983

Guiffrey, J., *Lettres illustrées de Edouard Manet,* Paris, 1929

Hanson, A.C., *Manet and the Modern Tradition*, New Haven and London, 1977

Jamot, Wildenstein and Bataille, *Manet*, 2 vols, Paris, 1932

Moreau-Nélaton, E., *Manet raconté par lui-même*, 2 vols, Paris, 1926

Proust, A., *Edouard Manet, souvenirs*, Paris, 1913

Reff, T., *Manet and Modern Paris*, ex. cat., The National Gallery of Art, Washington, 1982-83

Rouart, D., and Wildenstein, D., *Edouard Manet: Catalogue raisonné*, 2 vols, Lausanne and Paris, 1975

Sandblad, N.G., *Manet — Three Studies in Artistic Conception*, Lund, 1954

Tabarant, A., *Manet et ses oeuvres*, Paris, 1947

MONET

Geffroy, G., *Claude Monet, sa vie, son temps, son oeuvre*, Paris, 1922

House, J., *Monet. Nature into Art*, New Haven and London, 1982

Isaacson, J., *Monet — Le Déjeuner sur l'Herbe*, London, 1972

Isaacson, J., *Claude Monet, Observation and Reflection,* Oxford and New York, 1978

Seitz, W.C., *Claude Monet*, New York, 1960

Tucker, P.H., *Monet et Argenteuil*, New Haven and London, 1982

Wildenstein, D., *Claude Monet: Catalogue raisonné*, 4 vols, Lausanne and Paris, 1974-85

MORISOT

Adler, K., and Garb, T., *Berthe Morisot*, Oxford, 1987

Bataille, M.L., and Wildenstein, G., *Berthe Morisot Catalogue des peintures, pastels et aquarelles,* Paris, 1961

Morgan, E., *Berthe Morisot — Drawings, Pastels, Watercolors*, New York, 1960

Rey, J.D., *Berthe Morisot*, New York and Paris, 1982

Rouart, D.(ed), *Correspondance de Berthe Morisot*, Paris, 1950

Stuckey, C.F., and Scott, W.P., *Berthe Morisot, Impressionist*, ex. cat., Mount Holyoke College Museum and The National Gallery of Art, Washington, 1987

PISSARRO

Pissarro, L.R., and Venturi, L., *Camille Pissarro, son art, son oeuvre*, 2 vols, Paris, 1939

Rewald, J.(ed), *Camille Pissarro, Letters to his son Lucien*, New York, 1943

Rewald, J., *C. Pissarro*, New York, 1963

Tabarant, A., *Pissarro*, Paris, 1924, New York, 1925

RENOIR

Daulte, F., *Auguste Renoir — Catalogue raisonné de l'oeuvre peint*, vol. I, Lausanne, 1971

Drucker, M., *Renoir,* Paris, 1949

House, J., et al., *Renoir*, ex. cat., The Hayward Gallery, London, The Grand Palais, Paris, and The Museum of Fine Arts, Boston, 1985-86

Pach, W., *Renoir*, New York, 1950

Renoir, J., *Renoir, My Father,* Boston, 1962

Rivière, G., *Renoir et ses amis,* Paris, 1921

Vollard, A., *Renoir*, Paris, 1918, 1920, 1938

White, B.E., *Renoir, His Life, Art and Letters*, New York, 1984

SISLEY

Cogniat, R., *Sisley*, New York and Paris, 1978

Daulte, A., *Alfred Sisley*, Munich, 1975

Daulte, F., *Alfred Sisley — Catalogue raisonné de l'oeuvre peint,* Lausanne, 1959

Geffroy, G., *Sisley*, Paris, 1923

Shone, R., *Sisley*, Oxford and New York, 1979

Index